How to Paint with
PASTELS

How to Paint with
PASTELS

S. G. Olmedo

Watson-Guptill Publications/New York

Copyright © 1988 by Parramón Ediciones, S.A.
Published in 1988 in Spain by Parramón Ediciones, S.A.,
Barcelona

First published in 1989 in the United States by Watson-Guptill
Publications, a division of Billboard Publications, Inc.,
1515 Broadway, New York, New York 10036.

Library of Congress Cataloging-in-Publication Data

Olmedo, S. G. (Salvador González)
 [Cómo pintar al pastel. English]
 How to paint with pastels / S.G. Olmedo.
 p. cm. — (Watson-Guptill artist's library)
 Translation of: Cómo pintar al pastel.
 ISBN 0-8230-2464-4
 1. Pastel drawing-Technique. I. Title. II. Series.
 NC880.05613 1989 89-5816
 741.2'35—dc20 CIP

Distributed in the United Kingdom by Phaidon Press Ltd.,
Musterlin House, Jordan Hill Road, Oxford OX2 8DP

Manufactured in Spain by Sirven Gràfic
Legal Deposit: B.21.063-89
1 2 3 4 5 6 7 8 9 / 93 92 91 90 89

Contents

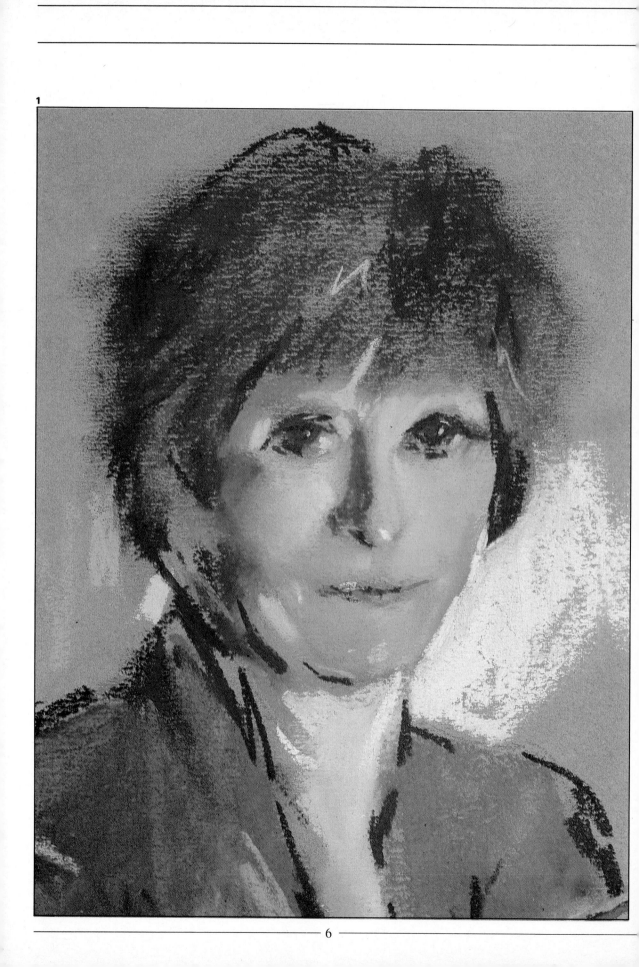

Introduction

Fig. 1. Portrait in pastel painted by Salvador G. Olmedo.

A painting, or indeed any work of art, is the crystallization of an idea. It is a very special form of expression made up of feelings, innate skills, and learned behavior—and effort which often involves suffering—never lacking that intimate savoring of the act of creation which is the preserve of the artist.

The aim of this book is to arouse the reader's enthusiasm for a method of artistic expression that combines the expressive immediacy of drawing and the sensual attraction of great painting, whose aesthetic possibilities it also shares to a large extent. We are, of course, referring to the medium known as *pastel*, which we would like to be your way of taking part in the great adventure of artistic creation.

Pastel, as we shall see, gives us the chance to express our aesthetic conceptions—our way of interpreting the world of shapes and color—with a minimum of complicated equipment. We need only be capable of working with courage, speed, and agility. And so it should come as no surprise that pastel has interested many great figures in art history from quite different periods. If the characteristics we have mentioned make pastel an attractive medium for people who have an impressionist conception of painting, the physical resemblance of the material of pastel to charcoal has also drawn artists of more academic tendencies.

By observing the works of great masters and the magnificent examples furnished by the pastellists who have helped with the preparation of this book, we will discover the secrets of the medium we are studying. For my part, as an admirer and enthusiastic practitioner of pastel painting, I promise that I will help you. To do so, I offer you my "trade secrets"—what we might call my practical wisdom expressed through examples and advice. This book is the work of a painter who is far more used to expressing himself with his pastels and sticks of color than through the written word and who, as a result, puts efficacy before erudition. I recall something Sir Joshua Reynolds (1723-1792) once said:

The shortest essay written by a painter will do far more to advance the theory of art than a million volumes.

My most earnest wish, and that of all the people who have helped with this book, is that is should be the fulfillment of Reynolds's idea.

It only remains for me to thank José M. Parramón and everyone who has helped with the book. Thanks to them all for their encouragement and their invaluable assistance.

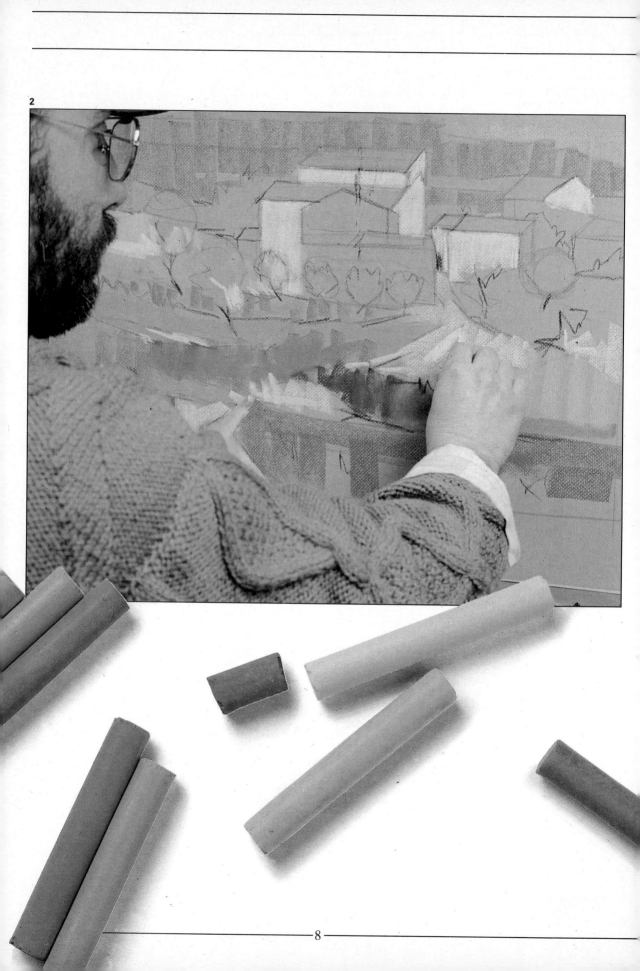

Presentation of the medium

Fig. 2. Pastel is an artistic medium that requires maximum contact with the material. The color is almost an extension of the fingers. The relationship established between hand and material is comparable only to that between a sculptor's hand and the clay he is modelling.

My personal opinion is that too little has been written about pastel. The truth is that for many artists who work with other media, pastel colors (the material) and what can be achieved with them (the specialists' work) are still undiscovered territory. And yet, how much there is to be said about the art of pastel painting!

I insist that my trade is not writing, but as a pastellist I am attempting to convey my experiences to the reader. Moreover, being a lover of painting in general and of pastel in particular, I can hope that my enthusiasm and my experience combined will provide sufficient encouragement for you to want to discover a truly thrilling technique: a solid medium with which you establish an extraordinarily intimate relationship, to the point where it seems to get under your very skin. I would be content if my works could infect you with the wonderful sensation of painting that you feel when you work with your fingers, you even think that the color springs directly from them.

Like all procedures, pastel makes its own specific demands. A work in pastel must be characterized by its spontaneity. The material does not allow insistence; even though corrections can be made, they must always be made with moderation. That is why good pastellists are characterized by inimitable boldness and freshness in their work.

Like most artists, I began painting in oils until one day, in an artists' center, I discovered pastel and pastellists. I was impressed by the ease with which they created their works, quite different from one another, but all extremely attractive. Between the work of one artist who achieved hyperrealist images and another whose work barely suggested reality, I found the widest possible range of styles I could have imagined.

Any subject will do for a pastel painting, although pastellists have a special predilection for the female nude or seminude, perhaps because of the ease with which the color can be blended over the background impastos to provide extremely delicate shades and chiaroscuros.

In the Parramón Editions dictionary *Art and Artists*, we find this definition:

PASTEL: Medium consisting of a dry color mixed with a binder, usually gum arabic. The mixture is left to stand in molds from which fragile sticks about the size of a finger are obtained. When these sticks are rubbed on suitable paper, they release a very fine powder that adheres closely to it. There are *soft pastels* that, when generously applied, provide impasto similar to that obtained from a thick paint. But it is also possible to use *hard pastels* (similar to chalk) to obtain results closer to drawing.

The great French pastellists of the baroque period, such as Quentin de Latour and Chardin, mastered the technique of soft pastel and took it to the limits of its possibilities; they created finished works with the quality of great painting. Hard pastel is used more for studies. Edgar Degas, one of the greatest pastellists ever, drew out all the expressive possibilities of hard pastel, even though it must be acknowledged that he used the technique more as a form of drawing than as a painterly medium. To "paint in pastel," with the full meaning of the verb *paint*, soft pastels are obligatory because of their ductility and because they allow and even facilitate mixtures of colors on the surface of the paper.

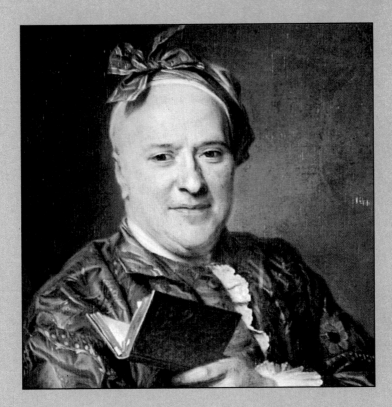

PASTEL IN
THE HISTORY
OF PAINTING

The precursors

Painting with pastel as we conceive of it today (that is, as one of the many pictorial procedures suitable for artistic expression through color) appears in art history at a relatively recent date.

Indeed, pastel began to be considered a medium that could provide all the resources of great painting only around 1720. Nevertheless, the flowering of pastel in art history is not the product of chance or of a stroke of genius. The nature of pastel, which is physically similar to other media suitable for drawing, made it popular when artists began to see drawing not only as a pre-painting method but as an expressive possibility in its own right.

This reevaluation of drawing began during the Renaissance, when the artists of the fifteenth century rediscovered Greek and Roman culture with all its humanistic elements. This led to a new way of looking at nature and man. It was during the Renaissance that the anatomy of the human body was first discovered through studies that required the graphic support of drawing. Similarly, the development of the complex Gothic forms led artists to search for new techniques capable of expressing the rich, dynamic possibilities of this style. From the sixteenth century, during the so-called cinquecento, drawing became an obligatory course of study for all artists, who practiced it to the limits of the possibilities supplied by the materials known at the time (inks, lead, charcoal, red chalk, plaster) and the use of two or three in combination. In the drawings of Leonardo da Vinci, Andrea del Sarto, Raphael, and Michelangelo, among others, for the first time we find qualities close to those of pastel, where expressive media were used for drawing. A perfect example of this is a study by the great Michelangelo that depicts a Madonna and Child, done around 1512.

Although they used very different materials, the great painters of the cinquecento may be considered conceptually as the pioneers of a technique similar to that of pastel.

This form of drawing overlaps with the baroque period, whose boundary with the Renaissance is very complex. In fact, Raphael and Michelangelo, to name the two most famous, and all the great painters of the last quarter of the sixteenth century, were already quite close to the aesthetics of the baroque. It is not mere chance that Italian art in the last third of the sixteenth century should tend toward the "grand manner" of painting and turn it into an artistic movement that we know by the name of mannerism.

Fig. 3. Study in red chalk for *Venus and Psyche*, school of Raphael, Louvre Museum, Paris.

Fig. 4. *Virgin and Child with St. Anne and John the Baptist*, Leonardo da Vinci, National Gallery, London.

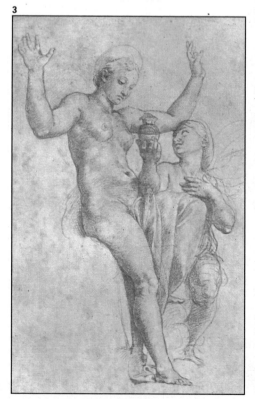

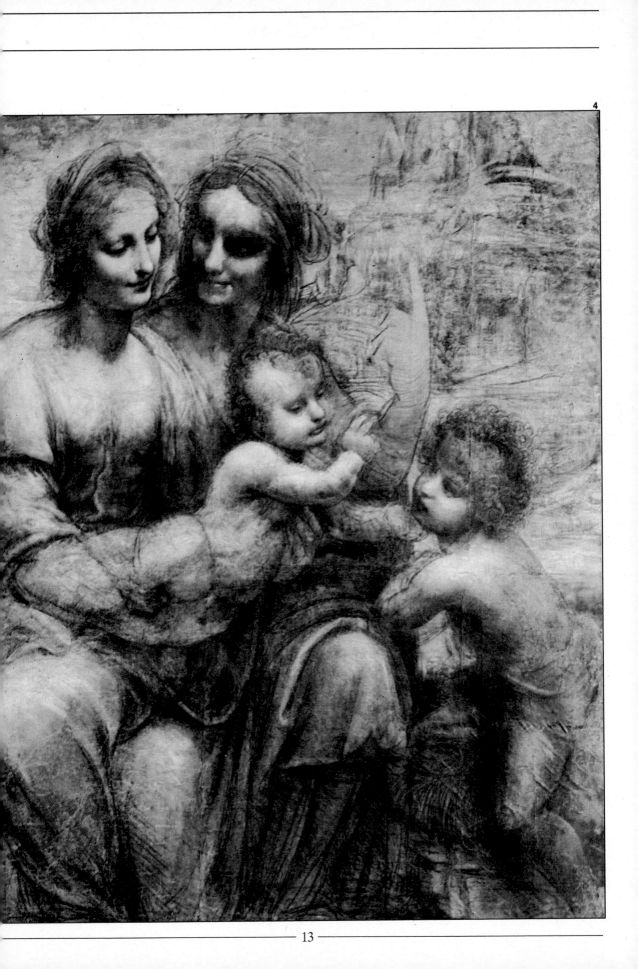

The baroque

Mannerism is the precursor to the baroque period, which occurred between the Renaissance and neoclassicism, from approximately 1600 to 1750.

The baroque is characterized by a true apotheosis of fantasy, attained from the admiration aroused by the great painters of the sixteenth century and the continuing interest in the study of classical antiquity.

The baroque movement spread throughout Europe, and in the last decades of the period (1720-1750) special characteristics known as the rococo style appeared in France and in the Germanic countries.

It was in this period of the exaltation of the decorative that pastel made its entrance into art history. And it must be said that it was an entrance in full splendor at the hand of the Venetian artist Rosalba Carriera (1674-1757), a painter of the somewhat frivolous elegance typical of European society of the day. Rosalba Carriera is known most of all for her magnificent pastel portraits, but she was also an outstanding miniaturist and figurative painter.

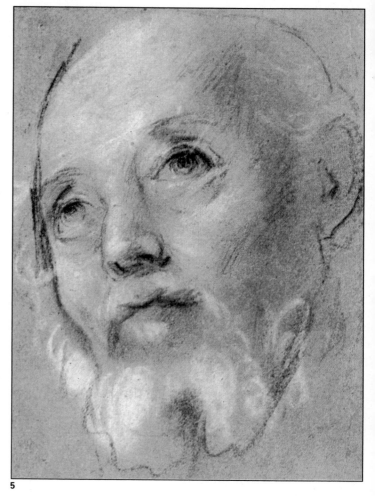

5

Figs. 5 to 8. Above: *Study for the Head of an Old Man*, by Federico Barocci. Hermitage Museum, Leningrad. Below: *Recumbent Dead Man*, by Agostino Carracci. Red chalk with white chalk relief. Janos Scholz Collection, New York. Right: *Portrait of an Unknown Woman*, by Jean Clouet. Charcoal and red chalk. British Museum, London. Facing page: *Study of a Young Woman*, by Pietro Berrettini da Cortana. Albertina Museum, Vienna.

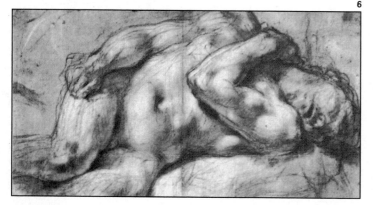

6

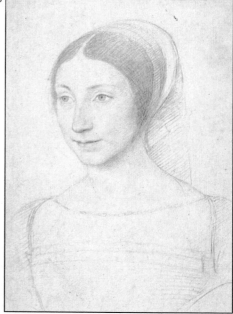

7

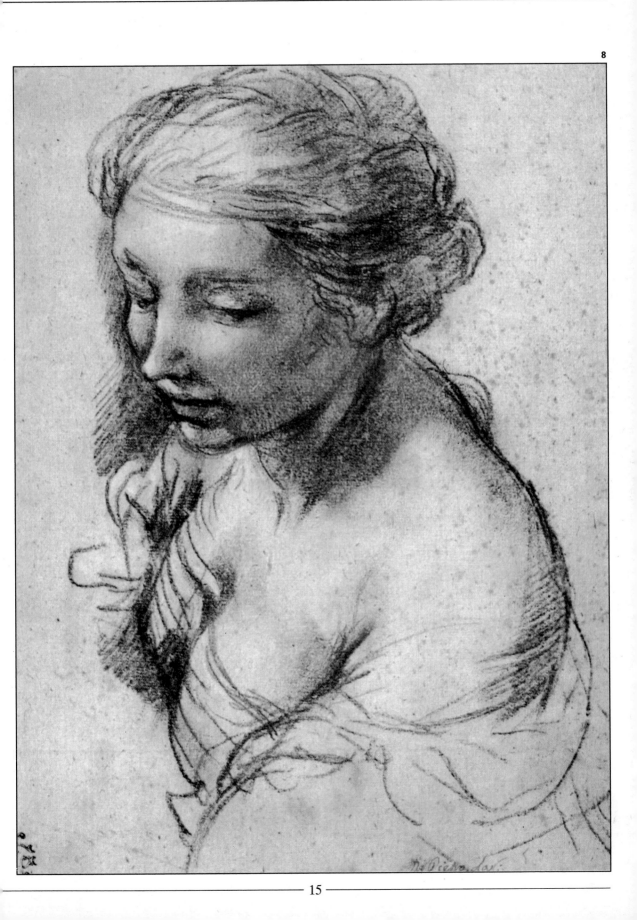

The rococo and the birth of pastel

9

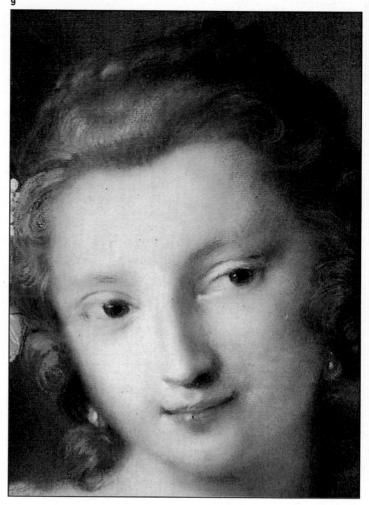

Rosalba Carriera was very successful when she worked in France under the Regency of Louis XV. In Dresden one hundred fifty of her pastels are still preserved.

A contemporary of Rosalba Carriera was Maurice Quentin de Latour (1704-1788), the most famous portraitist of the period, who reflected all the frivolity of his fellow citizens (with their rococo silks and satins) through his portraits. His subjects smile out at us as if they want to speak to us.

In Paris, people were mad about pastel painting. It has been estimated that around 1780 there were more than fifteen hundred pastellists working in the city. The subtlety of pastel went perfectly with the Gallic temperament for portraying the characteristics of an era as reflected in its most conspicuous figures.

All of us who are attracted to pastel should study the work of Rosalba Carriera, Quentin de Latour, and their contemporary, Perroneau. These masters show us that pastel is a technique that can satisfy all the demands of a good painter.

In this period of history, it is virtually impossible not to mention Jean Antoine Watteau (1684-1721). A great admirer of Rubens, Watteau was the painter of *fêtes galantes*. In his numerous paintings and his magnificent red chalk drawings, whose execution is surprisingly modern, we may glimpse a special disposition, a fleeting and melancholy sense of the transitoriness of the pleasures of life. Other artists, contemporaries of Watteau, were Boucher and Fragonard. All of them have left us a large number of excellent works, which bear witness to a time when luxury and ornamentation were extremely important.

We have already said that de Latour was the most famous French pastellist of the eighteenth century, the painter who delved most deeply into the technical possibilities of the medium. The best collection of de Latour's pastels is located in St. Quentin, where he was born and died, though he spent most of his life in Paris.

Today in St. Quentin, pastel students can see many of de Latour's studies and sketches, some of which are more instructive than his finished portraits.

After travelling during his youth, de Latour settled in Paris in 1724—only a few years after Rosalba Carriera had achieved smashing success with her pastel portraits in 1719 and 1720. De Latour spent the next sixty years in Paris taking full advantage of the pastel fad she had started. His portraits are rendered with extreme grace, occasionally bordering on vulgarity—but the viewer is always impressed by the artist's unerring knack for conveying the character of his model.

Figs. 9 and 10. Above, detail of the *Allegory of Painting* by Rosalba Carriera. On the facing page, *Young Girl of the Leblond House,* by Rosalba Carriera. Pastel on paper.

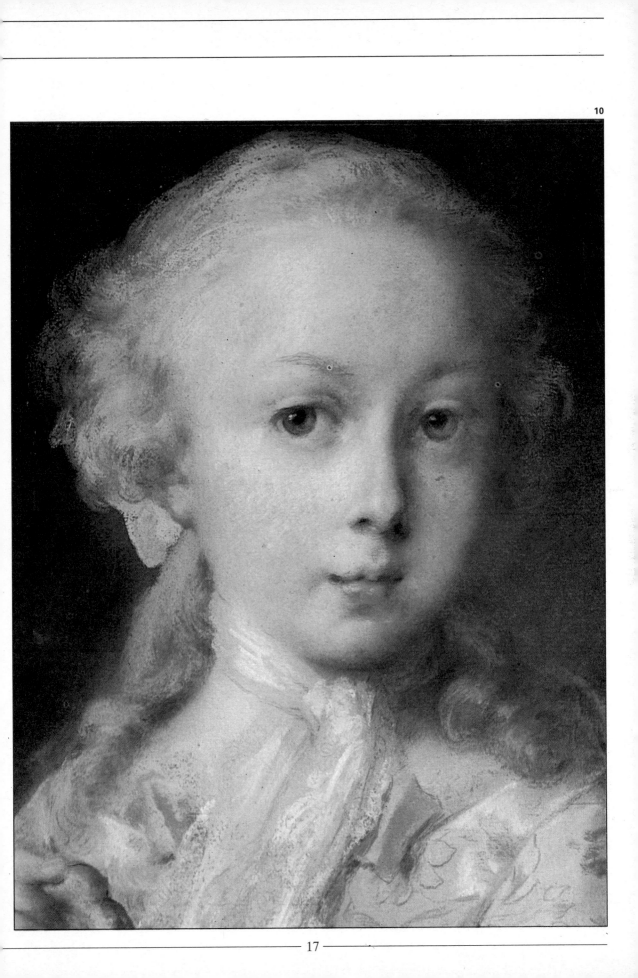

The rococo and the birth of pastel

De Latour surpassed all portraitists of that time, not only for his astounding skill and technical perfection, but also for his desire to capture the psychological essence of the century through a whole gallery of people: D'Alembert, Rousseau, Maurice of Saxony, and Madame de Pompadour, among others.

This central period of the eighteenth century was rich with good portraitists. In Spain, Vicente López y Portaña (1772-1854) was an excellent pastellist and portraitist. His work won him the appointment as first court painter to Ferdinand VII in 1815. Alongside the names of de Latour, Perronneau, and Portaña, we find other famous artists, such as Jacques André Aved (1702-1766), an intimate friend of Jean Baptiste Siméon Chardin (1699-1779), and François Hubert Drouais (1727-1775). whose style was somewhat sentimental; he was a disciple of François Boucher (his father) and a specialist in portraits of children.

Perronneau was de Latour's only rival: he travelled through Europe and died in Amsterdam. One example of the charm of his work is the famous *Girl with a Cat*, shown below.

11

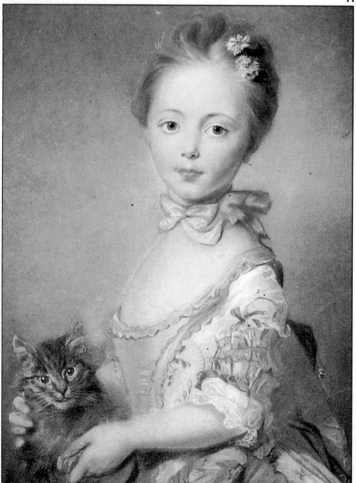

Fig. 11. *Girl with a Cat,* by Jean Baptiste Perronneau, National Gallery, London.

Fig. 12. *Monsieur Duval de l'Epinoy,* by Maurice Quentin de Latour. Calouste Gulbenkian Museum, Lisbon.

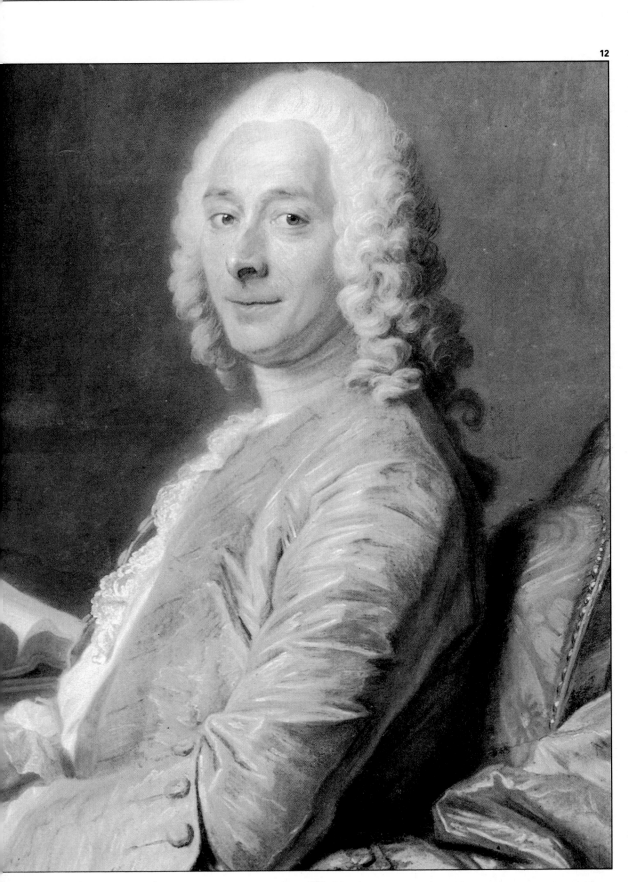

Impressionism

The term *impressionism* was first used in 1874 on the occasion of the exhibition of a canvas by Claude Monet entitled *Impression, Rising Sun*. It was used by a critic in a pejorative sense and extended to the other paintings in the exhibition, which was organized by the society of painters, sculptors, and engravers to which Pissarro, Monet, Degas, Renoir, Sisley, and Cézanne belonged. The idea that brought these artists together was a break with the official, academic art of the period.

This group of artists was also called "independents" or "plein air painters." Impressionism represented a break not only in technique, since it was a new way of painting, but also in the fact of introducing subjects that any academician would have rejected as not artistic. The movement of the boulevards, the color of festival days in the gardens, the lowest-class urban landscapes—all was seen with a new sensibility, a new concept of color that inevitably clashed with academic tradition. The impressionists' way of juxtaposing colors resulted in a blending of the borders between the background and the foreground, between objects and their shadows, in such a way that drawing, insofar as it meant the limit of shapes, disappeared. It was, in fact, a new concept of painting. We may generalize and say that impressionism tries to evoke things through impressions of color, an idea that finds an ideal medium in pastel.

Some painters of the time used pastel to capture in sketches what would later be a canvas painted in oil. Others, like Degas, found in pastel the medium in which they were most at ease and with which they obtained their most brilliant results. Degas's pastels are the most famous in the world. It is no exaggeration to say that thanks to Degas, many laymen know what a pastel painting is and can distinguish it, for example, from a watercolor.

Fig. 13. Detail of *The Tub,* by Edgar Degas. Louvre Museum, Paris.

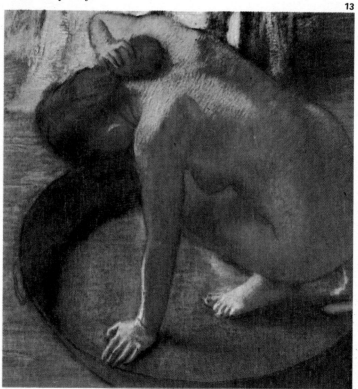

13

Fig. 14. Facing page: *Seated Dancer Tying Her Dancing Shoe,* by Edgar Degas. Louvre Museum, Paris.

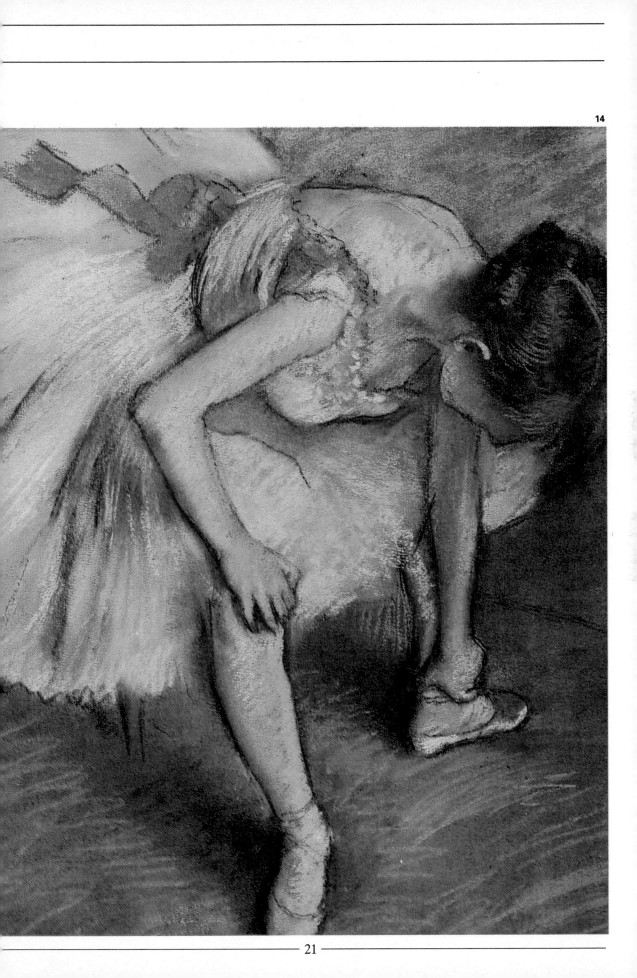

Impressionism

15

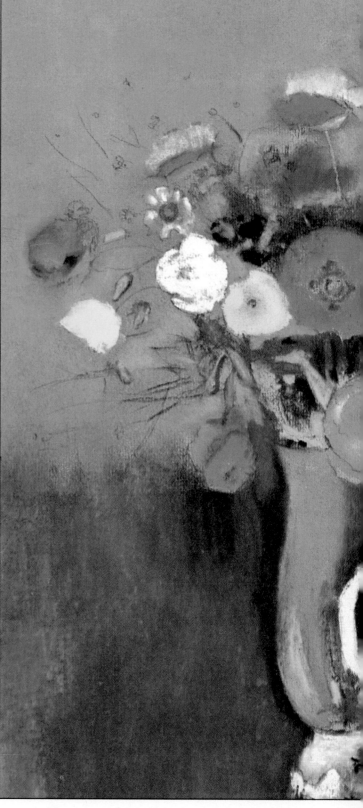

In impressionist pastels, color was used as a conductor of light, and its purpose was to evoke a reality by clarifying an image with luminosity and vivacity. Impressionism redefined the pictorial world and helped lead to the emergence of modern painting. As always happens, the new was met with total incomprehension.

Some of the most important artists to form the impressionist movement were Mary Cassatt, Boudin, Berthe Morisot, Toulouse-Lautrec, and Bazille. For dedication to pastel, we should single out Mary Cassatt, born in Pittsburgh in 1844. A disciple of Degas, she developed a technique of pastel that she applied with extraordinary mastery and sensibility to beautiful, tender subjects of women and children. Mary Cassatt and Rosalba Carriera are two women who, thanks to pastel, have left a completely personal touch of femininity and tenderness as their legacy to art history.

In the impressionist pastellists' way of painting, we find a rather vague image, almost reduced to an apparition. In order to understand what the art of painting represented for the artists of the period, we may refer to Corot's words: "Beauty, in art, is truth bathed in the first impression that we have received from nature."

Fig. 15. *Wildflowers in a Long-Necked Vase*, by Odilon Redon. Orsay Museum, Paris.

Fig. 16. *Portrait of Vincent Van Gogh*, by Henri de Toulouse-Lautrec. Stedelijk Museum, Amsterdam.

Fig. 17. Mary Cassatt, the extraordinary pastellist, shows her sensibility in this study called *Mother and Child*. Art Institute of Chicago.

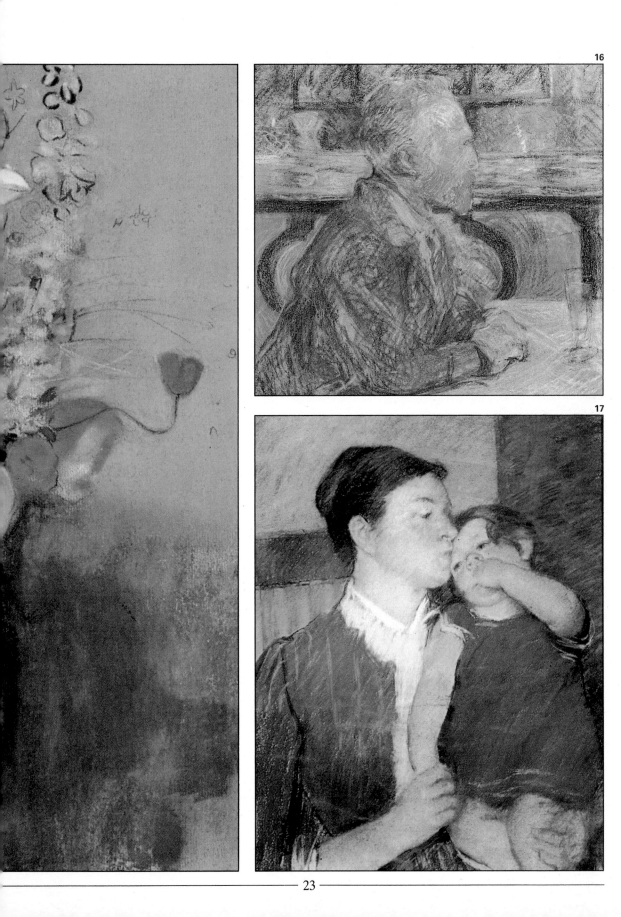

The twentieth century

The twentieth century has teemed with fine pastel artists. Since it would be difficult to make a selection worldwide, I would like to devote these next few pages to those artists from my own country—Spain—who have contributed much to pastel technique.

In May 1984, people formed long lines in the Ramblas in Barcelona. They were waiting to enter the Palacio de la Virreina. The occasion was an exhibition in tribute to the great painter and peerless draftsman Ramón Casas Carbó (1866-1932). The large collection of drawings in red chalk and charcoal was, for many visitors to the exhibition, a true revelation. The same would also go, no doubt, for the pastels of the great Spanish landscape painters Joaquín Mir (1873-1940) and Joaquín Sorolla (1883-1924), two artists who understood the secret of Mediterranean light like no one else and knew how to capture it in their pastels.

Fig. 18. Pastel portrait by Ramón Casas Carbó, 1866.

Fig. 19. *Pastel Landscape*, by Joaquín Mir. M. Lerín Collection, Barcelona.

ARTISTS AND DATES	1675	1685	1695	1705	1715	1725	1735	1745	1755	1765	1775	1785	1795
CARRIERA, Rosalba													
WATTEAU, Jean-Antoine													
LATOUR, Maurice Quentin													
PERRONNEAU, J.-Baptiste													
MENGS, Anton Rafael													
FRAGONARD, J. Honoré													
PORTAÑA, Vicente López													
DEGAS, Edgar													
REDON, Odilon													
CASSATT, Mary													
CASAS, Ramón													
MIR, Joaquín													
PICASSO, Pablo Ruiz													
SOROLLA, Joaquín													
SERRA, Francesc													

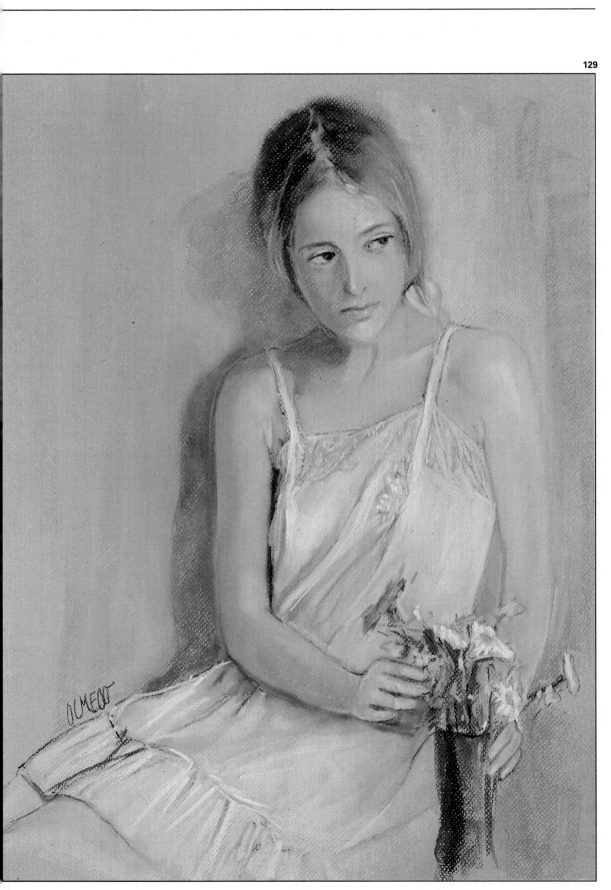

USEFUL
ADVICE

Order and cleanliness

Just as it is worth maintaining a certain order in our things, it is also advisable to be concerned with the cleanliness of our pastels. This detail makes it easier to identify colors and use them immediately and without errors. That is one piece of advice. Here are some others. The sticks of pastel, whether we buy them in cases or loose, come in a protective wrapping. Take it off, because it is useless while you are working. And another thing: cut the sticks in half, because they are too long for working. Besides, if you put away one of the two halves of each stick, you will have a double range of colors, a spare

to clean them with a rag or absorbent paper before putting them away in the box — very simple.

I know good artists who are models of cleanliness and order, and I know artists who are the exact opposite. But even where there is total chaos, I have noticed that in fact it is a *well-ordered disorder* (pardon the platitude). My most disordered colleagues always know exactly where, amid the chaos of their work table, they have to reach out for the color they want. (It's one of the mysteries of art.) You can be a

Fig. 131. Example of how pastels (half lengths and smaller pieces) can be arranged and organized into different compartments so that we do not have to search to find a cool or warm color.

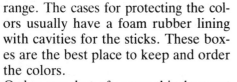

range. The cases for protecting the colors usually have a foam rubber lining with cavities for the sticks. These boxes are the best place to keep and order the colors.

Order, yes, but of course this does not mean that you should be constantly taking sticks out and putting them back. During the working session, we do not usually put the colors back in place; we keep them in our nondrawing hand to make the task easier.

But pastels get dirty; with use and rubbing, they become covered with color that is not their own. It is a good idea

Fig. 130. Pastels are sold with a paper wrapping. Before using a new stick for the first time, take off the wrapping, because when you are working it is more of a hindrance than a help.

130

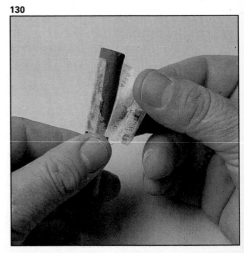

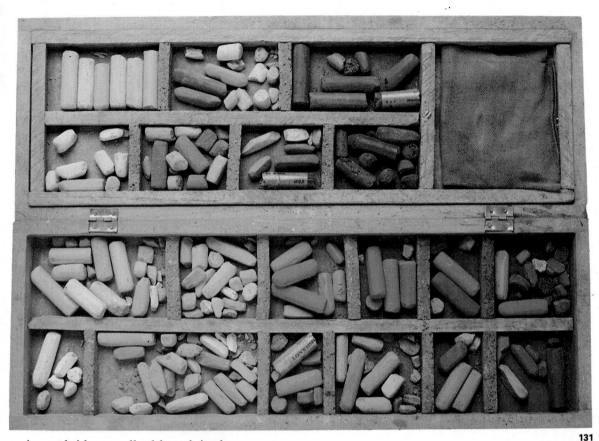

131

genius and tidy as well, although in the whirlpool of work, when you are painting with great intensity, you can lose all sense of order. Generally it is at these times when we manage to show what we have inside us. Afterwards, everything will return to normal, to the order that our temperament imposes on the work.

132

133

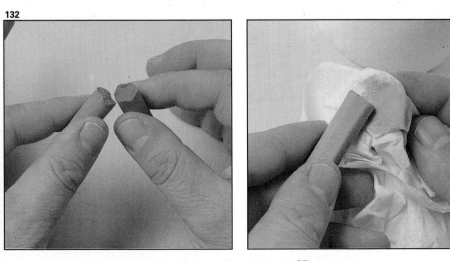

Figs. 132 and 133. Get used to working with half sticks. The whole stick is too long and is going to break anyway with the excessive pressure on it. A half stick is the ideal measure for working "in plane" and getting broad lines. Before putting the colors back in place, get used to cleaning them with a piece of rag or paper.

Protective measures

Our material, pastel, is especially delicate. Once the work is finished it needs to be protected from any friction. This is a negative feature of pastel, so in some way we have to prevent our work from being destroyed.

There are various systems for protecting pastel from rubbing and knocks. These range from fixing with spray (various brands of fixatives are on the market) to the ideal but most expensive formula: a glass frame done by a professional. Other compromise solutions include inserting sheets of laid paper between sheets in a block of Canson bristol board. This semitransparent paper will also be useful if we have to protect larger sheets of paper. A new type of frame that I highly recommend has recently appeared in art supply and frame stores. It is a mat reinforced with a plastic edge and a sheet of protective acetate (see illustration), which will do instead of glass. This provisional frame provides secure protection and is an attractive way to present paintings. It provides a useful system for transporting originals without having to worry about whether they will be preserved in a perfect state. The only problem is the price. These provisional frames are rather expensive, though when it comes to safeguarding a work of art, price is relative.

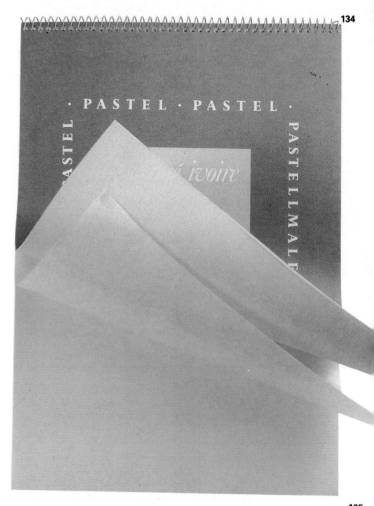

134

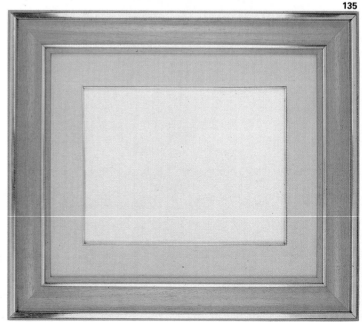

135

Fig. 134. Block of Canson paper with protective sheet of laid paper between each two sheets.

Fig. 135. This is the definitive answer to the conservation of a pastel painting: a glass frame and mat about 1/8" (3 mm) thick to separate and keep a layer of air between the glass and the painting.

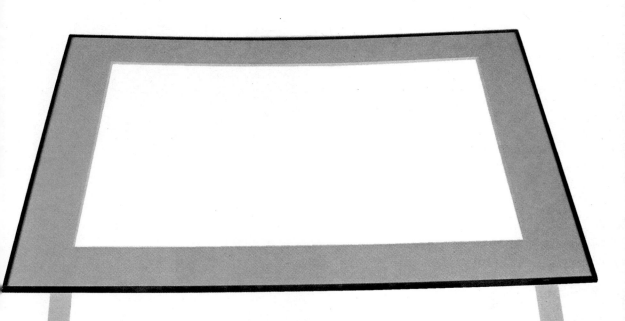

136

Fig. 136. Rigid protector with mat and acetate, which acts as glass. The set of pieces is edged with a strip of plastic that has two functions: it acts as a frame and provides fairly hermetic sealing against dust and damp.

16
FIXATIVE
Concentrated
pastel, charcoal, crayon and pencil

fixatif concentré
fixativ konzentriert
fissativo concentrato
fixatief geconcentreerd

137

Fig. 137. Aerosol fixative. Multipurpose for pastel, graphite, charcoal, pencil, and red chalk.

Frames

Yes, painting is highly gratifying and we can call the final moment exciting. I would stress that it is a very special satisfaction: the magic moment when we place the mat on the finished work and discover to our delight and excitement that it looks far better with this simple addition. This is a thrilling experience, as if it were a prize for the effort we have made. Someone said that the frame is a prize for the work. Of course a simple mat is not enough. We should also add the glass and the frame, which is never a technical problem, though it may be an economic one because a quality frame costs money. To this we must add the price of the glass and the mat. There are, of course, simple narrow strips that, from a functional point of view, are just as good as a large frame. Choosing a frame depends mostly on the destiny of the picture (the surroundings where it will be hung) independent of the kind of strip, which must match the style and subject of the painting.

Although any work looks better in a good frame, this a question we should not consider until the end. The artist's concern must be to create a good painting. Then another professional will place it in a suitable frame, but we will always be solely responsible for the content and quality of the picture.

138

Fig. 138. Wooden frame with glass and mat with metal strip, which accentuates the optical separation between the painting and its surroundings. It also increases the separation between the glass and the work.

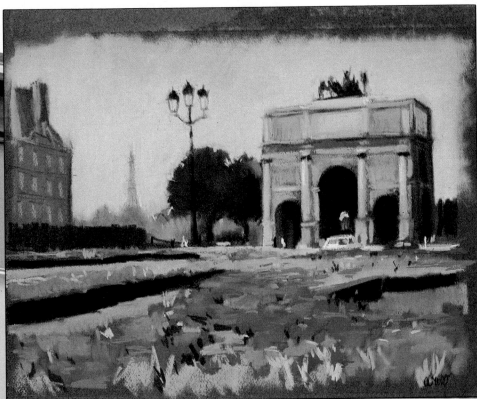

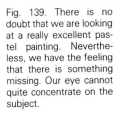

Fig. 139. There is no doubt that we are looking at a really excellent pastel painting. Nevertheless, we have the feeling that there is something missing. Our eye cannot quite concentrate on the subject.

Fig. 140. What a difference! A simple mat in a warm color (harmonizing with the painting's color scheme), dark enough to create a good contrast, has concentrated the eye and given a considerable boost to the feeling of depth in the picture.

Rubbing out and correcting

A former professor at the San Jorge School of Fine Arts in Barcelona, the master Labarta (1883-1963) was very popular among his students because of reprimands such as: "Look, boy (or Miss; the girls were always Miss), it's fine by me that you want to be a painter; when all's said and done, it's not my responsibility. And it doesn't worry me that you tried to paint a pear and it's turned out to be an artichoke. What does worry me is that YOU DIDN'T EVEN REALIZE IT!"

With reprimands like that (he had a large repertoire), the good master wanted to make his students realize that, provided they were aware of their mistakes, they had what it took to be-come artists, since they could always learn to correct them.

The problem lies not in making mistakes, but in failing to recognize them. Learn to correct! Here is a great challenge.

It happens (not often, but it does happen) that we have embarked enthusiastically on a work in pastel, but there comes a moment when we realize that something isn't working. This happened to me with the portrait that illustrates this commentary.

The portrait on the left, although treated with flow and positive successes in color, has serious defects in the drawing.

Don't ask me why I didn't realize

Fig. 141. Pastel portrait done *alla prima* without paying much attention to the mistakes, basically of form, made while working in a single sitting.

Fig. 142. This is the same portrait deliberately rubbed out to obtain a sfumato —blending of tones— that serves as a base or starting point for a new and more careful execution. The deliberate rubbing out of a pastel is reminiscent in a way of the sfumato of the Turin shroud in positive. (Fig. 143).

141

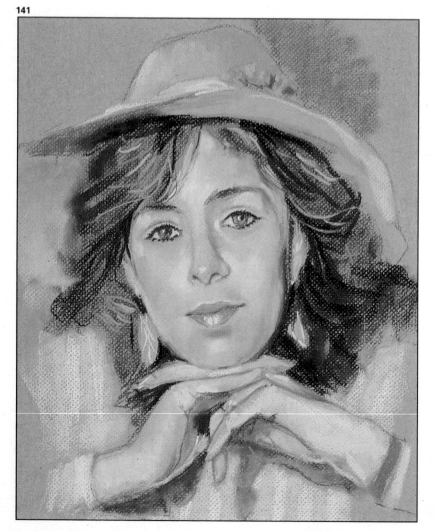

142

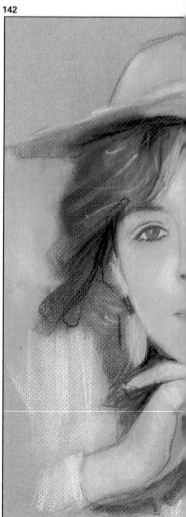

earlier; I honestly don't know. Perhaps overconfidence? The positive thing is that I was aware of the mistakes I had made.

What should I do? Tear up the painting? Not a bit of it. Pastel provides another far more constructive answer: take a clean cloth and rub the painting with it to eliminate as much color as possible. We will never manage to make it disappear altogether, but we will be left with a blurred image that will often provide a good base for restructuring the work, leaving what is useful and correcting the mistakes. You can be quite sure that the painter learns his trade by a lot of rubbing out and correcting; there is no other way.

Discovering defects in the painting led me on to a very useful and interesting exercise: redoing a picture on the basis of a first version in which there were also positive features. Thanks to exercises like this I have acquired experience and lost all my fear of rubbing out.

Fig. 144. Here is the finished work. The defects of form have disappeared, and the first attempt has been used to refine the color. The small "strident notes" and hardnesses that you no doubt noticed in the first version of the portrait have been eliminated.

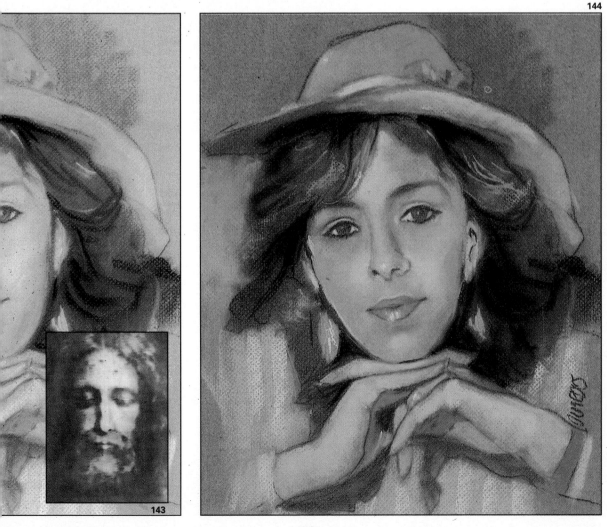

143

144

103

Problems

Pastel, like all pictorial procedures, has advantages and disadvantages. Here are some examples.

Storing the finished works. The works must be kept in trays or boxes wide enough to accommodate them, or in folders, but remember that each painting must be protected with the proper laid paper. Whatever the way you keep your originals, you must guarantee, as far as possible, that they do not come in contact with one another.

Fixing pastels is always a problem. The fixative liquid may produce stains, especially in the zones of the painting that contain little color—that is, the zones with little impasto where the paper shows through. If we decide to fix a pastel we should do it very carefully, applying the spray in successive layers and leaving each one to dry before proceeding. If necessary, we can retouch the zones stained by the fixative.

Transporting large paintings. Although there are large folders, you may have to transport pastels too large even for them. In these rather unusual cases, the best way to prevent knocking is to roll them with the proper layers of laid paper. There are cylinders with lids that provide greater safety for transport.

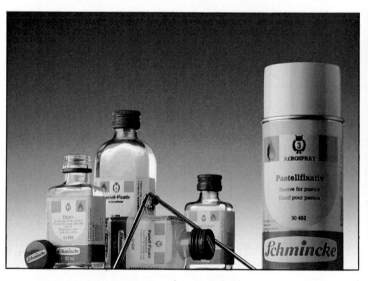

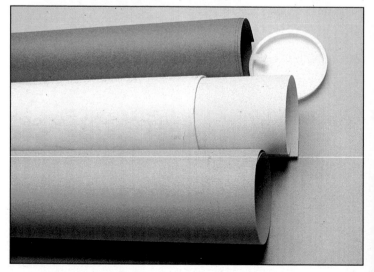

Ignorance of the medium. Another problem that may arise is the general public ignorance of the medium. How often does the pastellist have to bend over backward to persuade the customer that pastel is as valid a pictorial medium as any other, that the quality of a painting does not depend on the technique used, and that in art the only thing that counts is the result. Pastel is the medium we have chosen, and when we use it we feel totally fulfilled as artists.

The fragility of the material. It not infrequently happens that a box of pastels falls to the ground, which may be a greater or lesser disaster for the owner: sticks smashed to smithereens, pieces of different colors mixed up and scattered all over the place—a nasty experience.

The fragility of pastel sticks is a problem to bear in mind. Take precautions that will protect you from "traumatic" accidents. Find a safe place to keep your case of pastels.

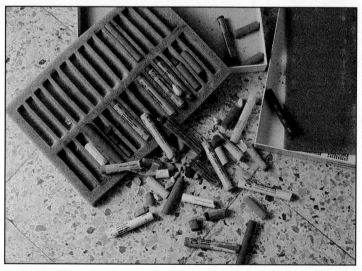

The price of a good frame. There are other minor problems and snags that we have not mentioned, but all of them can be solved. To end this chapter I would like to reiterate the economic problem that may be involved in framing a work in a way worthy of it, a problem that sooner or later every pastellist has to face. A good pastel is finished only when we see it with its mat, its glass, and its frame. This is the happy ending our work deserves.

MASTER
PASTELLISTS

Mary Franquet

145

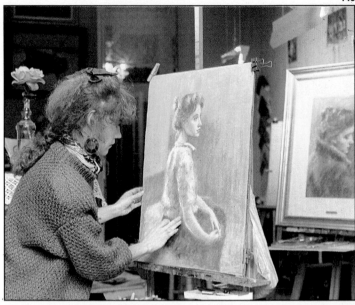

146

147

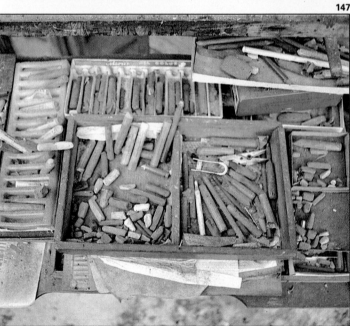

Mary Franquet was born in Barcelona in 1953. From an early age she yearned to become an artist. She began to study art in the Lonja School of Art; she also attended nature classes at the Barcelona Royal Art Circle and later merged her drawing and painting studies.

All along, this artist has studied the work of the great masters of impressionism in depth. Mary Franquet has won three prizes: Fundación Guell (1977), Lola Anglada (second prize, 1981), and an honorable mention in a painting competition in Arles. She has exhibited works in galleries in Spain, Germany, France, and England.

Her favorite subject is the figure. Mary Franquet tries to make her figures breathe, to move with a life of their own, always within an intimate female world full of charm and magic. They are figures at rest, but they express both defiance and strength in their eyes. All of them are women—special women whose faces, radiating strength, are enigmatic and full of mystery. In her painting, mystery is a constant that gazes out from the eyes of her protagonists.

Mary Franquet's pastels are full of harmony and color. Her tones are soft but strong, so that the color vibrates to unsuspected limits.

Figs. 145 to 148. In her Barcelona studio Mary Franquet uses a palette in which there is a perfectly ordered disorder. In her paintings the vigorous line of the pastel is visible, as can be seen in the enlarged detail (Fig. 148) of the portrait on the facing page.

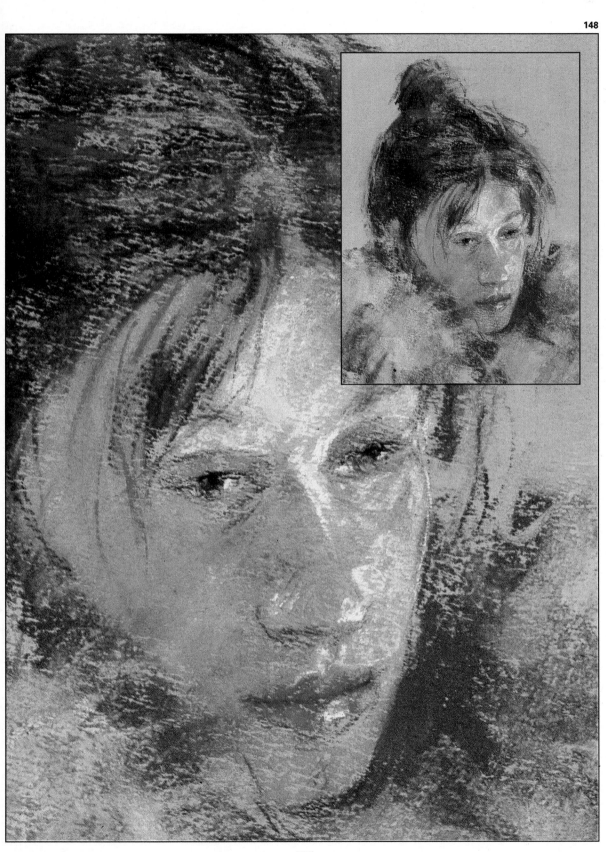

Selected works

149

150

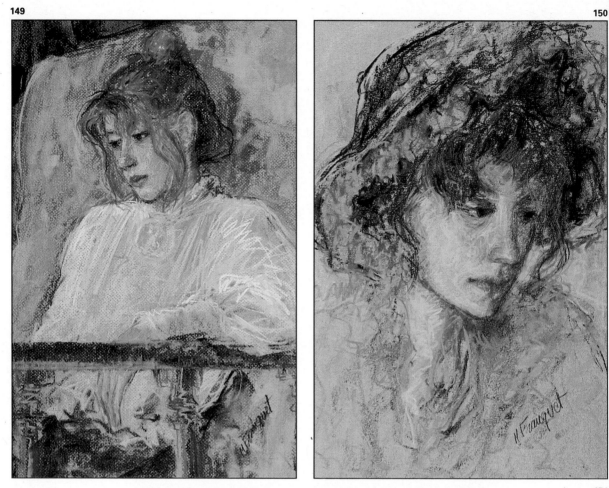

151

Figs. 149 to 152. The opinion that pastel does not allow vibrant, bold strokes of color is proved mistaken by Mary Franquet, whose female portraits radiate a sense of strength and character.

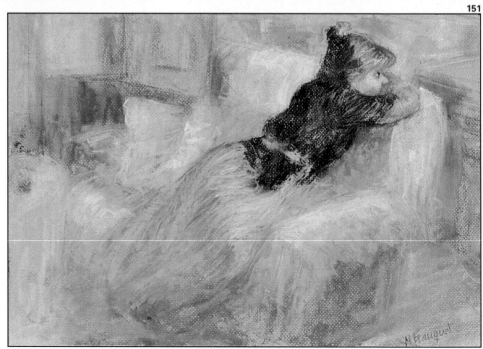

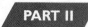

Exercise List

Preface

During our many years of counseling and teaching, we have observed that low self-esteem affects an individual's ability and/or willingness to take positive action in his or her life. Like many other educators, we have also noted that factors such as a student's family background, personality style, and current personal situations can create stress and vulnerability. These stressors can stifle the necessary willingness to make changes and further diminish self-esteem. Performance and efficacy suffer.

The second edition of *Building Self-Esteem: Strategies for Success in School and Beyond* continues to address these issues in a practical and positive manner. We continue to teach the course, "Developing Self-Esteem," and Pima Community College, one of the country's largest multicampus colleges, maintains its commitment to empowering students through offering this course. The class is supported by our school because self-esteem is strongly linked to student retention and success. Over an eight-year period, we have taught more than 30 sections of the class; our students ages range from 17 to 70.

Features of the first edition, such as the concentric circle model of self-esteem development, continue to be the core of what makes this book unique. Students and faculty alike appreciate this easy-to-grasp visual representation of the complexity of self-esteem. Many exercises are included for the class and instructor to choose from, and everything that is included is well-grounded in research and professional experience. Many of the exercises lend themselves to both individual and group processing.

New features of this edition of the text include:

- Incorporation of the most recent, practically applicable psychological and sociological research about self-esteem.
- Examples of how individuals presented in the case studies of earlier chapters applied the self-esteem enhancing strategies that are presented in Chapters Seven and Eight to ensure personal and academic success.
- Recent information and research about psychological type (the core circle of our circle model).
- An assessment tool in the first and last chapters (a kind of pre- and post-test) that allows readers to subjectively determine their progress in areas in which they would like to focus their personal growth.
- The self-esteem symptom checklist in Chapter Six now allows the reader not only to determine symptoms of low self-esteem, but also to realize that they are probably practicing high self-esteem behaviors already.

We hope that each reader will be as challenged and fulfilled while reading and practicing the strategies presented in the text as we have been while teaching the enhancement of self-esteem to our students.

ACKNOWLEDGMENTS

Our sincere thanks to the following individuals, who reviewed this text in earlier stages and offered suggestions toward its refinement: Rod Agassiz, Bellevue Community College; Guadalupe Alvarado, Rio Hondo College; Ann Appley, Women at Work; G. Maxine Beatty, Nelson Community College; Maya Durnovo, Houston Community College; Jon Lea Fimbres, Paradise Valley Community College; Kit Hayes, Northeastern University; Donna Mosher, Paradise Valley Community College; and Joyce Stumpe, Purdue University. The book is strengthened as a result of their efforts.

Through the support, assistance, and encouragement of the staff at Gorsuch Scarisbrick, Publishers, we welcome this opportunity to share our learning and experience with you.

Introduction

I really like and accept myself and feel good about who I am. Entering college as an adult will be a challenge, but I know I can do it!

If you can repeat these sentences with conviction, your college experience will be pleasurable, rewarding, and successful. For a variety of reasons, though, many people have fears and doubts when becoming students again. These insecurities can produce behaviors that work against school success. Withdrawal from activities, lack of assertiveness, fear of success, lowered aspirations, and grades that don't reflect a student's true ability are just a few ways in which low self-esteem can manifest itself in a school setting.

Self-esteem refers to your sense of personal worth and value and your belief in your own power. Any person can experience self-doubt or low self-esteem, and this book is written for anyone experiencing these problems. Such problems may be especially troublesome, however, for those who have to deal with other concerns while attending school: supporting a family, working full-time, attending without the support of significant others, being back in school after working for many years.

DEFINING THE "NONTRADITIONAL" STUDENT

Throughout this text you will encounter the terms *nontraditional student*, *returning student*, and *re-entry student*. These terms describe individuals who in one way or another do not meet the profile of the "traditional" college student. The traditional student is one who enters college at age 17 or 18 directly after completing high school and who typically expects to complete a degree program in four years. Each year, fewer and fewer individuals meet this traditional student profile.

Due to many different circumstances, people who once would not have attended college or returned to college are doing so. Many are in school because of loss of a job or the desire to change jobs. Others hope to complete degrees they started working toward earlier. Still others are searching for skills and experiences that will help them set a new course in life. Many are women who previously worked in the home and now want or need to work outside the home. Some were discouraged from going to college years ago but have now found the resources and motivation to attend.

If you are older than the traditional college student and are either return-ing to school or entering higher education for the first time, you have plenty of company. Adults ages 25 and older are enrolling in school in record numbers. In fact, students over 25, part-time attendees, and people who work are the fastest growing groups in education today. The group we used to think of as the "traditional" students, the 18- to 22-year-olds who lived on campus, now con-stitutes only one-fifth of the university population.[1] Community colleges also reflect a change. Their students are likely to be older, female, and come from ethnic groups traditionally underrepresented in colleges and universities.[2] The "typical college student" no longer exists. Instead, college students come in a variety of ages, ethnicities, and social backgrounds. They represent a wide range of past academic backgrounds and levels of preparation.

The decision to return to school often revolves around changes in work. As all students realize, the world of work has changed greatly since their par-ents' day. Until recent years, an individual often worked for the same company for an entire working career. Today the U.S. worker averages an estimated five to seven career changes in a lifetime.[3]

Many factors account for the more mobile workforce. In times of reces-sion, formerly stable companies face budget cuts and downsizing. During the 1980s, large Fortune 500 companies such as Sears, IBM, General Motors, and others eliminated 3 million jobs. One-third of management jobs were elimi-nated and 20 percent of the workforce was thrown into unemployment or underemployment.[4] Technological advances led to job losses as companies automated functions and employed smaller staffs. The military was not immune to the changes in the workforce and eliminated an estimated 200,000 jobs as a result of bases closing or being realigned.[5]

The trend in downsizing has continued.[6] Rapidly advancing technology has altered our ways of thinking about job skills and our view of the role con-tinuing education plays in our work lives. Workers continue to retrain and upgrade skills to meet the demands of the shifting job market. For example, employees who never thought they would work with computers are finding that computers are a regular part of their workday. Since workers who have computer skills earn 10 percent to 15 percent more than workers in similar jobs who don't know how to use computers, the incentive to retrain is strong.[7] The old concept of employer-guaranteed job security has been replaced by the knowledge that true security is self-generated and comes from the ability to meet ever-changing workplace demands.

Sometimes other factors give impetus to change and improve. Some of today's students are women who are resuming education after child-rearing or are "displaced homemakers," women who have worked in the home but now, because of divorce or widowhood, need to find a job outside the home. These women face a unique set of challenges. Although homemaking careers are hon-orable and necessary, the skills involved are rarely recognized as marketable. Therefore, these women often need to attend school to learn new career skills or update old ones to compete in today's job market. Many of these students

are single parents with limited time and limited financial resources, so they must learn to utilize internal and external resources to the fullest.

Adults also return to school to increase opportunities for advancement. Workers decide to become managers, legal secretaries decide to become lawyers, students decide to become teachers. To climb the ladder of opportunity is the American dream.

As you can see, nontraditional students are not alone; they have the support of others like themselves who seek new opportunities by furthering their education. Discovering these support systems is important to succeed in school. Most important, however, is discovering your own strengths and abilities.

THE ROLE OF SELF-ESTEEM IN YOUR LIFE AS A STUDENT

Becoming a college student—either for the first time or again after an absence—can be overwhelming for any adult who already has myriad responsibilities and life pressures. The personal baggage that adults bring into the higher education setting can trigger self-doubt, negatively impact self-esteem, and thus hamper academic performance. A vicious circle is set into motion: lack of academic success feeds low self-esteem.

In our combined total of over 35 years counseling and teaching adults in post-secondary settings, we have studied the essential differences between students who reach their goals and those who don't. We believe that success for any student has less to do with intelligence and more to do with attitude, drive, clarity of goals, support systems, and, most of all, positive self-esteem. We have observed that one of the biggest stumbling blocks to academic and personal success is a *lack of self-esteem.*

To create high self-esteem, first *you will need to know yourself.* In other words, you will learn to accept your capabilities and strengths as well as your weaknesses. You will feel generally positive about the person you are. By knowing yourself and your capabilities, you will learn to set appropriate goals. Reaching those goals will lead to increased competence and success, both of which are part of high self-esteem.

Knowing yourself does not happen overnight, of course, or even in a semester; it is a lifelong process. However, we have found that our students, through their participation in the classroom and with this book, have successfully used the tools included here to gain self-knowledge and appreciation, thus enhancing their self-esteem.

We believe an individual's self-view is impacted by a number of influential sources. Insight into the past is important because effective strategies can be applied to change faulty decisions. Rather than pointing fingers at "toxic parents" or "bad schools," we acknowledge the presence of past influences and put them into the perspective of a circle model, a model that is used throughout the text. Drawing from research on self-esteem and personality development, we examine the factors that can contribute to self-esteem.

Throughout the book, various learning features are incorporated to clarify the discussion and make it real for you. These features include:

- case studies
- written exercises with purpose and reflection
- learning activities to complete in class or outside of class, individually or in groups

This book is organized into two parts: "Sources of Self-Esteem," and "Symptoms of Low Self-Esteem and Strategies for Improvement." Exploring the sources of self-esteem through the circle model (Chapters One through Five) will help you gather and utilize information from past and present influences. Chapter Six outlines the symptoms of low self-esteem, explaining how self-esteem is manifested in daily life. After understanding the past and present, you will be ready to make future plans and develop practical self- and school-success strategies (Chapters Seven and Eight) for specific changes.

You are invited to use this book as a catalyst for thought and action in developing a more positive self-view. Self-exploration is exciting and personally rewarding, although it does have some potential difficulties. With this in mind, we offer some words of caution.

1. The past is to be viewed as a way to gather information and understanding, not as an exercise in "blame-fixing." We do not advocate blaming others for current status, as this is a futile task that wastes time better spent in self-development and growth.

2. Change is never easy. Discomfort has staying power not because it is enjoyable or particularly beneficial but, instead, because it is familiar. In clinging to the familiar, people may encounter internal resistance that makes change stressful and difficult. We offer suggestions on how to work around this.

3. At times a book alone does not provide enough support for the changes being made. Knowing when and how to seek outside help, whether from friends or from a trained professional, also will be discussed.

Central to success is an understanding of your past and present self in order to maximize strengths and minimize weaknesses. The final chapter summarizes and synthesizes self-discoveries as a basis for future growth.

As they re-enter the educational system, adult learners possess many strengths. Although returning to school is a challenge and can give rise to old fears and self-doubt, it also provides a self-validating opportunity for growth and development. Our goal is to guide you successfully through this challenging and rewarding process.

NOTES

1. Alisa Wabnik, "Typical University Student Becoming Not-so-Traditional," *Arizona Daily Star*, Aug. 24, 1995.

2. Steven R. Helfgot, "Counseling at the Center: High Tech, High Touch." In *New Directions for Student Services, Number 69*, Spring 1995. Josey Bass.

3. William Bendat, Editor, *Career Fitness Newsletter*, 2:1, (Scottsdale, AZ: Gorsuch Scarisbrick, 1994) p. 1.

4. Ronald Acquavita, Editor, "Tight Job Market Continues," *NRA Newsletter 48*, (Reston, VA: Rehabilitation Association, 1992).

5. Acquavita.

6. Alan Fischer, "Take Charge of Your Career or Await Downsizing," *Arizona Daily Star*, March 24, 1996.

7. Melynda Dovel Wilcox, "Starting Out in America Today," *Kiplinger's*, April 1994.

Sources of Self-Esteem

Part I of this book discusses the *sources* of self-esteem and their impact on our lives and particularly on our school behaviors. In Chapter One, we will use a visual model of concentric circles to illustrate those factors that influence self-esteem in each of us.

As you will see, at the center of the circle model is the core self, the natural self. The second circle represents the family and is the circle that has the most direct influence on the core self. The third circle is the world that influences us daily: teachers, school, and other learning experiences. This world has great impact on our self-esteem and on our confidence as learners. Finally, the outer circle represents societal influences, including the predominant culture and the media. How we perceive ourselves in relation to this world can also have great impact on us.

Each of these circles of influence will be discussed in the coming chapters. We will learn how the circles are interrelated and how each of us is molded by all that happens to us and around us. It is helpful for you to understand that *self-esteem* is rooted in early experiences—those of your family, school, and the outer world. Self-esteem grows from our interpretations of those events and the conclusions we draw from them. Thus, sources of self-esteem are highly individual. One person's character-building experience can be another person's devastating setback, depending on past background and experience.

The messages we receive from these sources prepare us to meet the world. For some of us, the self is more ready and able than for others. Many of us may need to explore, make different choices, and learn to deal more effectively with the world. This book and the exercises in each chapter will help us become aware of the factors that contribute to self-esteem and learn how we can change negative self-evaluations to positive ones.

Self-Esteem Development

▰ How is self-esteem defined?
▰ How can self-esteem be visualized?
▰ How is self-esteem formed?

Maggie, age 34, is in her second semester of a two-year legal assistant degree program. Her supervisor at work is convinced that Maggie is ready to advance beyond secretarial work and is willing to let her attend classes during office hours. This may sound like the ideal situation, but Maggie is so burdened by fear and self-doubt that she has become unable to function both on the job and in school.

Her job performance has slipped to a new low. She worries constantly about being good enough, can't seem to motivate herself to start tasks, and barely meets her deadlines. Her supervisor is beginning to lose patience with her. At college, Maggie is receiving below-average grades from her instructors.

Maggie experiences stress from pressure to perform, and she copes by putting off everything until the last minute. Procrastinating keeps her from having to prove herself. Thus, she never knows whether she can meet the standards at school and work.

Maggie suffers from low self-esteem. Her return to school has triggered old memories, and the resulting anxiety has turned what could be a marvelous opportunity to better her career into a nightmare. If Maggie had positive self-esteem, she could take more control of her academic life and see possibilities she now overlooks. As it is, she feels stuck and powerless to help herself. She knows she needs to make changes, but she isn't sure where to start.

WHAT IS SELF-ESTEEM?

Self-esteem is a unique internal self-rating. It determines how worthy we believe we are, how we see ourselves fitting into the world, and what we think we can or cannot do. Understandably, self-esteem has a strong impact on our success in life.

How capable, significant, successful, and worthy do you feel you are? This self-evaluation is self-esteem. In a school context, self-esteem is defined as self-confidence, sense of personal worth, and belief in your capability in

matters relating to education. In Maggie's case, lack of self-esteem, not intelligence or ability, is the deciding factor in her unsuccessful school performance. For Maggie, positive self-esteem would enable her to take risks, see alternatives, seek out the help she needs, and cope in more constructive ways. You'll see how Maggie dealt with her self-esteem and school issues in a later chapter.

THE NATURE OF SELF-ESTEEM

A person with low self-esteem thinks, feels, and behaves differently than a person with high self-esteem. For example, people with low self-esteem often avoid situations that test their capabilities and self-views. By not taking risks, they hold on to what little is "known" and protect the self-esteem they have. (In later chapters, we will discuss how to begin to increase your risk-taking behavior to enhance self-esteem.) This extremely conservative approach to making life changes can keep people with low self-esteem from growing.[1]

Other signs of low self-esteem can include lack of confidence and assertion in action, speech, and body posture; lack of self-care in areas such as eating and drinking; drug and alcohol abuse; and destructive personal relationships. Some people with low self-esteem, on the other hand, may employ "defensive self-esteem," behaving overly confidently and perhaps aggressively.[2]

Most people with low self-esteem do not hate themselves but instead give themselves neutral, not negative, ratings.[3] In contrast, people with high self-esteem rate themselves positively as capable, competent, and worthy individuals. There is a paradoxical nature to self-esteem. Although it is a relatively stable aspect of our personalities, it *can* change. The fact that self-esteem can be enhanced is very hopeful. For improvement to self-esteem, though, new thoughts and behaviors must be consistently practiced. (This book provides many of the tools to make those changes.)

You may be wondering what determines whether self-esteem will be high, low, or somewhere in between. Why do we see ourselves as capable on some days and incapable on other days? Why are we sometimes so afraid of success that we sabotage ourselves in the areas of life that mean the most to us?

Scanning the self-help sections of local bookstores, one might believe that self-esteem is a straightforward concept. There, buyers are promised quick-fix answers to what really is a complex issue. To understand self-esteem adequately, we will consider general self-esteem and then look at it in terms of life events and life areas. We will discuss symptoms of low self-esteem again in Chapter Six.

General Self-Esteem

General self-esteem, also referred to as global self-esteem[4], is your *overall* self-evaluation or rating. It focuses on general feelings of *worthiness*. We make decisions about our worthiness as human beings very early in life, based largely on the treatment and acceptance of our major caregivers. These decisions about our general worthiness often remain intact, even if they have a

negative impact on our self-esteem. In fact, we frequently recreate the family of origin interactions that impacted our self-esteem with people in relationships or even at work. This is because these dynamics are familiar to us, even though they may not be healthy. Determination to change, and growth and learning gained in adulthood (through sources such as this book), however, can positively impact your general self-esteem, and thus your relationships with others. We will examine your early decisions in Chapter Three.

Life Events and Self-Esteem

If, like most people, you have noticed variations in your self-esteem, you are normal. Emotional highs and lows are part of life, so self-esteem can fluctuate during times of emotional upheaval. Both internal and external factors cause this fluctuation. External events such as life changes (divorce, job loss, a death in the family) can cause your self-esteem to drop temporarily. Internal changes such as physical illness, different stress levels, and events reminding you of past experiences likewise affect self-esteem. However, as we pointed out earlier, your overall level of self-esteem will return to its usual level *until* a decision is made to make a concerted effort to enhance self-esteem.

Life Areas and Self-Esteem

At different points in time, there are various areas of our lives that are important to us, and our success in those areas does contribute to our general self-esteem. For example, athletic success, such as running fast or swimming well, may have been more important to you as a child than it is to you as an adult.

Education is one of the life areas in which self-esteem is played out, and returning to school may uncover old insecurities. If the return to school is prompted by a job loss or other major life change, the potential impact on self-esteem is compounded. Viewing self-esteem from this perspective of many dimensions helps to explain its complexity, as well as its variations and fluctuations.

Rose writes "A" papers, excels at tests, and receives outstanding grades. At the same time, Rose's intimate relationships are unhealthy; she seems to choose partners who tend to be negative and disrespectful. Rose's friends are puzzled. How can this brilliant woman make such poor relationship choices? Is her self-esteem high, low, or in-between? By examining more about the nature of self-esteem, we can begin to solve this puzzle.

For Rose, the two life areas at issue are relationships and academic success. If it is very important to Rose that she achieve success in school, then her excellence in that life area will help to elevate her general self-esteem. However, if her success in relationships (which Rose has yet to achieve) is more important than school or other areas in her life, her overall self-esteem will begin to suffer if she values relationship success over other achievements in her life.

Thus, your self-esteem is strengthened through a general self-rating of worthiness as well as proven success and competence in areas that are important to you.

How does each of us determine what areas are important to us? Areas important to self-esteem will be determined by both your individual life situation *and* what your culture and society deems important. For example, academic performance, intelligence, family relationships, physical appearance, sociability, workplace success, love relationships, and internal behaviors are some areas that various researchers have identified as important for enhancing self-esteem among many people in our culture.[5]

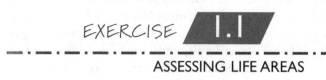

EXERCISE **1.1**

ASSESSING LIFE AREAS

PURPOSES

To assess your current level of satisfaction with life areas that are important for your self-esteem.

To show that there are areas in your life where you are satisfied as well as areas you would like to improve.

To help you set specific goals for enhancing your self-esteem.

To provide a baseline indicator of progress for self-esteem enhancement.

INSTRUCTIONS

Step One: Rate your current level of satisfaction with the following life areas related to self-esteem. Remember that not all the dimensions listed here may be relevant to you. Feel free to include additional life areas that suit *you* as an individual.

Step Two: Now look at each item again and this time make a mark showing where you would like to be on each dimension. Use a different symbol or a different color pen so you can easily see where you are and where you wish to be.

THE DIMENSIONS OF SELF-ESTEEM

Academic Performance

1_____2_____3_____4_____5_____6_____7_____8_____9_____10
low medium high

Work Performance

1_____2_____3_____4_____5_____6_____7_____8_____9_____10
low medium high

Intelligence

1_____2_____3_____4_____5_____6_____7_____8_____9_____10
low medium high

Sociability

1_____2_____3_____4_____5_____6_____7_____8_____9_____10
low medium high

Family Relationships

1_____2_____3_____4_____5_____6_____7_____8_____9_____10
low medium high

Love Relationships

1_____2_____3_____4_____5_____6_____7_____8_____9_____10
low medium high

Physical Self

1_____2_____3_____4_____5_____6_____7_____8_____9_____10
low medium high

Emotional Self

1_____2_____3_____4_____5_____6_____7_____8_____9_____10
low medium high

Other Dimensions (specify)

1_____2_____3_____4_____5_____6_____7_____8_____9_____10
low medium high

REFLECTIONS

How did you feel when you examined your current patterns of satisfaction compared to where you would like to be?

With what areas are you most satisfied? Least satisfied?

Prioritize the two to three life areas on which you would most like to focus your attention.

THE CIRCLE MODEL

We have developed a visual way to explore and understand the factors that contribute to the development of self-esteem. Figure 1.1 illustrates four concentric circles. Each of these circles represents one circle of influence that has helped make you who you are.

The inner circle is the *core self*, who you are genetically. Within it are all of your inherited characteristics and tendencies. To help you capitalize on your strengths and minimize your weaknesses, you can learn more about yourself and the strengths you possess within your inborn tendencies. This self-knowledge, introduced in Chapter Two, has implications for your success in school and other domains important to you.

In the next circle reside your family of origin and any other caregivers having an impact on your early years. As an adult, they consist of your current family, however you may define it. As the circle closest to your core self, your original family had a major influence on the development of your self-esteem, because it was your first picture of relationships, support, and love. This circle can give you strength and buffer the next two circles, or it can represent a source of problems. It includes messages received from your family and from memorable early events. Understanding decisions you make based on these

FIGURE 1.1

Model of self-esteem development.

early messages and events is a necessary piece in each person's self-esteem puzzle. This circle is examined in depth in Chapter Three.

The next circle consists of the world immediately outside the home: school, playmates, teachers, and other people who are important to you. As an adult, it may include work, church or temple relationships, or status. Experiences with peers have much influence on early self-esteem development. Our views of ourselves in the social world of school or work originate in this circle. After the family, this circle has the greatest influence on development of self-esteem.

Our society at large forms the outer circle. This is where cultural values are communicated, mainly through the media. The psychological effects of perceiving ourselves as "different," or as not measuring up culturally, physically, or otherwise, originate here.

Using the circle model to visualize self-esteem illustrates the impact of all of these forces on us. The four circles are interrelated; they affect one another and are interdependent. For example, when society's views of men's and women's roles change, this change affects classrooms and even influences gender expectations within our own families (just as society's views were initially influenced by the personal views held by individual men and women). Each of the four circles is permeable in a sense, open to the flow of impressions and influences from the other circles. If we are to understand how self-esteem is formed, it is necessary to understand all four circles. These layers form our self-view and shape how we relate to ourselves, others, and the world.

According to Carl Jung in his classic text, *Man and His Symbols*, a circle has symbolized wholeness and the psyche since ancient times.[6] Thus, the circle is a good metaphor for self-esteem development. In addition to using concentric circles to visualize the sources of self-esteem, you will see how the formation of self-esteem—both positive and negative—can be a circular process.

You will understand the circle model and self-esteem better as you apply it to yourself. In the chapters that follow, you will be asked to do just that. Join us for an exciting journey of self-discovery!

NOTES

1. Roy Baumeister, "Understanding the Inner Nature of Low Self-Esteem," in *Self-Esteem: The Puzzle of Low Self-Regard* (New York: Plenum Press, 1993), pp. 201–218.

2. Chris Mruk, *Self-Esteem: Research, Theory, and Practice* (New York, Springer: 1995), pp. 138–140.

3. Baumeister, 201–218.

4. Susan Harter, "Causes, Correlates, and the Functional Role of Global Self-Worth: A Life-Span Perspective," in J. Kolligian and R. Sternberg, Editors, *Competence Considered* (New Haven: Yale University Press, 1989), pp. 67–100.

5. Bonnie Golden, *Self-Esteem and Psychological Type: Definitions, Interactions, and Expressions* (Gainsville, FL: Center for Applications of Psychological Type, Inc., 1996) pp. 15–16.

6. Carl Jung, *Man and His Symbols* (New York: Doubleday, 1964), pp. 240–249.

The Core Circle: Inborn Preferences

■ How can the "inner circle" be understood?

■ What are inborn personality preferences or types?

■ How can a person identify individual strengths and blindspots?

■ How do personality preferences impact self-esteem and success in college?

Chapter One contained a visual model of self-esteem development using four concentric circles. The focus of Chapter Two is the core self, the "inner circle" of self-esteem. A framework is provided for understanding inborn personality traits and the impact of inherited tendencies on self-esteem and school performance.

Carol was popular in high school. She was involved in cheerleading and the school's yearbook, among other activities. Teachers chose her for leadership positions, and peers elected her to class offices. Carol spent hours on the phone encouraging her friends, setting up dates, and giving advice. Academically, she did well on group projects and factual exams. With essay tests and research papers, however, she had trouble staying motivated. Her grades in those areas were mediocre.

Today, Carol has returned to college after a 10-year absence from formal education. Because she is raising two young children and has enrolled in several independent study classes, the adjustment to education and study has been difficult for Carol. Answering telephone calls and tending to her children's needs interrupt her concentration. Forcing herself to close the door and concentrate has been much harder than running errands on campus and talking to professors.

Carol's mother reminds her that, even as a child, she loved to go to school but finding motivation to do homework was often a struggle. Carol's behavior has been consistent over time. A better awareness of her unique personality characteristics and preferences might increase her self-understanding and improve her chances for success in school.

PERSONALITY TYPES

We are born into this world with inherited characteristics. These include not only physical characteristics—hair color, height—but also personality traits and patterns. Observers and caregivers of infants notice that, even in the earliest months, each baby's personality is distinct. One infant lies quietly and serenely much of the time, and another kicks or cries at even the slightest provocation. As children grow, their personalities become even more different from one another. Favorite activities, music, and toys all emerge. Children are products of internal, inherited sets of mechanisms as well as their environment.

Psychologists have performed research with sets of twins and triplets who have been reared apart. Their research has demonstrated that, despite being brought up in completely different environments thousands of miles apart, personality traits such as stress response, motivation, shyness, and even occupational and leisure interests are uncannily similar. This psychological research demonstrates the significant role heredity plays in personality development.[1]

The great Swiss psychologist Carl Jung gave us a system to understand some of those tendencies and inborn characteristics.[2] Later, Katherine Briggs and Isabel Briggs Myers expanded his theory and developed a psychological test to identify personality preferences. Now widely used, it is called the *Myers–Briggs Type Indicator*.* In addition, researchers such as Dr. Jerome Kagan,[3] and Dr. Martha Wilson, Martin Languis, and Dr. James Newman[4, 5] have demonstrated that psychological differences in areas such as brain wave activity and response to outside stimuli exist among different personality types. This research confirms parts of Jung's original theories about inborn preferences. The information and exercises that follow will help you to identify aspects of your natural, inborn personality.

* Myers–Briggs Type Indicator and MBTI are registered trademarks of Consulting Psychologists Press, Inc., Palo Alto, CA.

EXERCISE

YOUR PERSONALITY TYPE

Jung and Myers & Briggs provide us with a four-part framework to examine the typology of inborn tendencies.

PURPOSES

To begin to assess personality preferences using eight possibilities.
To enhance self-esteem through increased self-knowledge and understanding.
To begin to appreciate your strengths.

The following exercise is broken into four parts. Briefly, in Parts 1 through 4 you will select items that indicate personality tendencies toward (1) extraversion or introversion, (2) sensing or intuition, (3) thinking or feeling, and (4) judging or perceiving. Each of these characteristics will be explained below. In each part, you will determine which of two characteristics or preferences better describes you.

1. Flow of energy

Extraversion (E) Your natural energies, perceptions, and/or decisions flow outward, toward the world of people and things. You are stimulated by your surroundings.

Introversion (I) Your natural energies, perceptions, and decisions flow inward, toward the world of thoughts and ideas. You are stimulated by thoughts and ideas.

Susie is a preschool teacher. Preferring extraversion (E), she often joins or organizes a group of co-workers for dinner and a movie on Friday evenings. She experiences enjoyment and energy from the company of her peers and the activities of the evening.

Susie's colleague, Mike, preferring introversion (I), is drained and exhausted after a week of teaching and interacting with children, directors, and teachers. He consistently foregoes spending evenings in group activities. Instead, he goes home, plops on the couch, and reads his favorite science fiction author. After reading and simply enjoying solitary, internally focused time, he feels refreshed again.

The checklists in Exercise 2.1 are adapted from *People Types and Tiger Stripes: A Practical Guide to Learning Styles* by Dr. Gordon Lawrence (Gainesville, FL: Center for Applications of Psychological Type, Inc., 2815 N.W. 13th St., Gainesville, FL 32609), 3rd edition, 1993, pp. 2–4. Used with permission.

INSTRUCTIONS

To determine if you prefer extraversion or introversion, read the following pairs of descriptions and check which of each pair is like you *most of the time*. You may notice that both behaviors that we present sound like you. Try to choose the style that seems more comfortable and typical of you. To help you decide, think of your most natural self, your behavior as if no one were looking.

An extravert tends to:	*An introvert tends to:*
_____ Like action and variety.	_____ Like quiet and time to consider things.
_____ Do mental work out loud by talking to people.	_____ Do mental work privately and internally before talking.
_____ Act quickly, sometimes without much reflection.	_____ May be slow to try something without understanding it first.
_____ Work with other people on a job and see results.	_____ Understand the idea of a job and to work alone or with just a few people.
_____ Want to know what other people expect of him or her.	_____ Want to set his or her own standards.
_____ Appear more "social."	_____ Appear quiet and reserved.

In which column do you have the most checkmarks? What seems to be your preference, extraversion or introversion? _____ (E or I)

2. Taking in information

Sensing (S) You rely primarily on the five senses to observe the world and gather data. You focus on the present moment and immediate experience.

Intuitive (N) You primarily utilize a sixth sense (hunches or ideas) to see possibilities that cannot be perceived with the five senses. Your perception is beyond the present and includes future events and possibilities.

Frank, a sensing type (S), works as a convention planner for a local community center and is a skilled detail man. Frank makes sure that rooms are assigned correctly, the air-conditioning is comfortable, signs are color-coordinated, and the snack food is appropriate and tasteful. He does well at what he is working on right now.

Jan, an intuitive type (N), works with Frank. She is also a convention planner, but she is the idea generator. A "big picture" person, she writes proposals for clients, invents themes, and develops selling points for their facility. Jan is in charge of the overall planning and direction, whereas her colleague Frank works out the details. Both are outstanding at what they do.

INSTRUCTIONS

To determine if you prefer sensing or intuition, check the item in each pair that better fits you. You may notice that both behaviors that we present sound like you. Try to choose the style that seems more comfortable and typical of you. To help you decide, think of your most natural self, your true behavior—if no one were looking.

A sensing person tends to:

_____ Pay most attention to experience as it is, living in the present.

_____ Like to use eyes, ears, and other senses to find out what is happening.

_____ Dislike new problems unless prior experience shows how to solve them.

_____ Enjoy using skills already learned more than learning new ones.

_____ Be patient with details but impatient when the details get complicated.

_____ Be seen as realistic.

_____ Be good at precise work.

An intuitive person tends to:

_____ Pay most attention to the meaning of facts and how they fit together, looking toward the future.

_____ Like to use imagination to come up with new ways to do things, new possibilities.

_____ Like solving new problems, and dislike doing the same thing over and over.

_____ Like using new skills more than practicing old ones.

_____ Be impatient with details but doesn't mind complicated situations.

_____ Be seen as imaginative.

_____ Be good at planning and design.

In which column do you have the most checkmarks? What seems to be your preference, sensing or intuition? _____ (S or N)

3. Decision making

Thinking (T) Your process of decision making tends to be impersonal, based on observable facts and logic.

Feeling (F) Your process of decision making tends to be personal, based on values and people's feelings.

Arnold, a thinking type (T), is in the process of changing careers. He spends much of his time studying employment projections for the three career fields he has chosen to explore. He also is obtaining job descriptions from various employers in the community and comparing salary ranges and promotional potential among those employers. When he has gathered enough information, he will look at the data and will be ready to make a choice.

Carl, a feeling type (F), is also exploring careers and college majors. He has interviewed some people who currently are working in the field and, with the help of his career counselor, enjoys imagining how he would feel in different jobs. He sees this counselor twice a month, and they spend much of their time exploring his subjective reactions to various job descriptions. Carl often confides in his parents and girlfriend about his career plans and seeks their personal reactions to his progress. Carl knows that, at the right time, his feelings will tell him what to choose.

INSTRUCTIONS

To determine if you are a thinking type or a feeling type, check the item in each pair that better fits you. You may notice that both behaviors that we present sound like you. Try to choose which one feels more natural and comfortable. To help you decide, think of your most natural self, your behavior—if no one were looking.

A thinking person tends to:

_____ Like to decide things using logic, analysis.

_____ Want to be treated with justice and fair play.

_____ Neglect and hurt other people's feelings without knowing it.

_____ Give more attention to ideas or things than human relationships.

A feeling person tends to:

_____ Like to decide things using personal feelings, human values, and understanding.

_____ Like praise and to please people, even in small matters.

_____ Be very aware of other people's feelings.

_____ Predict how others will feel.

_____ Get along with little har-
mony, not be stressed by
arguments and conflict as
long as logic is present.

_____ Value harmony, feels unset-
tled by arguments and con-
flict.

_____ Question "Why?"

_____ Accommodate others.

In which column do you have the most checkmarks? What seems to be your preference, feeling or thinking? _____ (T or F)

4. Day-to-day lifestyle

Judging (J) You live a planned, orderly lifestyle and seek closure for most tasks and decisions.

Perceiving (P) You follow a flexible, spontaneous, go-with-the-flow style of living, without pushing for closure in activities and tasks.

Mike, a perceiving type (P), and Sarah, a judging type (J), are roommates. After dinner Mike checks the television listings for the latest sports events or his favorite shows. If something is airing that he would like to see, he washes the dishes afterward. Often, if a friend calls, he talks on the phone for a while. When his favorite magazine catches his eye, he may read a few articles. Eventually he completes his chores.

On Sarah's night for kitchen chores, she videotapes programs she might like to see. She tells friends who telephone that she will call them back later. If she has other chores to do, she lists them on a piece of paper and crosses things off the list as she completes each task. She feels irritated with Mike when the dishes aren't done until 9 o'clock at night. She cannot understand why he doesn't just "get to it!"

INSTRUCTIONS

To determine if you are a perceiving type or a judging type, check the item in each pair that better fits you. You may feel that both behaviors presented describe you. Try to select the one that seems more comfortable and typical of you. To help you decide, think of your most natural self, your true behavior—if no one were looking.

A judging person tends to:

_____ Like to make a schedule, to have things settled and de-cided ahead.

A perceptive person tends to:

_____ Like to stay flexible and avoid fixed plans, especially as new interests surface.

_____ Try to make things come out the way they "ought to be."	_____ Deal easily with unplanned and unexpected happenings.
_____ Like to finish one project before starting another.	_____ Like to start many projects and may have trouble finishing them all.
_____ Have his or her mind made up and be uncomfortable with uncertainty.	_____ Look for new information and be okay with ambiguity.
_____ Decide things too quickly.	_____ Decide things too slowly.
_____ Want to be right.	_____ Want to miss nothing.
_____ Live by standards and schedules that are not easily changed.	_____ Make changes to deal with problems as they come along.

In which column do you have the most checkmarks? What seems to be your preference, perceiving or judging? _____ (J or P)

CONCLUSION

What do these responses indicate your personality type is?

_____ (E or I) _____(S or N) _____(T or F) _____(J or P)

REFLECTIONS

You now have a four-letter personality preference code based primarily on the work of Jung and Myers. This preliminary self-estimate offers one way to appreciate and value your natural individuality. To understand your personality and preferences further, you might want to arrange to take the *Myers–Briggs Type Indicator*, an instrument developed by research, at your college counseling center.

You are discovering an aspect of the core self based on the four preferred dimensions (the inner circle of the Chapter One model) and what often is called the "natural self." Although all of us have the eight tendencies within us, the four preferred tendencies indicate your strengths, habits, and best abilities within the four identified dimensions. One person's preference is no better than another's, and each individual has a unique perspective to bring to most situations.

Because of these discoveries about your personality, you have taken another step toward increasing your self-esteem. Through this self-knowledge, based on understanding your strengths and preferences, your self-appreciation will be enhanced. According to Mayers and McCaulley, *"Finding out about type frees*

one to recognize one's own natural bent and to trust one's own potential for growth and excellence. There is no obligation or need to be like others, however admirable others may be in their respective ways." Let us now further explore ways to apply this new knowledge about personality type.

— ■ — ▪ — ■ — ▪ — ■ — ▪ — ■ — ▪ — ■ — ▪ — ■ — ▪ — ■ — ▪ — ■ — ▪ — ■ —

PERSONALITY TYPE, CULTURE, AND SELF-ESTEEM

The impact of personality type on self-esteem can be profound. We are first aware of its effect in our families of origin and through experiences of childhood and adolescence.

Tom is a quiet man, and, although he has many thoughts and opinions, he does not share them easily with others. They often conclude he has little to contribute. When he does speak up, his co-workers are so surprised that Tom becomes self-conscious. Tom's preference is introversion, and he was overwhelmed as a child by a family of extraverts. When he was quiet at the dinner table or pursuing solitary activities in his room, the others overlooked Tom's needs and feelings because they were dominant in their energy and ease of speaking out and saying what they felt. In school, Tom was a bit of a loner. Though he was a bright little boy, he was ill at ease raising his hand or speaking up in class. Because he was not acknowledged or appreciated for his intelligence, Tom concluded that he was not important and was too sensitive. His self-esteem suffered at home and at school.

Tom's family environment, his "family culture," was extraverted. Tom was a "minority" within his own household. Students in our classes have shared comparable experiences within their families. For example, Cheryl also has similar work experiences, in which her "feeling" decision-making preference was not rewarded and sometimes even ridiculed by co-workers who preferred "thinking."

Do our family and work cultures actually impact our self-esteem if our personality preferences and style are not of the "majority"? The North American culture at large does seem to reward extraverted behavior (e.g., "she's so bubbly," "he's the life of the party") and a decision-making style based on logic, objectivity, and analysis (thinking), more than a style based on feeling ("don't be so sensitive"). One North American culture research study, of 258 adult community college students,[6] revealed that students preferring extraversion or thinking did have higher levels of self-esteem than those preferring introversion or feeling. Does this mean that your self-esteem is going to stay low if you have IF preferences? *Not at all.* The key to looking at culture, type, and self-esteem is that cultures (from family cultures to cultures at large) differ in the way personality styles are rewarded and accepted.

For example, in certain cultures (some Native American, Japanese, or Chinese), introversion is the rewarded style. Individuals displaying too much extraversion might be thought of as "crass." Lack of sensitivity to the needs of their work group or family would be frowned upon. In contrast, in the United

States, individuality is encouraged. Thus, individuals who are not aware of and comfortable with the strengths of their type *may* be vulnerable to negative feedback from their environments.

A key to maintaining self-esteem if your style differs from the dominant culture is to develop detachment and objectivity. For example, Abraham Maslow[7] found that one characteristic of individuals with high self-esteem was that, while being part of their cultures and the social mainstream, they were able to detach themselves, rise above, and not let their feelings about themselves be *overly* influenced by what others expected or thought. As your self-esteem develops, this skill of detachment will also emerge. Chapters Seven and Eight provide strategies used by Tom and other students to enhance their self-esteem.

LEARNING AND PERSONALITY PREFERENCES

Personality type relates to learning and is crucial for improving self-esteem. Knowing and appreciating your natural personality type will alert you to your strengths and weaknesses as you become a student again. Instead of concluding you are "slow" or can't learn or are not able to understand the teacher, awareness of personality preferences can help you understand and appreciate individual styles and strengths, as well as the styles of your classmates and teachers.

Dr. Gordon Lawrence, an expert on the relation of personality type and education, has developed specific information on how knowledge of each person's preferences can promote success in the educational process. Table 2.1 lists examples of type as related to educational success (and thus greater self-esteem in school), based on Dr. Lawrence's work.

Looking back to the beginning of the chapter, we see that Carol probably is:

- an extravert, shown by her involvement in group activities, cheerleading, and pleasure in talking often on the telephone

TABLE 2.1

Core circle preferences and success in educational settings.

EXTRAVERTS	INTROVERTS
enjoy talk, movement, action learning	think, plan, and rehearse before sharing ideas
enjoy cooperative projects	enjoy solitary reading and writing
readily share and speak in class	can work for long periods on one project
want to experience things to really understand them	may spend too much time thinking about an assignment before doing it
need to plan more before leaping in	need to leap in sometimes without thinking so much

continued

TABLE 2.1

Continued

SENSING TYPES

learn best in step-by-step progression

are at home with programmed or computer learning

value practical applications of knowledge

excel in memorizing facts

enjoy structured classes

are good with details and predictable routines

THINKING TYPES

need logical rationales for projects

are more truthful than tactful

want fairness more than harmony

are able to be objective

contribute intellectual criticism

take facts, theories, and ideas seriously

JUDGING TYPES

may finish quickly but may miss new and valuable input and information

are good managers of time but could be too rigid

naturally plan and organize work

make and complete lists

want to do things as they are "supposed" to be done

enjoy closure, results, products

INTUITIVE TYPES

prefer concepts to discrete facts

excel at imaginative tasks

tend to avoid or overlook details

readily grasp words and symbols

are impatient with routine

need to know the overview, the "big picture"

FEELING TYPES

need personal encouragement, the human angle

allow feelings to override logic and objectivity

may suppress own needs and ideas to keep harmony

are able to be empathic

dislike expressing opinions that differ from those of peers

have difficulty being brief and businesslike

PERCEIVING TYPES

may be so open to new information that completion is delayed

are flexible and curious but may tend to procrastinate

may complete work in a last-minute flurry of activity

may make lists, may or may not complete them

are willing to "improvise" and change procedures

enjoy the "process" as much as the "product"

Source: Adapted from *People Types and Tiger Stripes: A Practical Guide to Learning Styles,* by Gordon Lawrence, 3rd edition, 1993 (Center for Applications of Psychological Type, 2815 NW 13th St., Suite 401, Gainesville, Florida 32609).

- a sensing type, indicated by her preference for the sounds and physical aspects of cheerleading and by her preference for factual exams
- a feeling type, highly sensitive to her friends' needs and empathetic in her role as confidante
- a perceptive type, because of her go-with-the-flow, open style

Carol's preferences (ESFP) contributed to a personally rewarding and successful high school experience, and she received positive feedback from others for those preferences. In Carol's school experience today, though, her preferences are not being utilized. Enrollment in independent study courses theoretically would work well for her schedule as a mother, but in practice she misses the energy of the group classroom experience on which her extraversion thrives. Her independent study course lacks the structured learning that the sensing part of Carol prefers, and, also because of her perceptive preference, she probably needs a more schedule-driven class. Her preference for feeling over thinking (empathy for people) and her need to use extraverted energy allow her to be interrupted easily. Furthermore, her classes require a lot of essay writing. Her strength as an S is the factual exam. Consequently, she has to work much harder to get good grades.

Too often, lack of knowledge of personality types causes students such as Carol to label themselves as "stupid" when a class causes them great difficulty. The difficulty might have more to do with a mismatch between the subject area and the particular learning style of their type than intelligence, and it can be overcome. You'll want to be aware that a class, major, or career choice that does not mesh with your personality preference *most of the time* takes more *energy and concentration* than one that more closely matches your preferences.

Knowledge of personality type assists in making informed choices of class, major, and career and helps individuals accept their unique strengths as well as areas for further development. The impact of this knowledge on self-esteem can be highly positive. That is because when we spend time in classes that utilize our strengths, satisfaction and self-esteem can increase. For example, students with sensing and introverted preferences often do quite well with majors such as accounting and computer science, which require many hours of solitary, detailed work. They might have a more difficult time with majors requiring abstract, intuitive thinking such as creative writing or literature if their intuitive preference is not fully developed. In contrast, an elementary education major who is extraverted and has a preference for sensing might find success in creating hands-on lessons for student teaching and working with groups of children.

Most college degrees require a broad array of general education classes (e.g., writing, math, social sciences, humanities) in which the student has to use all eight dimensions of personality. Before focusing on subjects required for their majors, successful students can develop skills for the study approaches required in disciplines that do *not* utilize their personality preferences and strengths. You should seek a *balance* in school schedules so, for example, you

do not take only classes that require factual tasks and exams if your strength is writing essay tests. You also will need to develop the skills most associated with the J preference: closure, completion, and ability to meet deadlines. In the college setting, these skills are most correlated with persistence and completion.[8]

If you are like Carol, you *can* be successful in classes that require exercising the least favorite preference. More self-understanding, self-acceptance, and success will result from developing these skills. Chapter Eight addresses how to practice these approaches.

Remember, the purpose of understanding personality type as related to your classes and major is not to discourage you from pursuing a specific career path but, instead, to help you become more aware of *why* you might master certain subjects more easily than others.

Carol may question her ability to succeed in college work, which often requires using introverted intuition (the opposite of her E and S preferences). Her discomfort, however, is simply a matter of her preferences (strengths) not being utilized in the classes she has chosen.

SUMMARY

Understanding inborn personality preferences is a way to appreciate personal uniqueness, increase self-understanding, and raise self-esteem. Through knowing the core self a little better, you can learn to like and even capitalize on special inborn gifts and also learn to understand the differences in others. Each person can acknowledge what parts of the self to focus on for further development and learn how personality characteristics, including strengths and weaknesses, can contribute to success in college.

An early foundation for understanding personality types and preferences was laid by Carl Jung, who developed a framework within which these concepts can be understood. Katherine Briggs and Isabel Briggs Myers expanded Jung's theory and developed the widely used *Myers–Briggs Type Indicator*.[9] This scale, combining eight dimensions, allows a person to determine his or her own type: extravert/introvert, sensing/intuitive, thinking/feeling, and judging/perceiving. No type is better than another, just different. Your four preferences interact in a dynamic way, with your information processing (sensing or intuition) or your decision making (thinking or feeling) function dominating. Thus, to make the most of understanding types, the college counseling center can arrange for you to take the *Myers–Briggs Type Indicator* if you are interested in further insight and information about psychological type.

NOTES

1. Thomas J. Bouchard, Jr., David T. Lykken, Matthew McGue, Nancy L. Segal, and Auke Tellegen, "Sources of Human Psychological Differences: The Minnesota Study of Twins Reared Apart," *Science* 250 (Oct. 12, 1990): 223–228.

2. Carl Jung, *Psychological Types* (Princeton, NJ: Princeton University Press, 1971; original work published 1921).

3. Jerome Kagan, *Unstable Ideas: Temperament, Cognition, and Self* (Cambridge, MA: Harvard University Press, 1989), p. 145. Kagan and his colleagues at Harvard have discovered strong introverted (inhibited) preferences that are evident at an early age for 10 percent to 15 percent of children.

4,5. Martha Wilson, Marlin Languis, and James Newman, "Did You Know?" in *Typeworks, USA*. Issue 4, Kay Abella and Sue Dutton, Editors and Publishers. (Washington Depot, CT: 1994)

6. Bonnie J. Golden, *Self-Esteem and Psychological Type: Definitions, Interactions, and Expressions* (Gainesville, FL: Center for Applications of Psychological Type, Inc., 1996).

7. Abraham Maslow, *Motivation and Personality* (New York: Harper and Row, 1970).

8. K. Terry Schurr and Virgil E. Ruble, "The *Myers–Briggs Type Indicator* and First Year College Achievement: A Look Beyond Aptitude Test Results," *Journal of Psychological Type* 12 (1986): 36.

9. Isabel Briggs Myers and Mary H. McCaulley, *Manual: A Guide to the Development and Use of the Myers–Briggs Type Indicator* (Palo Alto, CA: Consulting Psychologists Press, Inc., 1985).

The Second Circle:
The Influence of Family

- ◆ How do early family messages impact self-esteem?
- ◆ How do those messages affect us today?
- ◆ How do the messages affect school performance?

In Chapter Two we explored the core self, inherited tendencies, and how inborn preferences can be utilized to improve self-esteem as well as school performance. The second circle, consisting of messages from the family, has a substantial impact on development of positive self-esteem and can be a key to school success. The topic of this chapter is the second circle and how it contributes to life and school experiences.

EARLY FAMILY MESSAGES

Our view of the world is formed before we have words for or can comprehend the idea of self. Infants depend on adults for their most basic needs: food, warmth, care, and love. We each shape our view of the world and ourselves based on whether and how these needs are met. For an infant, being held gently and receiving love and care communicate safety. Being left hungry, cold, and wet gives quite another message. Thus, if our world is safe, secure, and peopled by adults who take care of us, we begin to see ourselves as having worth. If the reverse is true—if our world is unresponsive and frightening—we begin to distrust and have self-doubt.

As we continue to grow and our world expands, various factors determine self-esteem. We gather information about ourselves and our place in the world through messages from the significant people around us and from events and experiences in our childhood environment. Based on this information, we make decisions about ourselves and our worth. We carry these decisions into adulthood without checking to see if they still fit. If we decide we do not count in our family, we likely will view ourselves as insignificant in the larger world.

Growing up in a dysfunctional family complicates the messages we receive, and many of us carry these messages into adulthood. Children of alcoholics, survivors of sexual abuse, and others from homes marked by trauma may find their worlds colored by shame and guilt, as well as feelings of worthlessness and depression.[1, 2] In a school setting, children from homes such as these may behave consistently with the emotional pain they experience. For example, they might withdraw from activities, avoid social contact, perform poorly in schoolwork, lack concentration, or have learning problems. The opposite—excelling at school to compensate for negative attention at home—is also a possibility.[3] Messages about self-worth can shape school experiences and one's view of the world.

In many families, messages are communicated subtly. We learn about acceptable behaviors by observing nonverbal cues and hearing verbal messages.

Imagine a row of four playground slides. At the top of each slide is a small child, about to embark on her first solo journey. At the bottom stands her parent. Listen to what each parent has to say:

Parent 1: "Be careful. Don't slip. You know what happened last time."

Parent 2: "I don't know if you're ready for this. . . . Well, okay, baby . . . go ahead."

Parent 3: "What are you doing? Get down this instant! How many times do I have to tell you? You're going to get spanked!"

Parent 4: "All right! You can do it!"

How do you think each child feels after hearing each of these messages?

If a child hears regularly that he somehow is incompetent or incapable, he will learn to be afraid to try new things and take risks. Encouraging messages, such as those given by the fourth parent, help the child believe in herself, take risks, and experience success.

Parents 1 and 3 are criticizing their child's attempt at risking. Parent 1 actually is telling the child how to fail ("Don't slip") and reminding the child of past failures ("You know what happened last time"). Parent 3 is extremely critical, also shaming, discouraging, and stifling.

Parent 2's style is more subtle. On the surface it sounds supportive but, by patronizing and smothering, gives permission not to do well. The child learns to be afraid to try new things and afraid of making mistakes.

Nonverbal messages also are powerful. These are facial expressions and gestures that accompany words, or they can reflect attitudes without words. The loud sigh, rolling of the eyes, hands on hips, tapping of the foot, the slamming door say as much, if not more, than words. In many unhealthy families, for example, a child learns early in life to watch for nonverbal signals from the parent and makes decisions about self-worth based on these observations.

The messages we receive from families are powerful, and unless something happens to change our view, we live our lives as if all family messages are

true. They actually do become true for us. The result is a circular process that works like this:

I decide I don't count,
so I act that way.

Those around me see
the way I act and treat
me accordingly.

This confirms my low
self-worth, and my
behavior reflects this.

Others respond to my
negative self-perception
and I feel still worse.

Beginning with Freud, psychologists have discussed the importance of early events in a child's development. Alfred Adler, a contemporary of Freud, originated the concept of *lifestyle*, defined as "the pattern of dimly conscious beliefs and goals that a person uses for interacting with others and for measuring self-worth."[4] Eric Berne, a major figure in the *transactional analysis* (TA) movement, used the term *script* to describe a recurring pattern whereby people relive "unhappy childhood events."[5]

It is important to have insight into our origins. The purpose of this insight is *not* to place blame on our past caregivers, although it is natural to experience feelings such as disappointment or anger about our past. Instead, we hope you will understand and eventually accept your past as a part of you, then make a *conscious decision* to change the adult you are. We believe in your capability to do so. You can better understand yourself by identifying early messages.

EXERCISE **3.1**

ANALYZING YOUR LIFESCRIPT

PURPOSE

To help you understand your early messages as they relate to your school success.

INSTRUCTIONS

This exercise requires a quiet place and at least 30 minutes. The activity can trigger emotions that may be uncomfortable or even painful for you. That is a

normal response. Therefore, do only as much per session as is comfortable for you. If you do this exercise as part of a class, your instructor probably will allow some time for debriefing and venting. If you do the exercise on your own, you may find value in discussing it with a trusted friend, relative, or counselor.

Take a couple of deep breaths before you begin. Let your mind relax and your memory drift back to wherever you need to be to write the answers to the following:

1. When you were very young, what was the best thing anyone ever said or did to you?
2. How did you feel? When do you feel this way now?
3. What was the worst thing anyone ever said or did to you?
4. How did you feel? When do you have that feeling now?
5. Who in your family most encouraged your skills and interests?
6. In your family, who were you said to resemble, emotionally or physically? Was this seen as positive or negative?
7. Are you aware of the origins of your name? Whom were you named after? Did you have any nicknames? What were they? As you grew, how did you feel about your name?
8. What were your mother's expectations for you as a child? As an adult?
9. What were your father's expectations for you as a child? As an adult?
10. How close are you to their expectations? Why?
11. How did your caregivers react to mistakes? How do you feel now when you make mistakes?
12. What messages did you receive about:
 a. Your ability in school?
 b. Your intelligence?
 c. Your physical appearance?
 d. Your abilities in relation to those of your siblings (or other relatives if you were an only child)?

REFLECTIONS

Our lifescript messages can be deep, habitual, and powerful. However, making them conscious through this analysis is an important first step in diminishing their impact on us today. Remember, a crucial step toward enhanced self-esteem is to know yourself. This awareness will better allow you to accept and capitalize on your unique strengths, as well as develop parts of yourself that may need improvement.

Consider how these messages affect you today: Which are helpful? Which are hurtful?

Can you give one or two examples of how your lifescript is affecting your behavior? (Consider both positive and negative results.)

What decisions have you made about your competence in different life areas? How valid are these decisions today?

Consider the sources of these messages. How clearly or objectively could those individuals have seen your worth and gifts at the time? What may have clouded their perceptions?

FAMILY ROLE MODELS AND EDUCATIONAL MESSAGES

Our families of origin served as our role models in many areas. A role model is someone we learn from and try to imitate. Even when we choose to do the opposite of what we observed in our role models, they still impact us.

Families send messages about our appropriate place in the world and our ability to achieve success. By taking time and effort to focus on these messages, you can understand their impact and decide whether to keep or change them.

Educational Attainment of Parents

Parents' educational achievements can influence their children's views of education. In some homes, one or both parents are college graduates, and they clearly are role models attesting to the value of advanced education. College attendance is the unspoken expectation. As Nancy, a 29-year-old returning student, put it:

> My parents always spoke about their college days with great fondness. Dad dropped out during his sophomore year to go into business with his father, but he always talked about the fun he had. Mom just expected me to pledge the same sorority she was in. The question was *when* I would attend college, never *whether*. I know they were both disappointed when I dropped out after a semester and got married.

Robert's experience was just the opposite. He received strong messages about the unimportance of school in his parents' lives. When an industrial injury forced him out of his career as a backhoe operator, those messages came back to him. In addition to dealing with the usual insecurities of going back to school at age 30, Robert also needed to confront voices from the past. He relates this story:

> I grew up in an ethnic neighborhood in a large midwestern city. My parents were hardworking and thrifty people. Mom stayed home and raised the family while Dad worked in the automobile plant. Dad left school after the eighth grade and was a real success in his family's eyes because of his good job. He spoke suspiciously of people with education and always said that good common sense would get you further than schoolbooks. He certainly was living proof of that. My decision to enter school seems almost like a betrayal of my Dad's values, even though logically I know this is the best route for me to take.

Whether you identify with Nancy or Robert, be aware that conscious or unconscious family loyalties can be strained if you choose a different educational path.

Family Encouragement of Education

Families also differ in how they support and encourage their children's educational efforts. In Nancy's case, parental hopes are clear. The expectation begins early in life as the parents prepare the child for kindergarten with a feeling of anticipation. The parents let the child know school is important, and they expect their child to do well academically. Parents who value education commonly ask, "What did you do in school today, dear?" These parents encourage their children's learning and progress and take an interest in the specifics of their children's studies. They encourage good performance in a variety of ways. Kurt, 40, gives this account:

> In my family we were expected to show good grades on our report cards. We got money for every A we received, and a lot of praise. A good report card made me feel special.

Aspirations for the child's education beyond high school are discussed frequently. The child may hear that a relative has been accepted into college, and the implication of pride in this accomplishment is clear. Again, Kurt relates:

> When my cousin Carrie was accepted into law school, I remember my parents discussing it at the dinner table. From the tone of their voices and the admiration I heard, I knew Carrie had accomplished something exceptional.

In other homes parents convey a strong expectation that the children will attend school because that opportunity had been denied to the parents. A recent survey of Hispanic parents found that the less education the parents had, the more value they placed on a college education for their children.[6] African-American parents reported equally high aspirations for their children.[7] For parents to have high goals for their children always has been an important part of the American dream, and these goals usually include college.

Support of education in some families takes the form of a college savings fund beginning the day the child is born. The fund is discussed often in connection with family dreams and plans. Brenda, age 21, tells about her college fund:

> My parents started saving the day I was born. I always heard about my college fund, but it wasn't until I was in high school that I fully understood what it was all about and what college really meant. Of course, it made a big difference in my plans to go on to school.

In families where education is not encouraged, children receive different messages. The lack of support will not prevent you from having college expectations and plans for higher education. We hear success stories of first-generation students frequently. Family encouragement, however, gives a head start and can make the student's task easier.

EXERCISE **3.2**

FAMILY MESSAGES ABOUT EDUCATION

PURPOSE

To help you get in touch with some of your family's messages about education.

INSTRUCTIONS

Past Messages

Take a few minutes and just sit quietly. Breathe comfortably, and attempt to visualize yourself on the first day of school.

Where were you going? Preschool? Kindergarten? First grade?

Can you remember what clothes you wore?

What do you remember about your school? Your teacher?

What messages did you receive about the school experience awaiting you? Based on what you heard, what did you expect?

Who were the messages from? What did your parents and siblings say? Were some messages implied rather than verbalized?

Write down some of these messages as they come to you. Be aware of whatever information is available to you from these recollections.

Current Messages

Does your family and/or significant others support your educational goals?

What messages does your partner give you about your role as student and the responsibilities that accompany that role?

What about your children's reaction?

What about your parents' reaction?

REFLECTIONS

Think about how your family's (both past and current) feelings toward education impact your views of school in general and learning in particular. How valid are their feelings in your life today? Is your commitment to school affected by these views?

READING AS A FAMILY VALUE

Family educational values can be implied subtly or stated clearly. Some families, for example, value reading. Studies show that when parents or significant others read to children they are more likely to become readers themselves. As writer David Cooper says:

> I can still remember my mother reading to me as a child. I have snapshots over 50 years old of me seated in my father's lap as he read to me. I know without any doubt that a large part of any success I have had in my career as a reporter, writer and editor has stemmed from my love of reading and my voracious appetite for books, information and stories."[8]

In families that value reading, the child is likely to have fond memories of receiving books as holiday gifts, pride at being the owner of that first library card, and frequent trips to the library as a family outing.

Some homes do not emphasize books and reading. Children may grow up without recognizing reading as a useful means of gathering information or a form of recreation and may be handicapped in education in later life. According to one estimate, 44 percent of adults in the United States never read a book in the course of a year; 10 percent of the population reads 80 percent of the books. The average American spends 24 minutes each day reading, a 25 percent drop from 1965.[9] With the rising popularity of television, video games, and the internet, reading is less valued in today's society.

Reading is a necessary skill in school and at work. According to author Cooper, "Those who cannot read and communicate well in the future will be doomed to a growing number of low-paying jobs."[10]

Research shows that parents have a strong influence on a child's school performance.[11] Books on parenting extol the virtues of helping a child to love reading.[12, 13]

Lack of reading as a family value does not necessarily doom a child to a life as a nonreader. Novelist Bernard Malamud relates that he grew up in a home with few books and little cultural nourishment.[14] He clearly is an example of a person who learned the value of reading outside the home. If you grew up with a love of reading, however, you are likely to find re-entry into school smoother than if you need to develop your reading skills as an adult. Once again, it is never too late to develop study and reading skills. As your reading skills improve, so will your self-esteem.

CULTURAL SUPPORT FOR EDUCATION

Different cultures place different value on formal education, and these cultural messages are not right or wrong. In any case, cultures that place a high value on educational achievement as a way to improve their chances in life are likely to transmit these messages through the family.

A recent study of Indochinese refugee children illustrates this value and underscores the importance of the family in school achievement.[15] Although the children studied were traumatized severely by their escape from Southeast

Asia, had lost months and, in some cases, years of formal schooling, and arrived in the United States with limited skill in English, they adjusted quickly to U.S. schools and began to excel. When researchers from the University of Michigan sought to explain this level of achievement, their findings showed a strong link between family values and education. Even though the children attended schools in low-income metropolitan areas, family support, not the school itself, was what made the difference.

Researchers learned that in the refugee homes, schoolwork was a family affair. Although the parents spoke little English and were unable to provide academic assistance, they did create an atmosphere that contributed to their children's success. After the evening meal was over, the table was cleared and the children sat down to do homework. The older children helped the younger ones, and the parents assisted by doing household chores so the children could study. The Indochinese children invested far more time in schoolwork than their U.S. counterparts did. The Indochinese high school students averaged three hours and ten minutes per day on schoolwork. The junior high school students spent two and one half hours a day doing schoolwork. The grade schoolers did schoolwork two hours and five minutes each day. In U.S. homes, the average time spent on schoolwork is one and one half hours per day for both junior and senior high students.

The researchers found, in addition to family support and encouragement, a "love of learning" was reported by the parents and children alike. Learning was considered pleasurable for its own sake and as a means of advancement. The Indochinese participants found satisfaction in acquiring knowledge and growing intellectually. Contrast this view with one expressed in a newspaper story about a U.S. high school drop-out:

> "It was boring, boring, boring," he says. He found "no use" for history, and biology "was just cutting up animals. I didn't care what was inside."[16]

The Indochinese culture does not have a corner on helping its children succeed in school. Similar successes have been found in family studies of other ethnic groups, such as Jewish immigrant children in the 1930s and 1940s and Japanese-American children after World War II. A group of high-achieving African-American children from a low-income area of Chicago was also found to have family atmospheres that supported school and learning.[17]

Of Hispanics surveyed in 1991, 95 percent saw education as the key to their children's success in the world.[18] Study after study documents the impact the family can have on learning.

Cultural messages about education can also place the student at odds with the family and/or culture. In a poignant account of growing up in rural Appalachia, author Caffilene Allen tells of the conflict between what she learned at school and what she experienced at home. Her growing discomfort as she realized how her teachers viewed her mother's lack of education and the resulting split in her loyalties illustrates the push–pull feeling that can occur when school and culture clash. Allen voices appreciation for the encouragement of her teachers and the fact that they gave her books to take home and

helped find scholarships for her. At the same time she felt conflict because "they taught me to hate my culture, to despise people who had a different linguistic approach to life, even if one of those people was my mother." She goes on to say, "Regaining a sense of pride in my Appalachian heritage and an appreciation for who my mother was as a person was one of the hardest and most valuable tasks of my adult life."[19]

Because the family communicates cultural messages, a supportive culture makes a significant contribution in setting the stage for school success. Examining cultural messages is useful, not in a blaming way but, instead, as a source of information about ourselves. We all are products of our upbringing, and understanding this reality provides more tools with which to make changes.

Additionally, and of equal importance, the family that currently surrounds us transmits messages about our student role, study time, homework, and so on. If your significant others are supportive, college will be easier to adjust to and to manage. If they are not supportive in overt and obvious ways, it might be harder for you to devote your time and focus on attendance, study, and college requirements. If you feel some lack of support from your current family and friends, Chapters Seven and Eight contain some strategies that will work for you.

FIRST-GENERATION STUDENTS

Other educational messages come as a result of being the first generation in a family to attend college. First-generation students face a variety of pressures that are not present in families where education is an accepted and longstanding tradition. Recognizing the barriers that first-generation students face, the U.S. government legislated the landmark TRIO programs in the 1970s. The TRIO programs—Talent Search, Upward Bound, and Special Services—were charged with identifying and providing services to promising first-generation students to help them overcome educational barriers. These programs, administered by the United States Education Department's Division of Student Services, continue to target first-generation students in the 90s. They also assist the educational progress of students who have low income or disabilities.[20] Many colleges receive TRIO grants. Other schools have similar programs. The purpose of these programs, regardless of name or funding source, is to support and encourage first-generation students.

First-generation students often face barriers such as little family support, lack of educational role models, and no identifiable educational goals. Because of lack of experience, the family may not understand the time needed for study. Also, if family members do not hold college degrees, first-generation students may not see the long-term professional or monetary rewards of college.

Helen, age 19, says:

> I would try to study at home, but I think that to my mother it appeared I was doing nothing, just sitting around reading all the time. She would ask me to watch the younger kids or to run to the store, even though I had started my homework. She tried hard to understand, but I know she didn't. I guess I would have been the same before I knew about college.

THE IMPACT OF BIRTH ORDER

Another factor that impacts self-esteem is the order of birth in a family. Position within the family influences how one copes with the demands of school. Research on birth order reveals that first-born children because of their place in the families are more likely to attend college. They have high motivation to achieve. They tend to choose careers such as mathematics, engineering, physics, architecture, and chemistry, which require abstract thought and little social contact. Many first-borns become college faculty members, which probably accounts for more research conducted on this family position than any other! A frequently quoted fact substantiating the achievement orientation of this birth position is that 21 of the original 23 astronauts were either the oldest or only children.[21]

First-borns tend to be responsible, perfectionistic, and motivated to achieve. They are able to deal with authority and structured situations. As Kevin Leman says in *The Birth Order Book:* "They thrive on being in control, on time, and organized," all characteristics that lead to success in school.[22]

According to Wilson and Edington in their book *First Child, Second Child,* middle children are harder to define. They do not have the advantages of being trailblazing first-borns or the relaxed acceptance of being the "baby" in the family. They often compete in areas in which the oldest or youngest do not excel. For example, if the oldest in the family already has carved out a niche as the scholar, the middle child may become the artistic or athletic one, depending on his skills and abilities. Middle children tend to be more sociable, especially as teenagers. They develop tenacity in going after what they want—a skill needed in the family of origin, where they are caught between their siblings.[23] This tendency has been called the "Avis complex" after the old rental car company commercial in which the Avis Company promised to work harder for customers because they were "number two trying to be number one."[24] When middle children become students, their tenacity and willingness to try harder can be an advantage.

Youngest children have the advantage of having older siblings from whom they can learn about the world in general and school in particular. In some cases, a youngest child, as the baby of the family, may have been overprotected and lack self-esteem.[25] The lives of youngest children can be a series of contradictions—being pampered and coddled, yet feeling they are not taken seriously because of their position as the youngest. Given their last-born position, they often compensate by "grabbing the limelight" as a way to feel valued.

Psychologist and author Kevin Leman, the youngest of three children, describes himself as becoming a "clown" to seek attention when he believed he could not compete with his high-achieving oldest sister and second-born brother. "What I wanted was attention. That was my thing in life—getting people to laugh or point or comment."[26] Leman's struggle with school is typical of the academic life of many last-borns. He didn't apply himself in high school and performed so poorly that he had trouble getting accepted to college when he finally decided to turn himself around. Eventually Leman earned a master's and a doctoral degree and described himself as "one of the

few certified psychologists I know who went through college and post-graduate work—thirteen years in all—without the benefit of a high school education. I literally did not learn much of anything in high school, a fact that hardly makes me proud."27

Lack of ability did not keep Dr. Leman from achieving in high school. He had made some choices based on a view of the world as seen from his family position. Fortunately for all of us, decisions like this are subject to change once we have information on how we made them!

The ability to deal well with people is a strength youngest children tend to bring to the academic setting. They usually are charming, friendly, and relaxed around others, giving them an edge in the classroom, where interaction is a plus. The youngest-born are frequently drawn toward vocations that are people-oriented. They may need to develop skills in taking responsibility and being cooperative.

Birth order characteristics are not absolutes. Many factors affect self-image in relation to family position. If a person is from a large family, sibling spacing should be considered, as sub-groupings of children may exist within the larger group. A family of seven children, for example, may have a gap of five or more years between the first three children and the last four. Here, the children function as two sub-groups. If siblings have died or were born with a disability, the family's pattern may not be typical. If yours is a large family, or if you believe it has some unusual factors, you may want to refer to one or more of the books listed in the bibliography for additional information.

Table 3.1 lists typical characteristics of children in the first or oldest, middle, and youngest position within a family. These, again, are not absolute, and you may not fit them exactly.

Judy, a 28-year-old re-entry student, appeared in the counselor's office complaining that she felt stressed. She never had enough time to do her work the way she wanted to do it, and she seriously questioned her ability to be in school at all: "I just can't get it all done. By the time I got all the material from

TABLE 3.1

Characteristics of children by birth order in family.

Oldest	Middle	Youngest
Responsible	Independent	Charming
Conservative	Sociable	Limelight-loving
Perfectionistic	Sensitive to injustices	Manipulative
Disciplined	Striving	Playful
Serious	Diplomatic	Blaming
Conforming to authority	Good at negotiating	Rebellious
	Creative	Spontaneous

the library for my history paper, I didn't have enough time to do a good job typing it up. Then I was scheduled to help out at my daughter's preschool. It's just too much for me."

In discussing her family background with the counselor, Judy listed her family pattern like this:

Mark	age 39
Sara	age 38
Judy	age 28
Kathy	age 27
Jim	age 25

Viewing her family pattern on paper helped Judy see that she was like an eldest child in many ways. Because of the 10-year age difference between herself and her oldest sister, Judy behaved more like a first-born child than she realized. As she listened to the counselor's explanation of the effect of birth order, the perfectionistic tendencies that led her to counseling in the first place made sense. She was able to use this information to understand how she became overcommitted and set impossible standards for herself. A typical high achiever, she gathered more material for her paper than she had to. If she could ease up on her self-criticism and let go of some of the striving for perfection, she would feel less pressure and less self-doubt. Armed with a new understanding of herself, Judy was able to make positive changes in the ways she coped with school.

EXERCISE 3.3

ASSESSING THE EFFECTS OF BIRTH ORDER

Understanding the effect birth order has on your behavior can help you see if current patterns help or hinder your progress in school.

PURPOSE

To help you recognize your family pattern.

INSTRUCTIONS

List your siblings from oldest to youngest (including yourself) with their ages. Notice years between births. Then list words that describe you and each of your siblings. Which child was most like mother? Most like father?

REFLECTIONS

Consider these questions:

What patterns do you see? Can you draw any conclusions from your birth order? How might this affect your performance in school and your self-esteem?

▬ ▬ ▪ ▬ ▪ ▬ ▪ ▬ ▪ ▬ ▪ ▬ ▪ ▬ ▪ ▬ ▪ ▬ ▪ ▬ ▪ ▬ ▪ ▬ ▪ ▬ ▪ ▬

SUMMARY

Early messages from your family influence your self-esteem and conclusions you reach about how you fit into the world, whether the world is a safe or a fearful place, and whether taking risks is okay. This can help or hinder your progress in school. If your parents and culture teach that learning for its own sake is valuable, that love of reading is a positive quality, and that education is a way to better yourself, you might have an easier time fitting into higher education.

By now you can begin to see how your personality is shaped by the messages of the second circle. This should help you build on your strengths and counteract your weaknesses. This knowledge can help you enhance your self-esteem and improve your chances for doing well in school.

NOTES

1. Janet Woititz, *The Struggle for Intimacy* (Deerfield Beach, FL: Health Communications, 1983), pp. 39–40.

2. Christine Courtois, *Healing the Incest Wound: Adult Survivors in Therapy* (New York: W. W. Norton, 1988), p. 105.

3. Courtois, p. 104.

4. Warren Rule, *Lifestyle Counseling for Adjustment to Disability* (Rockville, MD: Aspen Systems, 1984), p. 4.

5. Claude Steiner, *Scripts People Live* (New York: Bantam Books, 1975), p. 16.

6. Guillermo Grenier, "Who Are We? Hispanotrends Profiles: Hispanics' Lives and Aspirations," *Vista* 7 (1992): 8–12, 26 (U.S. Communications, Coral Gables, FL).

7. Ruth E. Thaler-Carter, "The Making of Strong African-American Families," *Guidepost* 34 (1992): 15 (American Association for Counseling and Development, Alexandria, VA).

8. David B. Cooper, "The Best Gift Ever: The Love of Reading," *Arizona Daily Star*, Dec. 16, 1991.

9. Cooper.

10. Cooper.

11. Walter Barbe, *Growing Up Learning: The Key to Your Child's Potential* (Washington, DC: Acropolis Books, 1985), p. 11.

12. Gene Maeroff, *The School-Smart Parent* (New York: Times Books, 1989), p. 45.

13. Jim Trelease, *The Read-Aloud Handbook* (New York: Penguin Books, 1985), p. 2.

14. Maeroff, p. 46.

15. Nathan Caplan, Marcella H. Choy, and John K. Whitmore, "Indochinese Refugee Families and Academic Achievement," *Scientific American*, Feb. 1992, pp. 36–42.

16. Keith Ray, "So Long to School," *Arizona Daily Star*, Dec. 16, 1991.

17. Caplan et al., p. 42.

18. Grenier, p. 10.

19. Caffilene Allen, "First They Changed My Name . . . ," *MS.*, January/February 1994.

20. U.S. Department of Education Announcement. Sarah Thompson, Office of Graduate Studies, Central Michigan University. http://pip.ehhs.cmich.edu/chart/grants/grants.txt

21. Lucille Forer, *The Birth Order Factor: How Your Personality Is Influenced by Your Place in the Family* (New York: David McKay, 1976), p. 9.

22. Kevin Leman, *The Birth Order Book: Why You Are the Way You Are* (Old Tappan, NJ: Fleming Revell, 1984), p. 83.

23. B. Wilson and G. Edington, *First Child, Second Child . . . Your Birth Order Profile* (New York: McGraw-Hill, 1981), p. 106.

24. Daniel Eckstein, Leroy Baruth, and David Mahrer, *Lifestyle: What It Is and How to Do It* (Hendersonville, NC: Mother Earth News, 1975), p. 9.

25. Forer, p. 77.

26. Leman, p. 83.

27. Leman, p. 91.

The Third Circle: Messages from the Immediate Environment

- How do teachers' personality types interact with core circle preferences?
- How does learning style influence the development of self-esteem?
- How do peers, school, and class size relate to self-esteem?
- How do physical differences affect self-esteem development?
- What effect does anxiety have on school performance?

Inborn preferences and family of origin have a significant impact on the development of self-esteem, as discussed in Chapters Two and Three. During the first five to seven years, children's perspectives on the world and their unique place in it are most often shaped by observations and interactions in the home. Although children may be in day care (and are certainly influenced by peers) parents still remain their primary reference to the world. Between ages five and seven, however, a child's world view undergoes a dramatic shift. When we realize that our children spend between four and nine hours a day, five days a week, in a school setting, we see how influential *peers* can be. Over 12 years, this averages out to more than 14,000 hours in school!

Thus, around age seven, a crucial psychological change occurs in children: they develop the ability to compare themselves to others. Before that age, children do not know how smart, physically adept, or attractive they are. Around age seven children begin to rate themselves, based on social comparisons, as more or less competent, attractive, intelligent, or physically able than their peers. This ability influences children's self-concepts tremendously. They measure themselves against others, and this impacts their self-esteem.[1]

Although children of all ages need parents and rely on their love and acceptance for self-esteem enhancement, there is a very pronounced shift in focus to the young person's friends as an important source of self-esteem. In addition to school friends, peers from the neighborhood can also greatly influence the self-rating.

Boys and girls are exposed regularly to children from upbringings different from theirs, to significant authoritative adults called teachers, and to new information. The influence of teachers, friends, and curriculum on self-esteem, with special attention to school, is the focus of this chapter.

SCHOOL PEER
GROUP AND CLASS SIZE

Do you recall who the "smartest" kids in your class or neighborhood were? How about the fastest runner? Teacher's "pets"? The "prettiest" girls? The "cutest" boys? Chances are you can still probably name these friends.

Ask this question of children you know today. If they are in at least first or second grade or even in high school, they will quickly be able to tell you the "pecking order" or hierarchy of the "fastest," "smartest," "funniest" kids in the class or neighborhood, and where they fit in!

As discussed in Chapter One, a person's self-esteem relies heavily on accomplishments in areas that are important, not only to the self but also for the peer group or culture to which we belong. Being viewed as successful among peers greatly influences how we rate ourselves. If a person consistently lands at the bottom of the group, especially in several areas that are important to their group and themselves, his or her self-esteem may suffer. Conversely, the more areas in which an individual is satisfied with themselves, the more likely it is their self-esteem will be enhanced.

Another variable is the size of your social group of peers. "A big fish in a small pond" is a common expression in our culture. Like many platitudes, this one contains a large grain of truth. Take the example of Sandy. She attended classes with 28 to 30 children. A naturally quiet, introverted child, she did her schoolwork diligently, performed well, and received A's and B's in all of her subjects. Ten other children in her class had similar grades, but they were extraverted. Therefore, Sandy did not receive the kind of recognition, attention, praise, or encouragement a child needs to build confidence. Her talents were taken for granted.

Now let's go back and put Sandy in a "smaller pond." Her class has 18 children, and only two or three other children also earn high grades. Consequently, Sandy receives more praise and recognition, and she develops more confidence. Feeling more comfortable in smaller groups, she speaks up more. She now views herself as special. Essentially, feedback in this environment reinforces her for her unique gifts. Therefore, the size of your social group and peers might influence your sense of personal effectiveness.

STUDENTS' LEARNING STYLES
AND TEACHERS' PERSONALITY PREFERENCES

Do you compare yourself to others and discover you are doing as well as or better than some of your peers? If so, your academic self-esteem might be quite healthy. For example, Sandy, an introvert and feeling-type child, relates that she had a difficult time in school emotionally when she began to consciously compare herself to others:

> You know, you just want to be like everyone else. No matter how often I raised my hand, it seems the teacher called on me and noticed me a lot less than others. I couldn't just shout out answers to questions. I wanted and waited to be called on, and it seems I just didn't get enough turns. I often came home from school feeling kind of different from others—almost invisible. . . . I mean, I knew the answers to questions, but it didn't seem to matter.

Chapter One presented a framework to understand certain aspects of the core self based on Jung's work and the Myers–Briggs framework. Your own preferences and your teacher's preferences interact in many ways. For example, an extraverted teacher who values classroom interaction may overlook the reflective style of a student who is introverted. If the classroom emphasis is on group rather than one-to-one dynamics, the introvert's more introspective style could be overlooked. If a sensing-type teacher provides mostly factual tests and programmed learning lessons, an intuitive-type student may have trouble with tests and motivation. In contrast, a highly intuitive teacher may focus on symbolic and conceptual lessons and testing, such as open-ended questions. A sensing-type student, who tends to prefer the concrete, will struggle with intuitive methods. A feeling-type student, who values human interaction and feedback, might feel intimidated and put down by an objective, thinking-oriented instructor who analyzes and criticizes impersonally. Teachers' personality preferences inevitably influence the style and methods in which instruction is delivered.

Generally, the closer your learning style is to your instructor's teaching style, the more comfortable you will be in that teacher's class. Although the subject matter being taught will influence the types of teachers and students attracted to certain classes, you will likely encounter college teachers with at least one or more preferences that are different from your own. Here's a look at some overall patterns you might expect from college teachers:

- intuition is preferred over sensing
- at least half of college teachers prefer introversion
- thinking occurs more frequently than the feeling preference
- judging is preferred more often than perception [2,3]

Once again, insights into your personality style can highlight areas of strength and areas where you will want to adjust, adapt, and learn new study skills. The goal is not to change who you are, but to recognize competence and broaden your repertoire of tools for success. You may want to review the

discussion of personality type and learning found in Chapter Two. Chapters Seven and Eight will provide strategies for increased academic success.

Keep in mind that although some of the patterns we discuss here do exist in some teachers (and all other human beings!), the intention, influence, and result of the work of a great majority of educators is to contribute in a positive way to student learning and development. All of us can probably name at least one educator who influenced our lives in a beneficial way, and in Exercise 4.1 you will have an opportunity to thank those individuals.

RACE, GENDER, AND MINORITY STATUS IN THE CLASSROOM

The U. S. educational system does not exist apart from the U. S. culture. Prejudices and attitudes toward individuals who are different inevitably permeate the classroom environment and are sometimes conveyed through teachers as well as other students. Consciously or not, teachers' stereotypes and opinions about any group of students they perceive as "different" will impact their treatment of those students. Jones and Watson cite several studies documenting the relationship between teachers' attitudes—whether positive or negative—and students' self-concept.[4] A student's higher or lower status in a teacher's eyes may determine how the teacher treats the student—whether the student is one of three Caucasian students in a class of 25 Hispanic students, or six African-American students in a class of 33 Caucasian students.

Researchers also have documented different treatment according to gender. Many students relate anecdotes from their school years (especially prior to the civil rights and women's movements), when teachers encouraged or discouraged them from certain interests or activities because of their gender. Scott wryly recalls:

> In high school I took a "boys'" class called "Bachelor Living." It was highly recommended and thought to be quite progressive. Sort of "equal opportunity." We learned to cook, sew, and run a household. It was a fun class, but when I think about it now, the class title implied that bachelors needed to be taught these home skills. After we got married, our wives would take over the "women's work," and then we wouldn't need to do this stuff any more!

Boys in elementary school often have been rewarded for passive and obedient behavior, which are traditional feminine characteristics. Unfortunately, in their first six years boys tended to be socialized to be "ideal boys"—physical, active, assertive. These contradictory messages may contribute to higher incidences of school-related behavior and academic problems in boys.[5] Young boys often concluded that school is mainly a place for girls.

Because most teachers are female, they tend to reinforce feminine characteristics. Jerome Kagan tested this concept in a study in which second-grade children associated school-related objects (eraser, chalkboard, and the like) with feminine gender. They thought that things related to school were female! Kagan asserts: "If young boys perceive the mission of the school as feminine,

they will resist complete involvement in classroom activities."[6] As boys progress in the educational system, however, the value of school changes and improves for them. They learn that education and training prepare them for their traditional, primary, and highly rewarded role as breadwinners.

The culture of the educational system can have a negative effect on females. In the 1970s, Guttentag and Bray reviewed the current research on achievement patterns of boys and girls.[7] They found that high-achieving girls in elementary school declined in their high school achievement and their IQ scores. At the same time, high school boys became oriented toward college and careers and became better students. Girls also consistently underestimated their abilities, whereas boys' self-esteem more realistically and accurately reflected their abilities. The research review by Guttentag and Bray showed that teachers interacted more often with boys in both approving and disapproving ways and perceived them more analytically and accurately.

Research during the last 20 years has shown little gain in equalizing the treatment of females and males in school, and gender bias continues in the 1990s. This inequality negatively impacts girls' self-esteem. In 1992, a poll of 3,000 fourth through tenth graders by the American Association of University Women revealed a dramatic drop in the self-esteem of girls as they entered adolescence.[8] Other current research documents that preteen girls are more likely than boys of that age to underestimate their intellectual abilities and show a decline in academic performance.

Authors Myra and David Sadker discuss gender bias in schools in their book, *Failing at Fairness: How America's Schools Cheat Girls*, pointing out that subtle gender lessons and inequities still occur. Although these may appear insignificant when considered on an individual basis, they actually have a powerful impact when taken all together.[9] Thus, in spite of major improvements in raising society's consciousness about women's abilities, the negative impact is still present.

Teacher interaction is not the only factor in school that contributes to our self-esteem. Obviously, much of what we learn is from books. If you are a re-entry student, you may have gone to school in the 1950s, 1960s, or early 1970s when:

- Plots of reading books centered primarily on male characters.

- The males in these readers were physically assertive and were astute problem solvers; the females carried out orders given by others.

- Most books did not depict minority children, and those that did depicted them according to stereotypes.

- The heroes of history books were Caucasian males, and women and minorities often had minor or stereotypical roles (for example, Betsy Ross worked as a seamstress).

- People with disabilities were shown in stereotyped ways, either as a super person (like Helen Keller) or a pathetic waif (like Charles Dickens' Tiny Tim).

These books reinforced society's stereotypes, and we did not have many opportunities to learn about "real" people.

Decisions about what books to use in school often are made at a district level, not by classroom teachers. Statistics show that most administrators at the district level are Caucasian males. When many of us were attending school in the last two to three decades, those in charge were not consciously aware of the psychological impact of the content of the books they selected. Fortunately, many changes have taken place since then. Title IX of the U. S. Educational Amendments clearly prohibits sex discrimination. Responding to market demands, many publishers of textbooks and children's books have adopted policies and guidelines regarding positive depictions of women and minorities in their publications.

Finally, role models are needed. To be able to say "If that person can do it, I can do it" is often the impetus a child needs to succeed at a certain task.

DISABILITIES AND SELF-ESTEEM

People with disabilities also feel the impact of the third circle. Those who are considering returning to school undoubtedly have felt the impact of school messages. As other minority groups have learned, the educational system does not adapt well to uniqueness. Those who were in school before legislation such as the federal Rehabilitation Act of 1973 (Public Law 93-112) and the Education for All Handicapped Children Act of 1975 (PL 94-142) and its 1990 amendments in the Individuals with Disabilities Education Act, guaranteeing equal access to education, are aware of the former restrictions. A person with a disability may have been placed in a residential or special school and not have attended classes with siblings or neighbors.

Treatment of students with disabilities affects their self-esteem. In interviewing classroom teachers about their fears of having students with disabilities in their classrooms, Maurer listed the negative attitudes a student with disabilities might face in a classroom.[10] These attitudes include:

- Assumptions of inferiority: treating the student as incapable, childlike, and in need of protection.
- Spread effect: assuming that because a student has disabilities in one area, other areas are affected as well (an example is the tendency to shout at a blind person, assuming that a person who can't see probably can't hear either).
- Stereotyping: assuming that all students with disabilities are alike, thus letting preconceived ideas define the student (an example is the notion that all deaf people are good with their hands and should be counseled into some kind of repair career).
- Lower expectations: holding the student with a disability to lesser standards than a student without disabilities and grading unrealistically (could be manifested in not recognizing above-average work when it exists or the opposite extreme of giving good grades out of pity rather than because the student has earned them).

- Fear and apathy: not being willing to find out what the student is really like and what is needed for success.

Claudia, a woman with cerebral palsy, tells of the hurt of sitting on the sidelines watching her classmates play running games at recess. Her unsteady gait and uncertain balance prevented her from partaking in active play. "The kids weren't really mean. They just were being kids. Nobody wanted to spend time with me at recess because I couldn't run and play rough."

A disability sets a person apart. Even in the most accepting schools, the differences are clear. At a time when belonging is so important, children with disabilities have trouble fitting in, and self-esteem can suffer. Depending on what kind of a buffer the family life provides, a person draws some conclusions about self-worth and ability as a student.

Some students have disabilities that are not visible, but they still feel the impact of school messages. Students who have learning disabilities are one example. These students have average or above-average intelligence, yet their inability to perform as required in the school system opens the door to misunderstandings. As one student with a learning disability puts it:

> My high school teachers thought I was stupid because I had difficulty spelling words. They thought I couldn't handle college. They would rip papers I submitted because they couldn't read my handwriting.[11]

Many students with learning disabilities report growing up feeling stupid because they were unable to process information the same way as their peers, had difficulty fitting into the educational system, and were thought by teachers and peers to be incapable.

Attention deficit hyperactivity disorder (ADHD) presents many of the same problems in the early school years. Youngsters with this disability are unable to sit still in school, finish tasks, listen, concentrate, and memorize. Socially, they may have problems maintaining friendships. Some young people seem to outgrow this disability as they reach adulthood, but the difficulties continue for others. A psychologist quoted in a *Wall Street Journal* article estimated that 8 to 15 million adult Americans suffer from ADHD.[12]

Those who grew up with a learning problem need to pay special attention to the messages received as learners. The disability may have caused some misunderstandings about their capabilities, and old messages may come back to haunt them if they are not aware of the impact. As adults they have the ability to succeed, but to do so requires revising old messages received from a system that didn't understand the unique learning needs of these students.

MATH ANXIETY, SCHOOL ANXIETY, AND OTHER FEARS

Jeanne, a re-entry student who is 44 years old, talks about her difficulty with math:

> When I was in high school, math was supposed to be a "boys'" subject. Girls weren't expected to be good at it, and I certainly wasn't. I really didn't

see a need to study math. It was hard and boring. Besides, according to my mother, all the women in her family had difficulty with math and science, so when I went to college right out of high school, I picked a major that didn't require math. It wasn't my first choice, but I was convinced I was going to fail math anyway.

Mack tells this story:

I enjoyed math until about the seventh grade. Then we moved to another city, and I found the new class was way ahead of me. The teacher made me feel dumb for being so behind, and the other kids made jokes about my stupid mistakes. I started really dreading that class and ditched it whenever I could. Now my math skills are so bad, I doubt I can handle even bonehead math.

Both these students point out what we now term *math anxiety*. It is defined as a physical and psychological reaction to math that impedes retention of the subject and affects performance in class and on tests. Students who have math anxiety usually have stories to tell about their negative experiences with the subject. Their self-esteem was impacted early by messages from their teachers and classmates. Most negative math experiences happen between the seventh and tenth grades.[13]

Many re-entry students also may experience fears about dealing with technologies that did not exist when they were in school the first time. While our children are being raised to be comfortable with computers, it has been estimated that about 55 percent of adult Americans are computerphobic. A recent contest by *HomePC* magazine to identify this country's biggest computerphobe drew more than 4,600 responses.[14] The entry rate would have been far higher if people who fear computers actually read computer magazines!

Some students experience generalized test anxiety as an issue affecting their return to school. These students freeze on any test, not just in a specific subject. This fear is similar to math anxiety but it is much more pervasive. We give suggestions for dealing with test anxiety in Chapter Eight.

Like math anxiety, school, test, and computer anxiety are generalized responses to scary or difficult experiences in the early years. If you had experiences of that nature in your early school life, you probably incorporated them into your messages about yourself as a learner, and you may have low self-esteem in the educational area. You may need to understand and re-evaluate these messages to give yourself a chance to succeed as a re-entry student.

Fortunately for Jeanne and Mack, their college provides workshops for conquering math anxiety. Through those resources, they have the tools to begin to overcome past programming. You will learn more about accessing personal and college resources for math anxiety and computer anxiety in Chapter Eight.

EXERCISE 4.1

THE IMPACT OF THE THIRD CIRCLE

PURPOSES

To highlight the impact of the educational system on your self-esteem.

To discuss the positive and negative influences of teachers on self-esteem and learning.

To discuss the influence of different learning styles, gender, feared subjects, and disabilities on your current feelings about school.

INSTRUCTIONS

Answer the following questions:

1. Recall your earliest experiences in school. Review memorable elementary school, high school, and any post-secondary experiences. Think about your teachers, counselors, or principals. What positive experiences or messages can you recall? What is the best thing an educator ever said or did for you? How do you think that has impacted your self-esteem? What is the worst thing an educator ever said or did to you? How do you think that has impacted your self-esteem in regard to education?

2. How large were your classes? Knowing what you know about the influence of class size on a child's perception of success, what impact did class size have on your personal view? How do you think you compared yourself to your peers? How did that comparison impact your feelings?

3. What were your best subjects? Worst? How much did your instructor (personality or teaching style) influence your feelings and performance in those subjects? How do you feel about those subjects today?

4. What role models influenced you in elementary school and high school? Whom did you want to emulate? Teachers? Clergy? Parents? Neighbors? Fictional or nonfictional characters in texts or literature?

5. Did any teachers or family members encourage or discourage you from pursuing interests in school because of, or in spite of, your gender?

Optional activity: Write a letter of thanks (whether you do or do not send it) to the teacher or counselor who influenced your self-esteem and confidence most positively.

REFLECTIONS

Discuss your answers as a class or in small groups. Small-group members are to report to the class on patterns and trends emerging from the small-group discussions.

SUMMARY

Like the other circles, the third one—the immediate environment outside the family, of which schools and peers are a large part—influences self-esteem. Teachers and classroom materials, our gender and our native culture, the size of our schools and classes, our abilities and disabilities, how we rate ourselves compared to the peer group we are part of, the time period when we attended school—all of these aspects combine in forming our view of ourselves. Other factors include math anxiety, fear of tests, and fear of school in general. As was the case with the inner circles, understanding these influences is a step toward understanding how to proceed from here.

The purpose of reviewing these influences is not to dwell upon their possible negative effects but, instead, to learn enough about ourselves to identify strengths that may have been overlooked or underdeveloped (in part because of where we happen to grow up), to develop patterns of action that emphasize our strengths and not our weaknesses, and to find the means of realizing our goals that take into account our personality preferences, learning styles, and other factors. If you now have a better idea of some of the messages that may have been conveyed to you, whether those messages were negative or positive, you are better prepared to grow beyond the effect of those messages.

NOTES

1. Jerome Kagan, *The Power and Limitations of Parents* (Austin: University of Texas, Hogg Foundation for Mental Health, 1986), p. 6.

2. Gordon Lawrence, *People Types and Tiger Stripes* (Gainsville, FL: Center for Applications of Psychological Type, Inc., 1993), p. 21.

3. John K. DiTiberio and Allen L. Hammer, *Introduction to Type in College* (Palo Alto: Consulting Psychologists Press, 1993), p. 7.

4. Dionne J. Jones and Betty Collier Watson, *High Risk Students in Higher Education* (Washington, DC: George Washington University, School of Education and Human Development, 1990), pp. 41–42.

5. Christopher T. Kilmarten, *The Masculine Self* (Macmillan, 1994), p. 86.

6. Jerome Kagan, *The Growth of the Child* (New York: W.W. Norton, 1978), p. 128.

7. Marcia Guttentag and Helen Bray, "Teachers as Mediators of Sex-Role Standards," in *Beyond Sex Roles* (New York: West Publishing Company, 1977), pp. 395–411.

8. Gini Kopecky, "The Age of Self-Doubt," *Working Mother,* July, 1992, p. 46.

9. Myra and David Sadker, *Failing at Fairness: How America's Schools Cheat Girls* (Macmillan, 1994), p. ix.

10. Lydia Maurer, *Opening Doors: Educating the Disabled* (Phoenix: Arizona Department of Education, 1985), p. 3.

11. Maria Elena Lopez, "Learning Enabled," *Tucson Daily Citizen*, Dec. 26, 1992.

12. Krystal Miller, "Attention Deficit Disorder Affects Adults but Some Doctors Question How Widely," *Wall Street Journal*, Jan. 11, 1993.

13. Stanley Kogelman and Warren Joseph, *Mind Over Math* (New York: Dial Press, 1978).

14. Maria Behan, "Atlanta Brave-Computerphobe Contest Winners," *HomePC*, Nov. 1995, no. 211: 166.

The Fourth Circle: Impact of the Outer World

▰ How do various media perpetuate stereotypical images that can impact self-esteem?

▰ How can U. S. culture have a negative impact on the self-esteem of women, nontraditional males, and minority students?

▰ What are some links among stereotypical sex roles, race, and higher education?

▰ How do "outer world" messages personally impact our self-esteem and behaviors?

The outer circle encompasses the influence of the world at large on self-esteem. This circle consists of the dominant culture and its interaction with an individual's cultural and ethnic background, including mass media communication of society's expectations and stereotypes about certain groups. The fourth circle has an impact on each of the other circles in the model. It affects parents, teachers, and other authority figures, and even self-acceptance of inborn preferences. The messages of the dominant culture have a bearing on our behaviors toward those who are different and these messages can damage self-esteem.

CULTURAL VALUES: GROWING UP "DIFFERENT"

As a child in the early 1960s, Gina liked to watch television. An African-American, she consciously began to take note: the children on her favorite shows were different from her! Gina lived in a nice apartment with her parents, but the television children—Dennis the Menace, Timmy on "Lassie," Richie on "The Dick Van Dyke Show"—lived in a big home with a second floor or in a sweeping farmhouse. The characters were boys, and they were Caucasian. How different their lives were from hers! Even the commercials featured children who looked and lived much differently than she did.

Gina was happy with her life and her family. She especially enjoyed church on Sundays. She was excited to see family and friends there, and she thrived on the exuberant sermons, gospel music, and energy and happiness she felt at church. But Gina knew those kids on television didn't attend a church like hers! Where were the TV kids who were like her?

By the time Gina began attending junior high school, she was very conscious of her minority status. More children in her school were Caucasian, and only two teachers were African-American. Gina thought a couple of the Caucasian teachers didn't often call on her. She also noticed that the only African-American people discussed in her texts were slaves, and the music of African-American people was "slave music." What about Gina's church music? She felt embarrassed when she heard a couple of the Caucasian children snickering at the pictures of slaves in the textbooks.

On Gina's 13th birthday she received a magazine subscription to a teen magazine. As she paged through the monthly publication, she noticed the same old thing: no girls who looked like her, no make-up like the kind she used, clothes that weren't available to her. Of course, the Caucasian girls in the articles seemed to be very concerned with boys, just as some of her friends were.

In high school, Gina began to wonder if the world always would be this way. After she joined the Black Pride movement, Gina knew she wanted to change some of her self-consciousness about being African-American to feelings of high self-esteem and pride. Although her parents thought she shouldn't rock the boat too much, they also were proud of her involvement. Even though Gina had some painful experiences being a member of a minority group, her strong, stable, and cohesive family background gave her some useful, positive tools.

The family often minimizes the negative effects on self-esteem from the messages and treatment of those in the outer world. The family, along with a supportive neighborhood (third-circle environment), often acts as a buffer to the negative effects of the outer world. Actually, many people do not personally experience the negative impact of stereotypes, discrimination, or prejudice until they leave their parents' home. If parents give their children some emotional and behavioral tools to handle prejudice, they are more prepared to deflect negative encounters. If an individual does not have those tools, however, those first negative encounters can damage self-esteem.

Brian is a Jewish child. His parents maintain a kosher home. This means he does not eat pork, milk with meat, or shellfish such as shrimp, and is not allowed to eat a cheeseburger. His family's most important religious observances, which occur in the early fall, are called Rosh Hashanah and Yom Kippur. Brian does not attend school on these holidays. Instead, he attends services at a synagogue several miles away. At Christmas time, his family does not celebrate by caroling, buying and trimming a tree, and putting presents under it. Yet, much of what he sees in the "outer world" —shopping, television, school, songs on the radio—is geared to Christmas.

Brian's neighborhood is predominantly Catholic. The children in his peer group eat the foods Brian is not allowed to eat. On Wednesday afternoons, his

classmates leave school early to attend catechism at the nearby Catholic school. The classroom empties except for Brian and a few children who are Protestants. Religious pictures and symbols decorate most of the homes in Brian's neighborhood.

Brian's parents have taught him to be neither ashamed nor proud of his religious differences. In fact, the differences are never really discussed. When Brian encounters situations such as refusing a piece of pork, he isn't sure how to explain why he can't eat it because he hasn't heard the reasons.

Occasionally, some of the children in his school call Brian derogatory names. Little by little, he has begun to conclude that being Jewish is something to hide. Furthermore, it seems as if the rest of the world ignores people like him. He begins to feel he is not good enough and his self-esteem suffers. Brian is having a hard time feeling open about his religion.

In Chapter Eight, we will revisit Brian to see how he has been able to enhance his self-esteem and identity through positive action.

SMITH'S THEORY OF ETHNIC IDENTITY DEVELOPMENT

Elsie Smith developed a theory of ethnic identity development, illustrated by Brian's and Gina's stories. In this theory, Smith asserts:

> An individual's emotional well-being is partly a function of the social conditions in which she or he matures. . . . Oppressive conditions—namely racism, discrimination and prejudice—may delimit a person's ability to fulfill his or her potential.[1]

Smith draws upon many research studies demonstrating that "an individual's embeddedness in his or her culture may (a) protect him or her from developing a vulnerable identity in the first place or (b) assist him or her when his identity becomes vulnerable."[2]

Alexander Astin's respected and exhaustive long-term study of college drop-outs found that connectedness to other students based on religion, race, and similar town size were factors increasing the likelihood of minority students' staying in college.[3] Put another way, we all need to experience feelings that we belong and are accepted to enhance our self-esteem. If we look around us and perceive that we are visibly "different" from the peers who are important to us, *and* those differences lead to feelings of being "less than," discomfort and lowered self-esteem may result. Additionally, if the peer group harbors prejudice and resentment toward us because we don't exactly "fit," we may experience shame and rejection. (At the extreme, harassment and violence might occur.)

However, if we are among "people like us," it is more likely that our cultural, ethnic, or religious identity will be reinforced, and we'll be comfortable simple "being ourselves." As Blanca, a Hispanic student in a predominantly Hispanic school, has said: "There are whole conversations and explanations of my feelings and my life that I never need to give when people have the same background and experiences that I have had."

Gina's and Brian's experiences support Smith's theory. Gina had the protection and comfort of a strong family and cultural background within her immediate neighborhood surroundings to minimize the impact of her negative experiences from the outer circle, whereas Brian had few tools and little protection. Smith's theory of ethnic identity development and Gina's and Brian's stories demonstrate that self-acceptance of the ethnic aspect of one's identity can contribute to higher self-esteem, and nonacceptance of that part of oneself might lower self-esteem.

PREJUDICE AND STEREOTYPES

In the United States, the extent of perceived similarity or difference from those holding the power (still Caucasian Americans, mostly male) transmits a strong message. This message is manifested in people's behavior, in the media, and in self-esteem. Ironically, in this culture, individuality is encouraged and rewarded. At the same time, one who is too different (as a male, a female, an ethnic minority, and so on) will feel pressure to conform to the roles society deems "appropriate." If individuals do not conform, they may be rejected, as well as view themselves as "less than." Repeated rejection often lowers self-esteem and stifles growth.

This is *not* to say that if a person is a member of an ethnic, racial, or religious minority, his self-esteem is low. In fact, research has demonstrated that the self-esteem of minority children in general is healthy.[4,5] Still, negative feedback (ranging from subtle to hostile) from dominant members of the culture and manifested in the media can cause individuals to question whether they are okay. Prejudice and discrimination throughout history have severely hampered the educational and economic opportunities of minorities.

People who are not minorities but who have stereotypical and racist beliefs about others can feel a false sense of high self-esteem (or superiority). They may be ignorant of the realities of history and the contributions of people of color and may lack intellectual growth and perspective. In fact, many writers consider racism a disease.[6] Thus, each person should become sensitized to the negative messages of the outer circle and their impact on self-esteem, regardless of gender, age, or ethnic background.

MEDIA STEROTYPES

By the time they complete high school, U.S. children will have spent more time watching television than attending school, doing homework, or engaging in any other activity.[7] Television is the primary "window to the world"—the outer circle—for most children. On that screen the child is exposed to role models and images of different categories of people—minorities, women, men, and so forth. TV often is the only means by which individual differences are conveyed. Study after study has demonstrated that the more time a child spends watching television, the greater is the likelihood that the child will hold

stereotypical views of the personal characteristics of and employment options for men, women, and minorities. The persuasiveness of the media can personally and often profoundly influence self-image and perspectives on work options.

Unfortunately, in spite of some positive changes in legislation and society during the past three decades, television executives have chosen to continue to portray stereotypical characterizations in most of their programming.

A summary of the research on the portrayal of minorities and females in children's TV programming shows that:

- Fewer minorities appear than in the population at large.
- Minorities appear less often in major roles.
- Proportionately, African-Americans are cast less often as either heroes *or* villains, and other minorities are cast more often as villains.
- African-Americans and other minorities are portrayed less frequently as being employed.
- Females compose only 27 percent of the human characters; when shown as employed, 50 percent of females are clerical workers, 35 percent are household workers, and only 15 percent are managerial or sales personnel.[8]
- Latinos compose only 1 percent of all characters portrayed even though they make up 9 percent of the U.S. population. Twenty-eight percent of Hispanic characters are depicted as poor compared with 24 percent of African-Americans and 18 percent of Caucasians.[9]
- African-Americans represent 17 percent of the population and account for 12 percent of all television characters.[9]

Other research reveals that:

- In commercials, women's voices rarely are used as voice-overs and men's voices often are used as authorities, even for women's products.
- In prime-time dramatic programming, men outnumber women by two or three to one and the women are younger and are cast in stereotypical roles.[10]

In an interview, Brian points out:

> As I would watch TV, I kept hoping that at Christmas time my favorite TV families would turn out to be Jewish after all. But it never failed: in December there would be a Christmas show, and maybe even mention of church. I again would feel let down. I was even different from those characters on television!

Even though television is the most powerful of the media, magazines and radio also exert a strong force in forming acceptable images of self. Magazines such as *American Girl, Glamour,* and *Seventeen* each have circulations in the millions. Not surprisingly, a recent analysis of teen-oriented magazines still demonstrates a bias in favor of Caucasian models in advertising.[11]

A deaf woman recalls that as a child, she assumed she would die before she grew up because she had never seen a deaf adult.[12] Before the late 1980s, to see

a person with a disability portrayed realistically anywhere in the media was unusual. Children with disabilities growing up during that time had few adult role models. No wonder the woman above concluded that she would die before she reached adulthood! She and other people with disabilities certainly didn't see anyone like themselves on television, in the movies, in books, or in magazines. Because of the stigma, physical barriers, and lack of role models, people with disabilities may have faced some difficulties and negative messages as they grew up.

> When you can't go to the same movies or parties as everyone else because there's no ramp, when you can't attend after-school activities because there's no sign language interpreter, when you can't read the same books as your friends because they're not in Braille, or when no one will take the extra time to understand your speech, it can be really hard to feel good about yourself.[13]

Each person needs to view television and print media critically and identify their possible impact on self-views and self-esteem. (The exercises at the end of this chapter will help you do this.) Once aware, each person has the choice to accept or reject the content of the messages being communicated.

GENDER-ROLE SOCIALIZATION

Many women grow up hearing messages that they need to select a career that will enable them to stay home with children and that some careers, such as those related to math and science, are not appropriate for women. Other women decide to have children early in life, before they decide to attend college or to complete their education.

Astin's study of college drop-outs points to gender-stereotyped differences as the reason some women did not complete college when they started 20 years earlier. Marriage, pregnancy, or other family responsibilities were the reasons women gave more often than any others for dropping out. Women were three times more likely than men to cite marriage as a reason for dropping out of college—supporting a number of earlier studies. In Astin's study, women consistently were more likely to state that having children was a reason for leaving college.[14] Clearly, women's traditional roles as nurturers and caregivers have made them less likely to complete college. These messages and choices often have resulted in women selecting careers associated with zero or lower compensation, such as homemaking, teaching, secretarial work, and other service-oriented professions. A lower salary level denotes lower status, and lower status can result in low self-esteem, self-blame, and isolation.

Many men, too, have felt the negative consequences of trying to live up to the gender-typed, achievement-oriented roles they are expected to play. These effects include stress symptoms and diseases, anger, violence, and substance abuse.[15] Ric relates:

> I'm the artistic type. I enjoy photography, design, and architecture. I really hated high school. Everyone expected the guys to be jocks and do sports. I

would rather have gone to galleries. It was hard to be cool and pretend to care about football and basketball like the rest of the guys. I just didn't care—and I still don't. All the peer pressure made it hard for me to be myself; I had a lot of self-doubt and it's still there. I'm just now starting to get over it.

As this commentary illustrates, personality style further complicates gender standards and expectations. For example, what if you are a female whose natural style is to take charge and be in control? How much positive feedback and reward do you consistently receive for that behavior, as a female? Or, like Ric, are you a male whose tendencies are to be more artistic, feeling-oriented, and nurturing?

Often, personality styles that don't "fit" societal expectations of gender roles are not validated, resulting in lower self-esteem. Ric's process of enhancing his self-esteem is discussed in Chapter Eight.

A 1992 *New Woman* survey[16] sampled 1,202 men and women in the United States regarding sources and attitudes of self-esteem. The keys to self-esteem for men and women did differ. Men chose earning $30,000 or more, power at home, satisfaction with friendships, and supervision of at least one person at work as the most significant factors contributing to their self-esteem. *Three of these four factors relate to work and power as ways to feel good about oneself.* Women, on the other hand, rated satisfaction with body and looks, simply having paid work, perceiving work as a career, and rating oneself as very attractive as their top four sources of self-esteem. Even though the focus on physical attractiveness is an important source of self-esteem for women, they equally value work.

Today, many women are returning to school to catch up educationally and economically. They are proving that they can and do succeed and excel in college. In fact, at some institutions, female graduates far outnumber their male counterparts. For women, the professional identity and higher earning power that come from completing a college degree inevitably contribute to higher self-esteem.

Similarly, many men who once selected careers based on societal messages about "appropriate" careers for males or expectations of being the main breadwinner in a family are also returning to school. For these men, the chance to pursue a career more in line with their personality helps build their self-esteem.

EXERCISE **5.1**

MESSAGES FROM THE OUTER CIRCLE

PURPOSES

To discover if your family and neighborhood provided self-esteem tools to buffer you from outer world negative events or messages.

To begin to develop and appreciate the cultural and ethnic uniqueness of yourself and others to enhance self-esteem.

INSTRUCTIONS

Complete the following questions:

1. At any time during your schooling, have you perceived yourself as different—in race, religion, physical abilities and attributes, or family life—from your classmates? Think about your answers in terms of elementary school, junior high (or middle) school, high school, and college.

2. How did your family equip you to handle these differences? Did they discuss feelings, pride in your heritage, your unique strengths, how to handle conflict?

3. What would you like to say to people who may have treated you rudely or cruelly because you were different from them?

4. What are at least three things you like and appreciate about your race, culture, abilities, or differentness?

REFLECTIONS

In small groups of three or four, exchange your responses to questions 1 and 4. Discuss your reactions in light of Smith's theory.

Optional activity: In the class, role-play alternative responses to past prejudicial encounters.

EXERCISE **5.2**

LANGUAGE AND EXPECTATIONS

PURPOSES

To raise awareness of internalized roles and expectations of people who are different from us.

To examine how language can produce value judgments about color.

To challenge expectations and discuss their impact on self-esteem.

INSTRUCTIONS

With the instructor or a volunteer serving as the recorder by writing responses on the board, complete, as a class, the following sentences and lists. Do not censor yourself or judge others' responses.

1. Women should . . .
2. Men should . . .
3. Men always . . .
4. Women always . . .
5. People who are different are . . .
6. List all the words and expressions you can think of containing the word "white" (example: "white as snow").*
7. List all the words and expressions you can think of containing the word "black" (example: "blackball").*
8. On both lists, put a (+) in front of the words that have positive connotations and a (–) in front of words that have negative connotations.

REFLECTIONS

What effects have the role expectations of women or men in our society had on your self-image? On how you treat others? What might be the effects of language on the self-image of Anglo-Americans, or Caucasians? African-Americans, or Blacks? (Especially if, in U. S. culture, white represents "good" and black, "bad.") Add other color words as you see fit.

* The section of this exercise on color word associations has been adapted from Judy Katz, *White Awareness* (Norman: University of Oklahoma Press, 1978).

EXERCISE

MEDIA AWARENESS

Information about how we compare with others comes from a variety of sources. Images flashed by television, motion pictures, and popular magazines provide "standards" against which we subconsciously compare our lives. Many of us lived our formative years before any of the changes demanded by civil rights movements took place in the media. These media still depict few role models for women and minorities. The images were, and still can be, internalized, impacting our self-esteem.

TELEVISION

PURPOSES

To examine television characters and their impact on your self-esteem as a child.

To analyze messages and stereotypes television communicates.

To discuss the impact these messages can have on children's self-esteem.

INSTRUCTIONS

1. Answer individually or in small-group discussion: What were your favorite television shows when you were growing up? Describe the main characters. What personality traits did they display? What physical traits did they have that you admired? How was their home and family life different from or the same as your situation? How do you think these shows impacted your self-image and self-esteem as a child?

2. In groups of two or three, videotape or watch two hours *total* of *one* of the following. The two hours do not have to be consecutive, but you should watch the same station during similar time periods. Choose from: Saturday morning children's television, children's public television, prime time weekday television, MTV, Lifetime, Nickelodeon, ESPN, soap operas, or other kinds of programming.

 For your time slot, complete the data on the following page.

Station watched:

Time slot(s):

Show(s) watched:

Number of women:
 Caucasian:
 Non-Caucasian:
 Middle-aged/older:

Careers/jobs held:

Characteristics of women depicted (bright, passive, mean, etc.):

How did women seem to be treated by other characters in the show?

Types of products women sold in commercials:

Tally the same information for:

Men

Male children

Female children

People with disabilities

REFLECTIONS

In class, report on and discuss the results. How balanced was the portrayal of each of the groups you tallied? How did you feel when you completed your viewing and tallying? Speculate about what messages may have been sent to children or teenagers who watched those two hours. What actions can you take individually or as a group to communicate any satisfaction or dissatisfaction?

MAGAZINES

Magazines depict individuals who conform to the culturally accepted norm of beauty. When we look at our friends and neighbors, however, few of them look like the models we see in magazines. (Naturally, we may be able to find exceptions.)

PURPOSES

To identify cultural standards of beauty.
To create your own definition and image of beauty.

INSTRUCTIONS

1. As a class, bring in as many fashion magazines for women, men, and teens as you can. You will need large pieces of newsprint, scissors, markers or crayons, and tape or glue.

2. Create a collage, individually or in a small group, that contrasts nontraditional images of beauty and attractiveness with traditional images. Use pictures, words, and drawings. You can even include pictures of yourself or your family. Focus solely on men, women, children, old, or young, or all aspects and images of beauty. There are no right or wrong collages. Be as creative as possible. Relate your feelings and thoughts as you create the collage.

3. Tape the collages around the room.

REFLECTIONS

Present and discuss the collages, the images portrayed, and your feelings about the pictures, words, and images.

EXERCISE **5.4**

CASE STUDY: ESTEVAN

PURPOSES

To highlight the impact minority status might have on higher education success. To identify strategies for school success.

INSTRUCTIONS

Read the following case study and discuss the questions in the "Reflections" section.

Estevan grew up in the southwest United States. His neighborhood was predominantly Hispanic. The first language he learned was Spanish, and it continued to be the main language spoken in his home. Estevan's family is large, demonstrative, supportive, and positive.

In school, 95 percent of his schoolmates were also Hispanic. He attended a private Catholic high school on a scholarship.

Several years after he graduated from high school, Estevan received a scholarship from his employer to attend a nearby university. His family was proud and elated. For the first time in his life, however, he felt self-conscious about the dark brown color of his skin. He sat in lecture halls of 200 students and noticed that he was the only obviously Hispanic student in the room. He felt different and consequently was shy about raising his hand and contributing in class.

After one semester, Estevan was on the verge of dropping out and giving up his scholarship. His self-confidence and belief in himself as an individual of achievement were low.

REFLECTIONS

In small groups or as a class, discuss:

- What advice you would give Estevan that might motivate him to stay in school.
- What you think Estevan needs to do to improve his chances for success as a student.
- Estevan's case in relation to Smith's theory.

SUMMARY

The media, particularly television, can impact a person's self-esteem. This is especially true for children because they spend so much time watching TV. Women, minorities, and nontraditional males are portrayed inaccurately and in disproportionate numbers in most TV programming. Sex-role expectations and personality style can influence each individual's treatment by others, as well as his or her self-view. The influence of stereotyping is also noted in higher education settings.

The immediate family (circle 2) can act as a buffer against negative messages of the neighborhood and the outer world. Smith's model describes this buffer. Feelings of belongingness with people similar to the self can enhance self-esteem. The influence of messages from the fourth circle often is overlooked when self-esteem is discussed. Through this chapter and the exercises, readers may discover the importance of these larger environmental factors in their own self-esteem and throughout life.

NOTES

1. Elsie Smith, "Ethnic Identity Development: Toward the Development of a Theory Within the Context of Majority/Minority Status," *Journal of Counseling and Development* 70 (Sept./Oct. 1991): 184.
2. Smith.
3. Alexander Astin, *Preventing Students from Dropping Out* (San Francisco: Jossey-Bass, 1975).
4. William E. Cross, "A Two-Factor Theory of Black Identity: Implications for the Study of Identity Development in Minority Children," in *Children's Ethnic Socialization*, Jean S. Phinney and Mary Jane Rotheram, Editors (Newbury Park, CA: Sage, 1987), pp. 129–130.
5. Doreen Rosenthal, "Ethnic Identity Development in Adolescents," in *Children's Ethnic Socialization*, p. 172.
6. Judy H. Katz, *White Awareness* (Norman: University of Oklahoma Press, 1978), p. 12.
7. Nancy Signorielli, *A Sourcebook on Children and Television* (New York: Greenwood Press, 1991), p. 170.
8. F. Earle Barcus, *Images of Life in Children's Television* (New York: Praeger Scientific, 1983), pp. 113–114.
9. "Hispanics Rarely on Prime Time TV, Study Finds," *Arizona Daily Star,* Sept. 7, 1994.
10. Signorielli, p. 72.
11. Ellis Evans et al., "Content Analysis of Contemporary Teen Magazines for Adolescent Females," *Youth and Society* 23 (Sept. 1991): 99–120.
12. Ann Cupolo Carrillo, Katherine Corbett, and Victoria Lewis, *No More Stares* (Berkeley, CA: Disability Rights Education and Defense Fund, 1982), p. 7.
13. Carrillo, et al., p. 11.
14. Astin, pp. 14–15.
15. Donna Davenport and John M. Yurich, "Multicultural Gender Issues," *Journal of Counseling and Development* 70 (Sept./Oct. 1991): 64.
16. Carin Rubenstein, "*New Woman*'s Report on Self-Esteem," *New Woman*, Oct. 1992, p. 60.

Symptoms of Low Self-Esteem and Strategies for Improvement

In Part I, we discussed the sources of self-esteem. In Part II, we discuss symptoms of low self-esteem and give strategies for improvement. Chapter Six discusses the *symptoms* of low self-esteem—how our view of self plays out in actual behaviors and, more important, how these behaviors can affect a return to school. A student with low self-esteem is vulnerable to a variety of fears and behaviors that hamper achievement in the educational setting. Identifying the symptoms of low self-esteem sets the stage for changing and for achieving in school and in life.

We then move to the action phase, strategies for improvement. Chapters Seven and Eight contain the key strategies for increasing self-esteem. Chapter Seven presents practical strategies for change that can be applied to any number of life situations. Chapter Eight contains strategies specifically related to your return to school. All of these strategies have proven to be effective in our classes, for students of all ages and backgrounds. Many other strategies are included in the publications listed in the bibliography at the end of this book.

We all have our individual strengths and weaknesses because we are all different. Your task is to pick the strategies that apply to you for raising your self-esteem and bettering your chances for success in school.

Symptoms of Low Self-Esteem

- How can we recognize self-esteem levels?
- What behaviors are indicators of low and high self-esteem?
- How can we use this information to ensure success in school?

How can levels of self-esteem be recognized? We cannot see self-esteem, but we certainly can see how it affects behavior. Someone with low self-esteem often thinks, feels, and behaves differently than someone with high self-esteem.

Think of a person who, in your opinion, has problems with self-esteem. What do you hear and see that gives you clues about this person's self-view?

EXERCISE 6.1

SPOTTING LOW AND HIGH SELF-ESTEEM

PURPOSE

To identify behaviors that indicate low and high self-esteem.

Anita constantly lets people take advantage of her. Last week she ended up taking care of a neighbor's child even though she had to rearrange her own study plans to do so. She complained about not having enough time to study for her upcoming exam but never said a word to her neighbor.

Sam is in a job that he is dissatisfied with. In his lunch hour, he calls people to spread the word that he is job-seeking. He is exploring a return to school, and after work he takes 20 minutes to relieve stress by walking around his neighborhood.

INSTRUCTIONS

List three behaviors characteristic of Anita or someone you know who has low self-esteem. What are the feelings you could infer from these behaviors? Do the same exercise again, listing Sam's characteristics and thinking of a person you view as having high self-esteem. After you have come up with your lists, brainstorm and exchange your lists of characteristics. In the case of Anita, for example, we might list "allowing people to take advantage of her" as a symptom of low self-esteem. We might guess her possible thoughts and feelings as "wants people to like her" and "thinks the only way they will like her is if she constantly does what other people want." Our goal is not to judge Anita or others for their behavior but, instead, to practice identifying symptoms of low and high self-esteem.

In Sam's case, we can list "taking action and not staying stuck," "managing his stress," and "reaching out" as signs of high self-esteem and empowering behavior.

PERSON WITH LOW SELF-ESTEEM

Behavior #1:

Possible thoughts and feelings:

Behavior #2:

Possible thoughts and feelings:

Behavior #3:

Possible thoughts and feelings:

PERSON WITH HIGH SELF-ESTEEM

Behavior #1:

Possible thoughts and feelings:

Behavior #2:

Possible thoughts and feelings:

Behavior #3:

Possible thoughts and feelings:

REFLECTIONS

What differences can you see between people with high and low self-esteem?

THE CASES OF JORGE AND MIA

Jorge frequently tells people he doesn't have a "head for math." When he took an algebra class as part of his program requirement, he had severe anxiety and did poorly on the first two exams. His self-definition as not capable at math convinced him this was a subject he could not master. He therefore did not seek help from the math tutors or from his academic counselor. Instead, he believed he would have to change to a major that did not require math.

Even though Mia has all the coursework she needs to transfer from the community college to the university as an engineering major, she continues to put off the application process. She has heard scary stories about the university being much bigger and more impersonal. Afraid that she will not be able to meet the stiffer demands of upper-division coursework, Mia lets her fears win out over her desire to transfer, and she creates one excuse after another not to leave her community college.

Jorge and Mia are exhibiting symptoms of low self-esteem. Because they do not believe in themselves, they slip back into old behavior patterns of fear and insecurity that keep them from achieving their goals. Low self-esteem leads to behaviors that clearly tell the world what we think of ourselves. We'll continue Jorge and Mia's stories in Chapter Seven, but for now, let's learn to identify the symptoms of self-esteem so that you can set goals for yourself.

From your everyday observations you probably can list some of the symptoms of low self-esteem we discuss here. People with low self-esteem frequently use the word "not" as part of their self-definition. They see themselves as "not capable," "not attractive," "not smart," "not lovable." They are harder on themselves than anyone else would dream of being. Because thoughts influence actions, people act out these beliefs.

People with low self-esteem are highly self-critical. They take the smallest error very much to heart and mentally replay it many times. Common refrains running through the mind of someone with low self-esteem are: "I should have known better," "Only a fool would do a thing like that," "I always mess up." In their book *Self-Esteem*, Matthew McKay and Patrick Fanning call this "listening to the critic."[1] Harmfully high stress levels, anxiety attacks, phobias, shame, guilt, and compulsions are extreme forms of this self-critical behavior.

As discussed in Chapter One, lack of self-esteem is linked to low risk-taking behavior. The person may have an abnormal fear of failure or its twin, fear of success. For a person with low self-esteem, the world is a scary place, and a way to remain safe and to preserve the self-esteem he or she does have is to avoid taking risks. In a school setting, the low risk-taker may select only the easy classes or majors and, like Mia in the example, might have difficulty moving on when the time is right.

Closely related symptoms are perfectionism and procrastination. The perfectionist has such unrealistically high standards that nothing is ever good enough or ever really completed. The procrastinator never gets started or puts things off until doing an adequate job is impossible. The perfectionist and the procrastinator both avoid risks and thus stay safe. A drawback is that without

risks, a person cannot grow and prove competence, and in a school setting, growth and competence are necessary.

Low self-esteem also is revealed by being overly concerned with the outward signs of social status and how one appears to others. This "other-esteem" focuses on things such as personal appearance, how much money one makes, the kind of car one drives, the performance of one's spouse and children, clubs one belongs to, and similar things. A person with low self-esteem often substitutes these qualities for genuine self-esteem.

Another symptom of low self-esteem is a lack of self-care. Taking care of everyone's needs ahead of one's own has been termed *co-dependency* and can be a symptom of low self-esteem. People with low self-esteem hesitate to ask for help from family members or counselors when needed. They may claim they can't find time to study because it conflicts with family needs. Extreme symptoms include overeating, substance abuse, and hurtful personal relationships.

Sometimes symptoms of low self-esteem are hard to detect because they are mistaken for an overinflated ego. The student who verbally dominates every class discussion and can't tolerate disagreement could be covering up feelings of not being okay. Aggressive, pushy, bossy, or boastful behaviors could well indicate low self-esteem. The blustery behavior disguises it.

EXERCISE **6.2**

SELF-EXAMINATION OF SELF-ESTEEM

PURPOSES

To understand yourself and your strengths better.
To identify areas in which you would like to raise your self-esteem.

INSTRUCTIONS

For each pair of statements, check the one that is *most* like you the majority of the time.

1. __ a. Constantly put myself down, am highly self-critical

 __ b. Generally I feel pretty positive about myself

2. __ a. Have difficulty accepting compliments

 __ b. Can smile and just say "Thank you" when someone gives me a compliment

3. __ a. Often feel victimized by others

 __ b. Usually can say no when I want/need to

4. __ a. Feel lonely, even when with other people

 __ b. Loneliness usually doesn't apply to me

5. __ a. Feel different from other people

 __ b. Feel I'm pretty much on the same wavelength as others

6. __ a. Feel empty, like having a hole inside

 __ b. Feel there are many positive things in my life at the present time

7. __ a. Often feel depressed

 __ b. Seldom feel depressed

8. __ a. Feel shame and guilt

 __ b. Shame and guilt are really not a big part of my life

9. __ a. Don't believe in my ability to achieve, have severe self-doubts

 __ b. Generally, I'm confident in my ability to achieve

10. __ a. Fear new situations

 __ b. Am stimulated and excited by new situations

11. __ a. Fear failure

 __ b. Seldom worry about failure

12. __ a. Fear success

 __ b. Have experienced reasonable successes in my life and expect that to continue

13. __ a. Fear being out of control

 __ b. Believe I have control over myself and my life much of the time

14. __ a. Have a high need to please others

 __ b. Can balance pleasing others with taking care of myself

15. __ a. Am highly anxious in school setting (test anxiety, panic attacks)

 __ b. Can take the school setting in stride, usually not overly anxious

16. __ a. Have trouble managing time demands, feel stress, excessive worry

 __ b. Time management is a skill I've mastered, so I keep worry under control

17. __ a. Put things off and get in trouble for it

 __ b. Keep on top of my tasks and seldom put things off

18. __ a. Am extremely vulnerable to others' criticism, real or imagined

 __ b. Others' criticism usually does not bother me; I can utilize what is constructive and let the rest go

19. __ a. Won't state opinions or feelings for fear of what others will think

 __ b. Am comfortable stating my opinions; if others disagree, so what?

20. __ a. Keep others at a distance emotionally

 __ b. Have good, close relationships with others

21. __ a. Have self-destructive behaviors (substance abuse, abusive relationships, no interest in or motivation for self-care)

 __ b. Generally am "my own best friend," take care of myself physically and emotionally

22. __ a. "Numb out" to relax (watch TV, eat, sleep, fantasize)

 __ b. Can relax when I need to, but it's under my control

23. __ a. Have negative attitudes, use negative self-talk

 __ b. Usually am positive in my attitudes and self-talk

24. __ a. Have difficulty setting and sticking to goals

 __ b. Know what my goals are and have a plan for meeting them

25. __ a. Have trouble asking for what I want and need

 __ b. Am good at asking for my needs and wants

26. __a. Am often angry and aggressive

 __b. Can express my anger in an appropriate manner and see myself as assertive not aggressive

27. __ a. Make unrealistic self-assessments, either too low or too high

 __ b. Generally on target with my self-assessments, have an accurate self-view

28. __a. Think in black and white, have no tolerance for ambiguity

 __b. Pretty flexible in my thinking, usually can see more than one side of an issue, don't need "instant answers"

29. __a. Can't tolerate imperfection

 __b. Perfection is nice, but usually it's not my top priority

30. __ a. Am unable to establish a support system of caring friends and relatives

 __ b. My friends and family are there for me

31. __ a. Don't feel connected to family or community

 __ b. Have strong connections to my family and community

32. __ a. Lack pride in or have little information about my ethnic, cultural, or gender group

 __ b. Know where my roots are, feel good about who I am

REFLECTIONS

Count the number of a's and b's you checked. The a's are areas in which your self-esteem probably needs some strengthening. Now go back over your list of a's and pick two to four areas you see as most vital to your success in school. Think about them and come up with solutions that will be helpful to you.

Example: Jenny identified self-criticism (#1), people pleasing (#14), putting things off (#17), and trouble asking for help (#25) as her four areas to target. She wrote:

1. Self-criticism: I always talk myself down, call myself "dummy," "loser," and other bad names. It makes me feel like not even trying.
2. People pleasing: I get so busy making others happy that no time is left for me.
3. Putting things off: I intended to go to school last semester, but I kept putting off getting my application in until I missed the deadline. I guess I was really scared they wouldn't accept me.
4. Trouble asking for help: I know I'll need help getting child care when I return to school, and I can afford to pay a sitter only so much. I have a hard time asking my mother and my best friend Delores to help me out with the rest.

Now look at the b's you checked. These are the strengths you have and can use to help you succeed.

Example: Leroy looked over his list and saw he had checked confidence in his ability to achieve (#7), readiness to take school in stride without undue anxiety (#15), generally positive attitudes (#23), and pride in his roots and culture (#32). He wrote:

> I have some strengths as I enter into this school experience. I feel pretty good about where I am heading and am willing to work on the areas that need improvement.

MAGGIE'S STORY REVISITED

Remember Maggie from Chapter One? Let's see how she dealt with her self-esteem issues to ensure her success in school.

Maggie's plummeting self-esteem almost cost her the college career she had worked so hard to pursue. Her low point came when a teacher returned an essay that Maggie had thrown together at the last minute. Because of her inability to balance work tasks and school life, Maggie had procrastinated, as usual. She knew it wasn't her best work but she had been able to coast before. Not this time. The grade of C- was bad enough, but what really got her attention was the instructor's bright red notation at the end of the essay:

> Maggie: This paper does not demonstrate quality work. Based on what I have seen in class, I expected better. See me!!

Gulping back tears of frustration and anger, she stuffed the paper in her notebook and headed for the campus advising office to withdraw from school. "I never should have tried this. I simply am not college material," she told herself. Fortunately, the advisor with whom Maggie consulted was wise enough to realize that Maggie didn't need help in withdrawing from school. She needed help in coping with self-esteem issues brought up by all the changes she was experiencing. He referred Maggie to a counselor who helped her assess what was really happening.

Together, Maggie and her college counselor outlined a plan of action to combat her stress and self-doubt. The counselor showed Maggie how to plan a schedule that would help her balance all of the tasks she needed to do. Procrastination would always be a temptation for her, but Maggie now could see that behavior hurt her chances for success. Most important, she had made a connection. Maggie could come back to see her counselor when she felt discouraged or needed a boost in confidence.

As Maggie learned how the role that her past school fears played in her current low self-esteem, she began to see that she could make new choices. Her performance in school has greatly improved and she is on her way to completing a legal assistant program. Eager to keep others from experiencing the rocky start she had, she volunteers in the college peer counseling program, helping new students to make the transition to school.

A WORD OF ENCOURAGEMENT

At this point, you may be experiencing some discomfort as you identify your individual symptoms of low self-esteem. You may even feel a bit discouraged as you look at the changes you want to make. These feelings are a good sign because they say that you are ready to do some things differently.

Know that any change, good or bad, brings some stress. It also brings opportunity for growth. Think back to past changes you made in your life and you will probably remember similar feelings of stress, discomfort, and possibly even fear. Now recall how you met those challenges. What strengths, skills, and

support systems did you draw on? Allow yourself to think about the positive qualities you have and tell yourself that you can work through any temporary discomfort. The result—enhanced self-esteem—will be worth the struggle.

SUMMARY

The feelings and behaviors revealing low self-esteem are varied and complex. Some symptoms, such as shame, are subtle. Others, such as negative self-talk, are clear and unmistakable. Identifying the areas critical to your success will help you choose practical strategies for change from Chapters Seven and Eight.

As you review your symptoms of low self-esteem identified in Exercise 6.2, you will need to narrow your goals and start with a few symptoms at a time. As you learned from analyzing your sources of self-esteem, your feelings about yourself did not develop overnight. In the same way, revising your feelings and behaviors also will take time and practice.

Nobody can *give* you positive self-esteem. You must earn it through self-examination, hard work, and willingness to take risks! Success leads to more success, so start small and allow yourself to build on each change. Raising your self-esteem is a choice you can make. You are now ready to apply what you learned so far as you move on to the strategies.

NOTES

1. Matthew McKay and Patrick Fanning, *Self-Esteem* (Oakland, CA: New Harbinger Publications, 1987), p. 15.

Strategies for Developing Self-Esteem

- What are some barriers to risking, and how can they be overcome?
- What is the essence of the ABC model of esteem thinking?
- What is self-talk, and how can it be used to advantage?
- What are some faulty thinking patterns, and how can they be reversed?
- How can a person become more assertive?
- What are some measures to reduce stress?

Self-esteem can be raised through certain strategies. The ones presented in this chapter can be applied in many life situations. They include risk-taking, removing internal barriers, becoming more assertive, and reducing stress. Within these broad strategies are specific methods to achieve results.

STRATEGY ONE: RISKING

Self-esteem strategies share a common element that is necessary for effectiveness: risking. *Risking means the willingness to try a new behavior or thinking style.* To risk implies "to put oneself out there." It means effort and work. Most important, risking significantly improves your chances for higher self-esteem. The risk–esteem connection is crucial. The more willing you are to try new things, the better are your chances for success. The more successes you chalk up, the stronger the foundation for self-esteem becomes. As we have indicated, enhancing your self-esteem greatly depends on competence and success in the areas of life that are important to you.

The obvious question is: if risking is essential to the development of self-esteem, why not just do it? The answer lies in a four-letter word: fear. As highlighted in the circle model, critical messages and experiences at home, at school, and in the world at large may stifle risk-taking. Fear of being "shot down" stifles initiative. Therefore most people decide, based on the evidence,

to incorporate messages like "don't even try," "be seen and not heard," and "it's not worth it" into their lifescripts. This self-talk leads to inaction, stagnation, and a lack of successes on which to build self-esteem.

Barriers to Risk-Taking

A person may avoid risk-taking for the following reasons, among others:

- *Perfectionism*: Attempting to get everything just right all of the time or spending so much time perfecting a project that it often doesn't get done; the risk of imperfection is too great.
- *Maintaining status quo:* People with low self-esteem want to conserve and protect what self-esteem they do possess. Risking means if they fail, they may lose even more self-esteem. The status quo is known and safe.
- *Failure*: Having risked and failed, then beating up on oneself for "blowing it," learning not to try; it hurts too much.
- *Catastrophizing and awfulizing*: Mentally determining every horrible consequence of action and the negative and critical reactions of others and becoming immobilized by those horrible thoughts.
- *Ignorance:* Not knowing how to develop risk-taking behaviors.

EXERCISE **7.1**

DISSECTING YOUR FEARS

To fear is normal. In fact, fears often arise for good reasons: emotional and physical survival. Irrational and paralyzing fear is a warning signal that more than a normal protective mechanism is operating.

PURPOSES

To isolate and examine sources of fearful feelings.

To specify causes and costs of fears, and solutions for overcoming them.

INSTRUCTIONS

Take a moment to dissect an example of fear in your life today. Answer the following questions:

1. Describe an action you are afraid to take. Do not judge yourself for having this fear. Be honest. (Example: "I'm afraid to ask my supervisor at work for time off to take a class.")
2. What are you afraid of in yourself? About the other person or people? (Example: "I'm afraid of how embarrassed and tentative I might sound talking to my supervisor. I'm also afraid she'll think I'm not dedicated if I leave work early three days a week.")

3. What is the worst that could happen if you take this action? (Example: "She'll say no and treat me shabbily. I'll be miserable at work.")

4. What are the chances of that happening? (Example: "About 5 percent.")

5. What is the best that could happen? (Example: "She'll say *yes!* I'll further my education!")

6. What are the chances of that happening? (Example: "About 75 percent.")

7. What is the reward for your remaining fearful? (Example: "I don't rock the boat. She'll think I'm dedicated.")

8. What is the cost of remaining fearful? (Example: "I don't further my education. I stay stuck. I'll probably kick myself later. I don't want to stay in this job forever!")

9. What are three ways to handle this fear? (Example: "I'll rehearse with my friend before I actually talk to my supervisor. I'll think of ways in which my going to school will benefit my present employer. I'll talk to my friend so I don't stew about it all day.")

10. Share your answers to questions 1 and 9 with two or three trusted classmates or friends. Brainstorm three more practical ways to overcome fears that your partners can try. Caution: no "Yes, buts. . . ."

REFLECTIONS

How does analyzing and dissecting fear demystify the actual sources of fear? Do you feel less "stuck"? Does talking with others generate more solutions?

Mia, the student discussed in Chapter Six who let her fears keep her from transferring to the university, signed up for a self-esteem class at her community college campus. Although her primary goal in taking the class was to have additional credits for her financial aid, she found herself relating to much of what she heard other students share. As a result of the class discussions, she began to see how her reluctance to transfer reflected low self-esteem rather than the reality of her academic situation. She made an appointment with her college counselor, and together, they dissected her fears by looking at best- and worst-case scenarios. Mia realized that even if her worst fear—failing at the university—came true, she could cope with it. In fact, she decided it would be less painful than never knowing whether she could succeed. She made arrangements to transfer, was accepted, and reports that, although her first semester has been an adjustment, it doesn't come close to being as bad as she feared. She is convinced that she can make it and now sees that bachelor's degree within her reach.

Keep in mind that the basis for improving self-esteem lies in making small changes and taking risks. The rewards are positive feelings ranging from pleasure to exhilaration for accomplishments. Then we can *credit ourselves for*

trying, whether the result of risking is success, disappointment, or something in between. As long as risking is undertaken with wisdom, to make life more satisfying and enhance success, it cannot damage the risker or other people. When you begin to take more risks, others may not like the changes and growth that inevitably will happen for you. If those changes alter the unwritten contract covering how others want you to be, they may not like the "new you." At that point, both of you must grow together and adjust, or you may need to move on independently.

Let's start by creating a brief inventory of risks you've taken in your life. Each person's list is individual. What is risky for one person may be unchallenging for another. Your risks are your own.

EXERCISE 7.2

RISK INVENTORY

PURPOSES

To reveal your lifetime skills in risk-taking.
To build confidence in your ability to take risks.

INSTRUCTIONS

Think back and recall risks you are proud you took, regardless of the results. The risks might have been in school, with friends, family, or work, or in any other area of life. Share the results of your proudest risks with a partner in class. Relating this to your age may stimulate your thinking.

Example: Ages 20–29: Rachel broke up with a boyfriend whom she had outgrown. It took her a lot of courage to let go of the relationship she had had since age 17. She learned to be more self-reliant as a result.

Ages 5–12:

Ages 13–19:

Ages 20–29:

Ages 30–39:

Ages 40–49:

Ages 50–59:

Ages 60–69:

REFLECTIONS

For each of these risks, what were the outcomes? What did you learn from taking each risk? Use your answers to remind yourself of your own best self. Post them as an inventory of your risk-taking abilities and successes that came from trying new behaviors.

▬ ▬ ▬ ▬ ▬ ▬ ▬ ▬ ▬ ▬ ▬ ▬ ▬ ▬ ▬ ▬

Personal goals help build self-esteem. As you set goals in Exercise 7.3, remember that each person perceives risky behavior differently. What is risky for one person may be easy for the next. For example, Amelia finds it risky to ask for opinions, whereas Ted is afraid to risk changing jobs. Ted asks everyone's opinions, and Amelia often changes jobs. The risk and reward lie in trying something new and different, stretching yourself rather than staying stuck. Taking action enhances self-esteem.

EXERCISE **7.3**

RISK-TAKING GOALS

PURPOSE

To help build your self-esteem by setting personal risk-taking goals.

INSTRUCTIONS

1. List three actions that are risky for you in the following areas: work, mate or significant other, school, children, friends, sports/hobbies. Skip areas that are not applicable and add others that may be important to you.

2. Make a commitment to take action by setting dates for accomplishing each goal. You may want to set weekly, biweekly, or monthly deadlines.

Examples: Rick's list for risk-taking at work:

1. Admitting to my supervisor (a friend) that I need more help learning the computer system. By October 1.

2. Volunteering to chair the grievance committee. By December 1.

3. Making a presentation to the management team. The supervisor has done the talking in the past. By April 30.

REFLECTIONS

How does setting specific goals, with deadlines, help you to take chances? How has goal setting been helpful to you?

STRATEGY TWO: REMOVING INTERNAL BARRIERS

Recall the concentric circle model of the origins of self-esteem. Looking back at early experiences and messages, we acknowledge that the past cannot be changed. By examining the content of our circles, however, we gain knowledge and insight leading to change and growth. A powerful tool that can change the personal impact of the past and contribute to healthy self-esteem today and the rest of your life is offered through the ABC model.

The ABC Model of Esteem Thinking

That secretary made me so angry when he acted like he didn't care.—Lucy, age 40

When my teacher told me there would be a reception for new students, I got so nervous.—Ralph, age 21

I get so bent out of shape with that sitter. She drives me crazy.—
Joan, age 30

The premise of the ABC model—based on the work of Dr. Albert Ellis, Dr. Maxie Maultsby, and others—is that thoughts, interpretations, perceptions, and underlying beliefs about the world trigger and control feelings, behaviors, and even physical responses. Put another way, self-talk (also referred to as internal dialogue or mind chatter) strongly impacts self-esteem. Most people think outside events cause them to feel certain ways:

A	B	C
events	cause	feelings

To illustrate the ABC model, let's focus on the example of Lucy: That secretary . . . acted like he didn't care." The secretary's *actions* did not cause Lucy's anger. Something important happened in between "A" and "C": *self-talk*. The ABCs of esteem thinking look like this:

A	B	C
Activating event or situation	self-talk—evaluations, images about (A)	resulting feelings and behaviors

Our internal, personal reaction and evaluation at "B" is what makes an event good or bad. The events themselves have little or no meaning attached. We create personal meaning for events.

The three most important things people think about at "B" are *themselves*, the *other person*, and the *situation*. One quickly evaluates and judges those three things. If they are perceived as positive, positive feelings emerge. If they are perceived as negative, negative feelings emerge.

Children's minds are not developed enough to make logical and rational evaluations and assessments of the world around them. As adults, our life-scripts still may contain those faulty conclusions we drew when we were children. Now, however, we can learn and utilize the power of adult reasoning regarding self, other people, and the world. Healthy, esteem-raising thoughts can be created.

We add to the example of Lucy two additional reactions to the same behavior and the widely different feelings that result from those reactions:

Person 1: Lucy

A	B	C
A secretary coolly provided answers to Lucy's questions about the transcript evaluation process at the college.	"He should at least smile. What did I do wrong? He's acting like I'm so stupid."	Anger

Person 2: Tom

A	B	C
A secretary coolly provided answers to Tom's questions about the transcript evaluation process at the college.	"He must be having a bad day. I just read that secretaries hold one of the most stressful positions in the country. I'm surprised he can function after registration."	Sympathy

Person 3: Cheryl

A	B	C
A secretary coolly provided answers to Cheryl's questions about the transcript evaluation process at the college.	"Okay, now I know where to go—the registrar."	Neutral

The Camera Check and Your Special Lenses

Maxie Maultsby created the idea of the "camera check" to analyze how objective and rational one's thinking is at point "B."[1] Using the camera check analysis, Lucy could ask herself, "If I had taken a moving picture of what happened, would the camera have verified what I am thinking?" A moving picture would not have recorded Lucy's beliefs, values, and opinions ("He should at least smile. What did I do wrong? He's acting like I'm so stupid"). Lucy added those meanings and assumptions herself. Taking the camera analogy a step further, Lucy placed a cloudy set of lenses on the camera—cloudy and distorted by her own insecurities and faulty assumptions.

Self-Talk as an Unconscious Habit

Advertisers spend millions of dollars each year creating just the right words and pictures to sell their products. They use language and visual images to create positive feelings about products and generate sales. Advertising can create a desire for products and cause us to take action. Even rocks have been sold when advertised and packaged well! Likewise, the running conversation, or self-talk, in each person's mind contains words and images that trigger specific feelings and actions. The words we use in our thoughts are as powerful as advertising. Language alone can cause feelings and actions that lower self-esteem.

Most of the time, self-talk, visual negative images, and thinking happen so quickly that we are unaware of them. At some time in our lives, though, we

consciously learn and practice our thinking and behavioral patterns, for better or worse. Sam and Grace provide two illustrations of how learning becomes a habit.

When Sam was learning to drive a stick-shift car, he recited the process in his head: "Now, first press the clutch and let it out slowly. Second, listen to the engine. Third . . ." Since Sam has mastered the stick-shift method, he drives on "automatic pilot." His foot on the clutch is synchronized with his right hand on the stick shift, seemingly without thinking. The vehicle runs smoothly. Negative and positive thought processes become as automatic as driving a stick shift. Repetition creates the "automatic pilot" reaction.

Grace has a fear of meeting new people. She becomes tense, her stomach churns, and she mumbles her greetings. This physical and behavioral response is immediate, related to Grace's negative subconscious reactions such as: "What if she doesn't like me?" "He's looking at me strangely," "I'm so afraid of new people." Although these negative thoughts produce her reactions and self-conscious feelings, Grace does not consciously identify these thoughts. If she wants to change, she must identify and examine the self-talk and the underlying beliefs about new people and herself that are related to her fear.

Correcting yourself when using faulty language may seem almost too simple as a strategy for enhancing your self-esteem. However, if we *believe the premise* that our thinking originates in our basic belief system and that feelings do follow from thoughts (the ABC model), then the impact of the different uses of language will create a shift in our day-to-day feelings, outlook, and actions.

Mistaken Beliefs

Albert Ellis[2] contends that irrational and stress-producing self-talk at point "B" is a symptom of an underlying faulty belief system consisting of one or more of these mistaken beliefs:

1. I must do well, and isn't it awful if I don't? (personal beliefs)
2. Other people must treat me well. (beliefs about others)
3. The world must be good and nonfrustrating, and how awful it is if it's not. (beliefs about the world)

To change these painful, irrational beliefs, one must systematically and consistently challenge them.

The MOANS

MOANS is an acronym for five words: must, ought, always, never, and should. These words impose unwavering, rigid demands on yourself, others, or the world—demands that are impossible to meet 100 percent of the time.

MOANS	Esteem-building alternative
"I *must* get all A's."	"I would like to get all A's."
"I *ought* to leave this job."	"I'm going to leave this job."
"Why are you *always* arguing with me?"	"We argued about this last Sunday."
"I'll *never* learn algebra."	"With a lot of work, I'll learn algebra."
"I *should* have been screened in for that scholarship interview."	"I really would like to have been screened in for that interview."

To combat negative or faulty thinking, listen for the MOANS and replace them consistently with their alternatives.

Notice that the esteem-building alternatives shown above are characterized by realistic preferences and self-responsibility versus the unrealistic, blaming rigidity of the MOANS.

Words of a Victim Mentality

Words of a victim mentality rob people of freedom by placing them in victim positions that produce feelings of powerlessness. Three examples are "made me," "can't," and "if only."

Victim:	"My mother *made me* come over for dinner, but I really needed to study."
Responsible esteem alternative:	"I *chose* to go to my mother's for dinner even though I needed to study."

Lewis Losoncy points out that the word "can't" implies "never under any conditions whatsoever can I achieve this."[3] In using the word "can't," one feels victimized and powerless and often shirks responsibility for action. Although some "can'ts" in the world are realistic ("I can't turn back time"), most "can'ts" are really "won'ts":

Victim:	"I *can't* understand this text."
Responsible esteem alternative:	"I *won't* put the study or tutoring time in to understand this text, and I'm afraid to ask the instructor."

Notice the empowering, esteem-building difference!

"If only" places blame—on oneself and others. These words are wallowing and whiny, a victim quality. The resulting feeling is self-victimization or victimization by others.

Victim 1:	*"If only* I had changed careers sooner, then school wouldn't be so hard."
Responsible esteem alternative:	"School might have been easier to juggle when I was younger, but I made the decisions about my life that were best for me at the time, based on what I knew back then."

Victim 2: *"If only* my father had been less critical, I would be happy today."

Responsible esteem alternative: "Yes, my father was critical, and it hurt. But as an adult I can learn ways to counter the effects of my negative upbringing and take responsibility, through classes and counseling, to make changes in my life."

Notice that esteem-building alternatives do *not* deny your feelings. Instead, the alternative thoughts can help you acknowledge negativity, then move on.

Other Faulty Language

Fear of risk-taking and action arises when a person predicts dire consequences. Catastrophizing and awfulizing were introduced earlier in the chapter. The person predicts *awful* feelings and results if this "catastrophe" does happen. The phrases to target are "what if" and "that would be awful" (or horrible, terrible).

Many events in the world—famine, earthquakes, hideous crimes—*are* terrible. Many results *are* uncomfortable, disappointing, inconvenient, or not what *you* had in mind. The error of faulty thinking is in seeing *everything* that goes wrong as a major catastrophe.

If I go to class and everyone sees how rusty I am in math, that will be horrible.—Larry, age 25

What if I apply for that scholarship and don't get it? I know I'll feel terrible.—Steve, age 19

What if I ask him for lunch and he says no? That's so awful!—Trina, age 39

By imagining the worst that can happen through "what if-ing," a person *does* feel terrible—as if the negative event already has happened. Catastrophizing and awfulizing actually allow *failure rehearsal*. Bad feelings occur twice: *before* a possibly disappointing result and *after* the result if it doesn't turn out the way one would like.

An alternative to "what ifs" is to practice a philosophy and thinking style called *realistic positivism*.[4] Realistic positivism enables a person to avoid catastrophizing by viewing events realistically, optimistically, and as objectively as possible. Objectivity will help you to remove the habit of completely tying your self-esteem to risky events. Rather than a nondiscriminating "look at the world through rose-colored glasses," events are viewed realistically, allowing for positive, negative, or neutral consequences. Some alternatives to the "what if/awfulizing" examples given earlier are:

When I go to school, my teacher *may* see how rusty I am in math. I *might* be embarrassed, but *I can handle that*. I'll find out how to get help.—Larry, age 25

If I apply for that scholarship and don't get it, I'll be *disappointed*. I need to plan for that *possibility* by having "plan B"—a financial and employment plan. I'll go and see financial aid tomorrow.—Steve, age 19

When I ask him to lunch, it would be nice if he'd say yes. If he says no, I *may* feel awkward, but then it's his loss! Well, I'm going to go do it!—Trina, age 39

As indicated by these examples, alternatives to faulty thinking styles include:

- Acknowledging the possibility of *positive* or *negative* or *neutral* consequences and feelings.
- Assuring yourself that you *can handle* whatever the consequences are.
- Planning *alternatives* in case disappointment does result.
- Avoiding *"what ifs"* and *awfulizing* language.
- Avoiding *mind-reading* other people's thoughts and predicting their responses.
- Reminding yourself that a disappointing or failed risk does not make you a failure *as a person*.

EXERCISE **7.4**

IDENTIFYING AND CHANGING FAULTY THINKING

PURPOSES

To identify irrational self-talk that causes negative feelings and low self-esteem. To develop rational, esteem-building alternatives to negative self-talk.

INSTRUCTIONS

1. Think of a situation during the past week that you didn't handle well because you became angry, anxious, depressed, or impatient, or felt any other strong emotion. Briefly describe it under "A—Event."
2. Under "C—Feelings," describe how you felt about the situation.
3. Under "B—Self-Talk," give the dialogue or images or self-talk that took place at the time of the incident. Include any rational or irrational dialogues.
4. Under "D—Challenges," write down challenges to irrational thinking that happened at "B." Eliminate the MOANS, what ifs, can'ts, victim language, and catastrophizing. Use the camera check to create esteem-building alternatives to your thinking at "B."

EXAMPLE:

A *Event*	B *Self-Talk*	C *Feelings*	D *Challenges*
I made a display banner for my class presentation. Lynn made one too.	She's done a better job. She's more precise, better organized. My letters aren't good enough. I never think these things through. I will never do anything extra again. What if the professor compares us? I can't stand it. This is lousy.	Inadequate, silly, not good enough.	Just because my letters are crooked doesn't mean I did a lousy job. If I don't compare my banner, it looks fine. I spent lots of time on this. If the professor com-pares us, I can handle it. I've done my best. I went the extra mile, and I'm proud.

REFLECTIONS

What internal barriers to esteem thinking did you discover? (For example, MOANS, mistaken beliefs, and so on.)

How does this exercise help you think esteem-building thoughts?

STRATEGY THREE: ASSERTIVENESS

The strong connection between risk-taking and self-esteem has been established. (See Strategy One.) Internal barriers to taking action have been identified, and new thought and language patterns have been introduced. Now we present a strategy that provides a necessary link between internal thinking/feeling and external behaviors. That strategy is assertiveness. Through assertive self-expression, self-esteem can grow.

When faced with conflict, animals have two basic choices: run or fight. Human beings also have the survival mechanism of the fight-or-flight response and, in addition, another choice: assertiveness.

Assertiveness means focusing on a thought, need, feeling, or idea and expressing it in words. For those words to be assertive, they must be honest, appropriate, respectful, and direct—represented by the acronym HARD. In college, assertiveness further means asking questions and seeking the most from the educational process. Expanding on the HARD framework:

1. *Honest* means saying how one actually feels. For example, many people express positive feelings when they really feel neutral or even negative.

Others stifle their feelings and expose nothing. Families may not have modeled honest expression (or any expression) of feelings. They may have ignored their children's feelings because they felt uncomfortable with expressing feelings. Socialization (the third and fourth circles) also teaches how to stifle honest feelings through messages such as "don't rock the boat," "keep smiling," "wait and see how everyone else reacts." To practice assertiveness, one has to listen to and focus on feelings.

2. *Appropriate* relates to the environment: *where* one is assertive, *when* one is assertive, and with *whom* one is assertive. Appropriateness implies social acceptability. For example, an assertive supervisor would not discipline an employee in front of the employee's peers. The supervisor would do this in a private office. You may not want to tell your elderly grandfather you dislike his new tie; 100 percent honesty probably is inappropriate in that situation.

3. *Respectful* has two aspects: self-respect and respect for others. Individuals show self-respect by taking care of themselves assertively; they do not allow others to discount or exploit them, and they express their positive *and* negative feelings. They respect others by avoiding name-calling, blaming, embarrassing people, and directing other hurtful communication at others.

4. *Direct* is best understood by giving some examples of its opposite—*indirect* communication:

 - John drops hints to Elaine that he is angry about her being late all the time. He pouts and slams doors. He never says, "I'm angry because you've been so late for all our study sessions."

 - Carol keeps attending her astronomy class, complains to others about how difficult it is, and doesn't request academic help directly from a tutor or professor.

 - Manny talks and laughs with Jan after work, teases about how hungry he is, but doesn't say, "Hey, would you like to go get a bite to eat?"

Assumptions About Assertiveness

Underlying the concept of assertiveness are four assumptions about assertive behavior:

1. *People cannot read minds.* If you are uncomfortable, say so. If you feel positive, express it. If you don't understand something, ask. You do not have the power to read others' minds, and others cannot read your mind.

2. *The goal of assertiveness is communication, not winning.* By practicing assertiveness, you take responsibility for yourself in any given situation. Although you may repeat assertions, this is not a tool to try to make people behave a certain way. By communicating, individuals are empowered by having done all they could do. You may not always get what you want or produce the best results, but self-esteem is built by trying and making your feelings and preferences known.

3. *People can control only their own behavior. They can influence others but not control them.* Expressing needs, thoughts, and ideas increases the chance of negotiating change. If you make your feelings known, many people will be influenced by what you say. In the end, though, people will decide for themselves how to behave or feel. *Assertiveness is not the same as aggressive power plays.*

4. *People do not have to be assertive 100 percent of the time with 100 percent of the people.* Once people learn to be assertive they can choose not to be assertive. Ask yourself: How will I feel in three (or five or 20) days if I don't speak up? Is this person or situation worth it? Should I detach and let go? The choice not to be assertive, however, must not be an *excuse* to stifle feelings continually because "it's not worth it."

The Link Between Assertiveness and Self-Esteem

Let's take a closer look at some connections between assertiveness and self-esteem.

1. *By expressing positive and negative feelings, asking questions, and taking risks to enhance your life, you validate who you are.* You are saying, in effect, "This is who I am, this is how I feel, this is what I need to know in school (or elsewhere)." Taking care of your own needs and wants is self-esteem-building, "I'm worth it" behavior.

2. *Assertiveness earns self-respect.* Self-esteem is more likely to develop by minimizing victimlike behavior and maximizing self-control.

3. *Assertiveness earns the respect of others.* By practicing assertiveness, you help others learn that feelings, limits, and willingness to listen are important personal values. Through your assertion, others learn how you expect to be treated. You are less likely to be perceived as a doormat, too shy, or even uncaring.

4. *Assertiveness strengthens your risk-taking behavior.* Your self-esteem improves as you continue to grow and change.

Overcoming Barriers to Assertive Behavior

The most powerful barriers to assertiveness are internal. They include negative self-talk, catastrophic thinking, and fear of taking risks. Another major barrier to assertiveness is *guilt.* Cultural messages such as "peace at any price," "don't rock the boat," and "put others' needs ahead of your own" create guilt. Applying the ABC model, and supporting yourself through positive self-talk *after* assertiveness, reduces guilty feelings. Examples of post-assertive self-talk are: "I did it!" "I did my best, and I'm getting better all the time," "Good for me for trying!" "It's okay to say no."

The key is to provide yourself mental rewards for assertiveness. If guilty feelings crop up, acknowledge them, but keep being assertive. Don't let a little discomfort stifle self-expression.

Still another barrier is nonassertive *body language*. Even if your words are assertive, your tone of voice, eye contact, and posture may communicate passivity or aggressiveness. To overcome this barrier, become aware of your nonverbal style. Ask a trusted friend to give you feedback about your nonverbal communication. Think of people who appear to be comfortable with their assertiveness. Analyze their style, and adapt their techniques.

Pride also can be a barrier to assertiveness. For example, you may feel that by telling a professor, "I don't understand," you lose face. Some people may have been taught to "listen and learn" or "don't draw attention to yourself." Not asking for help, however, denies the information needed to succeed—in a lesson, in a class, and ultimately in life. Most teachers and counselors expect and welcome questions. Do not let false pride stifle assertiveness.

A final barrier to assertiveness is not knowing and not accepting *human rights*. By learning and accepting rights, you alleviate guilt and enhance confidence. Others have the same rights you do. That is where respect comes in.

Let's see how Jorge (first discussed in Chapter Six) worked through his low self-esteem in order to succeed in math. Looking back over his early messages from school, Jorge realized it wasn't that he "didn't have a head for math" as he frequently told others; the problem came from another source. Jorge's father was in the military, so his family had moved many times during his elementary and middle-school years. Every new school was at a different place in its math studies, and Jorge had become frustrated and discouraged trying to catch up. One classroom incident was particularly vivid in his memory: "The teacher would call us to the front of the room one by one and make us solve algebra problems on the board. I would pray to get an easy one but seldom did. One time, I didn't even know where to start. The teacher must have been in a really bad mood because he said this was stuff I should know and that I should stand there until I got the right answer. If the bell hadn't rung for lunch recess, I'd probably still be there. I can remember the humiliation and anger as if it were yesterday, and I know that was when I decided math was not for me."

Realizing that his difficulties with algebra had more to do with old fears than current ability, Jorge decided to change his beliefs and behaviors. After looking at his fears and then practicing some assertive techniques in his math anxiety class, he met with his algebra instructor to discuss his difficulties and get the help he needed. His instructor was understanding and willing to help. She also referred Jorge to the tutoring center where he could get additional help. Jorge found that once he conquered his fears, math was within his grasp. As he began to understand how to solve equations, his confidence in his ability grew. Not only did he learn to do algebra problems, Jorge now knows that asking for help when needed is a sure path to success in school.

EXERCISE **7.5**

ACCEPTING YOUR ASSERTIVE RIGHTS

PURPOSES

To recognize and identify assertive rights.

To remove barriers to assertive behavior by accepting rights.

To practice internalizing new human rights.

A partial list of basic human rights is:

- The right to have and express your own opinions.
- The right to interrupt to ask for clarification.
- The right to ask for help.
- The right to make mistakes.
- The right to ask for information from professionals.
- The right to decide how to spend your time, energy, and money.
- The right to have and express positive and negative feelings.
- The right to get what you pay for.
- The right to receive recognition for your achievements.

INSTRUCTIONS

1. Pick three of the rights that are toughest for you to accept.
2. Decide which of those three rights you would like to focus on for the next two or three weeks.
3. On index cards or reminder notes inscribe the right. Put them on your mirror, in your wallet, next to your bed, or wherever you know you will see those reminders. Use your name. *Example*: "Ann, you have the right to make mistakes."
4. Keep reminding yourself of your right until you feel comfortable accepting it.
5. Repeat steps 1 through 4 until you have internalized all the rights that were barriers to you.

REFLECTIONS

Through this exercise you've learned to identify and begun to eliminate one or more crucial barriers to assertiveness: accepting your right to behave assertively. How is it affecting your willingness to assert yourself?

Individual Styles of Assertion

Assertiveness does not conform to a right or wrong style. As indicated in the circle model, family environment and culture impact our self-esteem levels and behaviors. Individuals who are products of urban environments may learn communication styles different from those in rural environments. Many women were taught to place others' needs before their own and to be people pleasers. Many men are rewarded for aggressive behavior and are labeled "wimpy" if they express their feelings. All of these influences must be acknowledged.

Self-esteem is enhanced by finding an assertive style that is personally comfortable and meets the HARD criteria. Many students are quietly, yet directly, assertive. Others are introverts and have learned to ask for what they want. Some students have learned assertive behaviors very different from their families' and cultures' teachings while continuing to honor those important parts of themselves. In making behavioral changes to raise self-esteem, each individual has to start with small, easily attainable steps that are personally comfortable.

"I" Language

"I" language is a basic technique of assertive communication. It acknowledges the validity of one's own feelings and avoids blaming. In place of "victim" language, the person begins to take verbal responsibility for feelings and thoughts. Here are two examples that change "victim" language into "I" language:

Victim or Blaming Language	"I" Language
"Jack, you make me so angry."	"I feel angry with you, Jack."
"You never help around the house. This place is a mess during finals."	"I feel annoyed when you don't help with housework while I study for finals. Please do the laundry this weekend."

EXERCISE 7.6

PRACTICING ASSERTIVENESS

PURPOSE

To practice assertiveness through a sequence of five exercises.

INSTRUCTIONS

Listed below are some "I" message sentence patterns. Select any pattern (or patterns) that feels comfortable to you. In addition, do the exercises given for weeks 1 through 5. We suggest that you rehearse with each other in class. For example, the members of the class may pair up and practice giving and accepting compliments before practicing outside of class, in "real life."

"I feel _____ when you _____."

"I would prefer _____."

"I like _____."

"I am uncomfortable with _____."

"I don't understand _____."

"I would like your help with _____."

"I feel _____."

EXERCISE FOR WEEK 1: FEELINGS

PURPOSES

To identify your own feelings.

To recognize that you must identify internal feelings before translating them into assertive words.

INSTRUCTIONS

Six times a day for one week, write down on a small index card how you are feeling at that moment. Begin to identify feelings that occur in response to some situation. *Examples*: In class: "I feel confused." After breakfast: "I feel energetic." At work: "I feel sad." Use the following headings:

Feeling	*Date*	*Time of day*

EXERCISE FOR WEEK 2: COMPLIMENTS

PURPOSES

To accept expressions of positive feelings from others.
To practice expressing positive feelings.

INSTRUCTIONS

For one week, accept all compliments extended to you by replying "thank you." Give one compliment a day for one week. Record your compliments given under the following headings:

What I said *Other person's response* *How I felt after*

EXERCISE FOR WEEK 3: OPINIONS

PURPOSE

To practice expressing personal thoughts and points of view.

INSTRUCTIONS

For one week, express an opinion each day. Start with nonthreatening people and nonthreatening subjects. The opinions can be positive or negative as long as they're your own. *Examples*: "I don't like this cold weather," "I think this class is difficult." Record your opinions under the following headings:

Opinion expressed *To whom* *Response* *How I felt after*

EXERCISE FOR WEEK 4: ASKING QUESTIONS

PURPOSES

To learn the importance of asking questions.
To overcome the fear of appearing "stupid."

INSTRUCTIONS

For one week, ask questions for information and clarification of people you know. Start with your peers, then, toward the end of the week, practice asking questions of authority figures. *Examples*: To classmate: "How did you choose your academic advisor?" To math teacher: "Could you review Problem 6 again?" Under the headings below, record the responses and how you felt.

Question *Response* *How I felt after*

EXERCISE FOR WEEK 5: SAYING NO

PURPOSES

To practice setting limits.

To begin eliminating people-pleasing and overextending behaviors.

INSTRUCTIONS

For one week, practice saying no when someone asks you to do something you don't want to do. You may want to provide brief explanations, but don't make long-winded excuses. You may need to start with just thinking about saying no, and how that would feel. Write down all of the times you thought about saying no or said no, under the following headings:

What I was asked	*What I said*	*Response*	*How I felt*

REFLECTIONS

After you have completed all of the exercises, review them one by one. Were you able to identify your feelings? Give compliments? Express opinions? Ask questions? Say no when you didn't want to do something? Congratulate yourself on your progress. How did assertiveness "fit" your personality? What barriers to assertiveness need to be overcome?

—————————————————————————————

Assertiveness is a self-esteem building communication skill that you can utilize in college, on the job, and in relationships. By learning assertive roadblocks and techniques, you can create a personal style of assertiveness using the HARD method. Each person's assertive style is unique and fits that person's personality. If you want to learn more about assertiveness, your college may have workshops or entire classes on the subject. The publications listed in the bibliography are excellent sources for further reading.

STRATEGY FOUR: RELIEVING STRESS

If you feel your body tense up, your stomach churn, and your fists clench, you are experiencing physical symptoms of stress. Everyone's stress symptoms are unique, though, and what causes stress (the *stressor*) is highly individual. Cindy gets headaches when talking to professors. John becomes tense while studying for tests. Rico sweats when he simply thinks about seeing his ex-wife on campus. Stress feelings are so habitual that we often are unaware of the faulty thinking that started long ago to create the response.

The strategies presented here will relieve symptoms such as obsessive thoughts and chronic worries. The more effectively people learn to cope with stressful situations and the stress-producing thoughts that accompany them, the higher their confidence levels will rise.

Thought-Stopping

Thought-stopping is internal assertion. It consists simply of internally interrupting worries, "what if" thinking, catastrophizing, MOANS, and other obsessions—saying to yourself strongly and consistently: *stop!* If you are alone, you may want to say "stop" out loud, breaking the worry chain. You can control your thoughts rather than let them control you.

To accompany the internal assertion, many counselors recommend wearing a rubberband on your wrist. Each time the negative thought pops up, snap the rubberband while saying or thinking "stop!" Over time, the punishment of the rubberband becomes so annoying that the mind will not want to come near that thought!

If visualization works for you, you can picture a big, bright red STOP sign. This is your visual cue to *stop* that thought. Thought-stopping takes practice and repetition. Negative and obsessive thoughts and language creep back in. Each time, you will have to say or think "stop." Eventually the faulty thinking diminishes and is eliminated.

Breathing

All stressful thoughts and physical symptoms are accompanied by shallow or intermittent breathing. Phil Nuerenberger, author of *Freedom from Stress*, asserts that deep breathing and stressful thoughts are incompatible.[5] When thoughts drift to negative thinking patterns, breathing becomes shallow and irregular.

If you have watched a sleeping baby, you may have noticed the infant's lower stomach expanding and contracting in a natural, rhythmic pattern. We are born breathing naturally and deeply. Because of the daily stress of life and the tight clothes we are encouraged to wear, however, our breathing pattern changes to a learned, shallow style.

Negative, obsessive, self-esteem-reducing thoughts can be observed through your breathing patterns. Most people in the Western Hemisphere have not paid as much attention to the physical and psychological benefits of deep breathing as Eastern people have done through meditation techniques such as yoga, which integrally utilizes the power of the breath.

Simple awareness, practice, and correction of the stressful breathing patterns, connected to thoughts that lead to low self-esteem, will help you change those thought patterns.

EXERCISE

DEEP BREATHING

PURPOSES

To contrast stress-producing breathing with relaxed breathing.
To practice a more relaxed, controlled breathing style.

INSTRUCTIONS

1. Place your right hand on your upper chest, immediately below your collarbone. Breathe in and out five times. How does that feel?
2. Now place your right hand on your upper abdomen, a couple of inches above your navel. Breathe in and out five times. How does that feel?
3. Last, place your hand on your lower abdomen, below your navel. Imagine a long, narrow balloon in your chest. When you blow up that balloon, the bottom of the balloon fills with air first, and then the rest from the bottom up.[6]
4. Breathe in and out five times, filling up the lower abdomen first. If it is helpful, imagine the long balloon. Your hand will rise and fall as you slowly breathe in and out.
5. Breathe in through your nose and out through your mouth. What is the sensation and feeling of deep abdominal breathing?

REFLECTIONS

Notice how the deep breathing contrasts with the shallower, tension-filled breathing you experienced first. Choose an object such as a traffic light, or a clock, and practice your breathing every time you see this object.

Affirmations

After the mind is emptied of negative thoughts and the body becomes "centered" through deep breathing, simple statements called affirmations can direct mental energy in a more positive way. Affirmations are like the words of an internal nurturer or a best friend. Affirmations support a person through self-doubt and worry and eventually help create a new belief system. Previously irrational self-talk can be compared to ongoing convincing advertisements for low self-esteem. Through affirmations, *positive* advertising is created, enhancing self-esteem.

In her book *Creative Visualization*, Shakti Gawain[7] advises that affirmations be short, positive, simple statements. She suggests using the present tense and

putting full energy into the affirming thought. Other helpful recommendations are to write affirmations on paper and to use first, second, and third person while writing in the present tense, as in:

I, Ed, am competent and successful in college.

Ed, you are competent and successful in college.

Ed is competent and successful in college.

Notice that the affirmations are short and use Ed's name each time. If Ed finds himself worrying about his abilities to succeed and complete college, he can use thought-stopping, deep breathing, and then affirmations to cut short the worry cycle.

Affirmations should be repeated 15–20 times per day. To remind yourself of your affirmation, write it down, put it in your wallet, tape it to the bathroom mirror, put it in class notebooks and textbooks. Inundate yourself with new goals and ways of thinking!

The Case of Ed

Ed has not been to school in 25 years. He feels self-conscious about his age, although many re-entry students are in his classes. He has recurring self-doubts and worries about his ability to study and take tests. He also worries that he won't sound smart if he speaks in class. Through his counselor, he has learned stop-breathe-affirm techniques and has begun to apply them throughout the day.

Ed walks into his English class. He immediately feels tension throughout his body. Aware of his worries, he begins to apply the techniques (in italics):

Oh, no. Here I go again. I'm such a fool, getting so nervous. What if she calls on me? Some of these kids are so sharp. . . . *STOP! Ed, take a deep breath. Again. Okay.* But look at you—you're a mess. . . . *STOP! Breathe again. Remember, Ed, you are competent and successful in college. I, Ed, am competent and successful in college. Keep breathing.*

Ed relaxes as the instructor lectures. As the discussion portion of the class begins, Ed's fearful reaction commences again. He looks down at his notebook and sees the following affirmation written on the inside cover: *Ed, you are competent and successful in college.*

This affirmation reminds Ed to harness his internal nurturing voice. He reads the affirmation three times while breathing deeply. Although Ed does not join the discussion during his first Monday of practice, he continues to stop-breathe-affirm throughout the week. By the Friday session of his writing class, he asks the instructor two questions. He feels only slightly nervous but immediately repeats his affirmation to himself. Ed has begun to really believe he is competent and successful in college. He will need to keep practicing for several weeks, but as the semester continues, his good grades and the positive feedback from his teachers will be proof of his competence and abilities.

EXERCISE **7.8**

THOUGHT-STOPPING AND AFFIRMATION REHEARSAL

PURPOSE

To practice thought-stopping and affirmations

INSTRUCTIONS

1. List five worries and fears that presently are occupying your mind, interrupting your concentration, or causing you to lose sleep. They can be worries about class, career, family, relationships, money, or any other issues.

2. Choose one worry on which to focus. *Example*: Barb's number-one worry is about her decision to quit her job and go back to school for a degree. She continuously questions and second-guesses her decision, although she does a great job of researching the possibilities and talking to resource people. She would like to stop obsessing about her decision throughout the day and affirm her self-confidence in her own general decision-making abilities.

3. Write an affirmation to counter your worry. Make it brief, in the present tense, and use your name. This is Barb's affirmation: "I, Barb, am a thorough decision maker, and I like how I make decisions." Write your affirmation three times—in first, second, and third person.

4. Put a rubberband on your wrist. Now concentrate on your worry. Really experience it until you feel the tension in your body and mind. Keep worrying for a few minutes.

5. Now say "STOP!" while simultaneously snapping the rubberband on your wrist and repeating the affirmations you listed.

6. Repeat steps 4 and 5 until you really believe and feel the affirmations.

REFLECTIONS

How can affirming techniques help you in your college life? List at least one affirmation you will use for the rest of the school term.

SUMMARY

This chapter is the first in this book to translate what you have learned into action. It addresses esteem-building in general, through concepts of risking, removing internal barriers, assertiveness, and reducing stress.

Among the barriers to risking are perfectionism, maintaining status quo, fear of failure, catastrophizing, and awfulizing. These impediments can be broken down by setting achievable goals and working toward them in small steps, one at a time.

Internal barriers to self-esteem begin early in life and may be reinforced in your current environment, so they can't be changed overnight. The ABC model sets the proper course by showing how you, not outside events, produce feelings and reactions. The camera check and realistic positivism are two specific strategies to overcome internal barriers to success.

Assertiveness training is based on the HARD premise: honesty, appropriateness, respect, and directness. Among the obstacles to assertiveness are guilt, negative self-talk and body language, false pride, and inattention to human rights. Strategies to improve assertiveness include "I" language, expressing opinions, asking questions, and learning to say no.

Stress hinders esteem-building. It can be relieved by thought-stopping (internal assertion), breathing techniques, and affirmations.

The strategies in this chapter apply to school, work, relationships, and a number of life situations in general. Chapter Eight provides strategies geared specifically to your return to school.

NOTES

1. Maxie Maultsby, *Help Yourself to Happiness* (New York: Institute for Rational Living, 1975), pp. 10–11.
2. Albert Ellis, address on rational-emotive therapy (RET), National Convention of American Personnel and Guidance Association, St. Louis, MO, March 21, 1983.
3. Lewis Losoncy, *You Can Do It* (Englewood Cliffs, NJ: Prentice-Hall, 1980), p. 93.
4. Losoncy, pp. 49–62.
5. Phil Nuerenberger, *Freedom from Stress: A Holistic Approach* (Honesdale, PA: Himalayan Institute, 1985), pp. 184–185.
6. The balloon technique is from Gay Luce, *Your Second Life* (New York: Delacorte Press, 1979), pp. 80–81.
7. Shakti Gawain, *Creative Visualization* (New York: Bantam Books, 1985), p. 22.

Strategies for Success in School

- How can time management skills be affected by your personality?
- How can you overcome procrastination?
- Will goal setting enhance self-esteem?
- Can you create a support system for success?

Once you have practiced the techniques presented in this chapter, you will be more likely to achieve academic and personal success in college. Good time management and study skills, as well as full utilization of campus resources, build self-confidence. You will learn to view tests, papers, and other college tasks from a responsible, esteem-enhancing perspective. These skills won't be difficult to learn. The keys are diligent practice and a desire for success.

TIME MANAGEMENT ISSUES

Advice for managing your time often consists of paper-and-pen strategies for scheduling tasks and responsibilities. Although those strategies are important in attaining goals, the ability and willingness to implement time management techniques also are tied to self-esteem. Underlying time management are issues of personality type, procrastination, perfectionism, assertiveness, orientation and motivation toward success, and meeting life goals.

Personality Type: A Look at Extraverts and Introverts

In Chapter Two we explained the core circle, consisting of inborn personality tendencies, drawn from Jung's conceptualization and the Myers–Briggs typology. Before we explore this connection, write down your four-letter code from Exercise 2.1 in Chapter Two. Keep your preference code in mind as we examine the time/type connection: Personality Preference Code __ __ __ __.

Carol in Chapter Two let herself be interrupted by phone calls and other distractions while she studied. Carol is an extravert with an orientation toward people and the world outside herself. As with most extraverts, her energy flows out to people and things, and Carol sometimes has difficulty

concentrating on individual study projects. If you prefer extraversion, you may need to develop the strategy of inward (introverted) concentration for your studies by making one- or two-hour commitments to uninterrupted study, then rewarding yourself with a 15-minute phone call break. The difficulty some extraverts have in adapting to uninterrupted, inward-directed study time can be alleviated by some kind of reward system.

Introverts, on the other hand, can become so lost in thought that their subject matter concentration is interrupted by their own competing thoughts. If you prefer introversion, you may also tend to avoid study groups or talking through academic ideas with others. If so, you are naturally doing what is most comfortable for you. However, reaching out to fellow students and teachers for questions and feedback could increase your college success through enhanced use of study time. Both types may need to learn to discipline themselves accordingly for college study. Knowing your tendencies and learning to use both introverted and extraverted skills will help you accept and adapt your preferences so you can be more successful in college.

Procrastination

How often have you put off studying, although a part of you knows you "should" get to it? Have you worked with others who don't seem able to meet deadlines or timelines? Both of these scenarios can be frustrating and may involve the behavior of procrastination.

Procrastination is a time management issue, but it is also an important piece of the self-esteem puzzle. A large part of self-esteem building is based on engaging in activities that allow us to experience competence. In the short run, procrastination may provide temporary relief from stress. However, in the long run, if our procrastinating behavior results in mediocre or simply "passable" results, we may have little to be proud of. We will lack a sense of real success and feelings of competence.

Another way procrastination may relate to your self-esteem is its connection to risk-taking. We may procrastinate doing something that is scary, challenging, or new to us because we fear the unknown. Sticking to the status quo might be safe in the short run, but in the long term, we will miss out on experiencing competence from engaging in new activities.

Procrastinating behaviors might also be type-related for you. For example, a preference for perceiving rather than judging may lead you to put off completing tasks because you may tend to overextend yourself. Or, if you prefer intuition, you might spend so much time researching, gathering information, and looking at possibilities that simply starting a project might leave you feeling that you've missed some "better" approach.

For example, Jesse starts writing his papers on the last possible day before the deadline. Before he begins to write, Jesse works in the library for weeks at a time, following up on every footnote and bibliographic entry he discovers in his research, just in case he finds more information to include. Although he is

often complimented for his thoroughness, it is difficult for him to begin the actual task of writing. He often feels there is something "missing." Jesse needs to begin his process of completion sooner, but his standards for readiness are often unreasonably high.

If your homework or other chores do not appeal to you, instead of just "getting it over with," you may put it off. Most of us know, however, those ever-present, low levels of tension and stress that go along with a responsibility that is hanging over our heads. This stress drains the concentration and energy we need in order to focus on doing things we really enjoy. Eventually, we may feel guilty and angry with ourselves for not accomplishing what we have set out to do. Our self-esteem might suffer once again.

Priorities and Perfectionism

Accomplishing your best in areas of life that are important to you (such as parenting, work, schoolwork, and so on) is clearly worth striving for. Many of us may achieve near perfection in specific areas. To accomplish something "just right" is indeed a gratifying result of your efforts. Extreme perfectionists, however, then start believing that everything they do should turn out perfectly, in order to maintain their self-esteem. We are only human, so eventually some things will turn out differently than the way we would like. Perfectionists, who hold the strong, irrational belief that "everything should turn out perfectly or I am a failure," become extremely upset and sometimes depressed because their self-esteem has come to depend on achieving 100-percent perfection. One mistake or less-than-perfect accomplishment is interpreted as personal failure. From the breakfast dishes, to the impeccable shine on the car, to the perfect grade report, perfectionists feel everything must be "just so" to maintain self-worth.

Irrational perfectionism is a barrier to high self-esteem. It can keep you from risking. You may be spending time, money, and energy trying to achieve what may not be physically possible. To avoid the pitfall of perfectionism ask yourself:

1. Am I spending too much energy on this task?
2. Is it really worth it?
3. Does my effort further my personal goals or am I trying to prove something to someone else (from my past or present life)?
4. What exactly is it I am trying to prove?
5. To whom am I trying to prove something?

Perfectionism and prioritization are closely tied. If you are a perfectionist, your lifetime, yearly, and even weekly goals must be identified and clarified. When you are clear about the goals you have *developed for yourself* (not to please someone else), spending time perfecting activities that are irrelevant to your life's direction becomes counterproductive.

However, once your priorities are clearer, you can stick with them. To practice letting go of unrealistic perfectionistic expectations, tell yourself:

- It's okay to make mistakes. (You may be less forgiving of your own mistakes than those of others.)
- It's okay to ask for help. You don't have to do everything yourself.
- It's okay to leave chores undone some days.
- It's okay not to have a perfect grade. *Effort* and *improvement* are what is important.

EXERCISE 8.1

LETTING GO OF PERFECTIONISM

PURPOSES

To identify areas in which you may hold perfectionistic tendencies.
To practice letting go of those tendencies.

INSTRUCTIONS

1. List three aspects of your life in which you feel a need to be perfect. *Example*: perfect meals; appearing competent all of the time at school; kitchen floor swept after each meal; perfect clothing, make-up, office, and so on.
2. For which one are you willing to let go of perfection for one week?
3. Complete this sentence: "I'm willing to let go of _____ for one week, and I'm still okay."
4. Record your feelings (and anyone else's) about the process of letting go.

REFLECTIONS

After the week is up, consider the outcome. How did letting go affect you? You may have discovered that life goes on, the roof doesn't fall in, and you're okay even when things aren't done perfectly. By letting go of perfection, you free time and energy for school, relationships with loved ones, or whatever your real priorities are. Self-esteem does not depend on the appearance of perfection.

Optional activity: As a group or class, brainstorm and record areas of life in which you feel you should be perfect. Then choose a "letting go" area and repeat aloud the sentence from #3 above.

Assertiveness

As an adult student with a myriad of family or work-related commitments in your life, you face seemingly endless demands on your time. Loved ones may expect the same degree of availability of you as before you were a student. When assuming the added responsibility of school, skills that can be developed include setting limits by saying no and learning the art of negotiation.

Significant family members—mates, children, parents—may not understand the amount of time you need for study. As the hours formerly spent with significant others are transferred to study (even when taking one class), they may feel shut out or resent your school time. Communication, negotiation, and assertiveness strategies often are effective in those cases.

By *communication*, we mean educating your loved ones about the time required for study. A study time formula is presented in the next section. Show family members this formula if they are old enough to understand it. Some three-year-olds may understand simple concepts such as "Mom needs privacy to read these 10 pages." Explain how your class relates to your long-term occupational and educational goals. All the while, use "I" language and a non-apologetic, assertive tone of voice.

Negotiation simply means "make a deal!" Jane's spouse Joe will watch the children while she does her math. She'll take them to the zoo while he plays softball. If Tim's son Leroy will type Tim's paper on his computer, Tim will let Leroy use the car Saturday night. Trade favors with adults and provide positive consequences and rewards for children.

When your loved ones see and hear what school means to you, your success will take on a positive meaning to them. It will happen if you communicate and negotiate your priorities. If they still do not provide support for you, you may want to seek counseling and/or outside support.

EXERCISE **8.2**

SETTING GOALS

Self-esteem is tied closely to global feelings about yourself and also to feelings of accomplishment. By setting goals, starting with the smallest attainable ones, you can build self-esteem through successes. Setting goals has the larger benefit of helping you establish priorities for time throughout your life.

PURPOSES

To establish short- and long-term educational or career goals.
To break down those goals into smaller, attainable subgoals.

INSTRUCTIONS

1. Write down a four-year goal. Specify this goal as either an education or a career accomplishment.

 Example: Juan's goal: "Since I'm a part-time student, in four years I would like to have graduated with an associate degree in nursing. I want to be an RN."

2. To reach that four-year goal, what do you have to accomplish within two years?

 Juan's two-year goal: "In two years, I will have completed my required biology, writing, and chemistry courses to be accepted into the nursing program."

3. Now let's narrow the focus to the current semester or quarter. By the end of the semester/quarter, what do you want to accomplish?

 Juan's semester/quarter goal: "By the end of this semester, I want to have completed my sociology and writing classes with a grade of at least B."

4. Let's go one step further: What will you do today to reach your one-semester goal?

 Juan's answer: "I will read one chapter in sociology and write three pages of my six-page writing assignment."

REFLECTIONS

Focusing on and writing down short- and long-term goals clarifies the relevance of daily school assignments. Furthermore, family and other important people in your life can literally see *why* you need to study today. Think about how you can utilize this goal-setting exercise for career, housing, relationship, and almost any other kind of goal in your life.

DEVELOPING STUDY SKILLS

If you have been away from school for a number of years, your study skills may be rusty. Perhaps in high school you never developed strong study habits or have forgotten those you once had. In either case, you can raise your self-esteem (and your grades) by identifying the study skills you lack and developing an action plan to get the help you need.

EXERCISE **8.3**

ASSESSING STUDY SKILLS

PURPOSE

To help you determine your current level of study skills.

INSTRUCTIONS

Rate your school skills according to the following scale:

 1 = very poor 2 = poor 3 = average 4 = good 5 = excellent

1. Capacity to set clear goals that help me understand why I'm in school and explain how my coursework relates to the big picture. 1 2 3 4 5

2. Ability to maintain my motivation throughout an entire quarter/semester. 1 2 3 4 5

3. Ability to follow a lecture, picking out main points, supporting details, and relevant information. 1 2 3 4 5

4. Ability to adapt to a variety of lecture styles, including being able to deal with boring or uninspiring courses. 1 2 3 4 5

5. Ability to perform well on objective tests. 1 2 3 4 5

6. Ability to perform well on essay tests. 1 2 3 4 5

7. Ability to perform on tests without excessive anxiety. 1 2 3 4 5

8. Ability to manage time. 1 2 3 4 5

9. Ability to use the library to conduct research. 1 2 3 4 5

10. Reasonable level of comfort with technology such as personal computers, telephone registration system, databases at the library, and so forth. 1 2 3 4 5

11. Understanding the concept of "active learning" and knowing about the study methods that work best for me. 1 2 3 4 5

12. Understanding my unique style of learning. 1 2 3 4 5

13. Knowing how memory works and techniques I can use to help remember key concepts in my courses. 1 2 3 4 5

14. Knowing about tutoring resources. 1 2 3 4 5

15. Knowing about resources for improving my study skills. 1 2 3 4 5

Your score: _____

If you had a perfect score (75), skip the rest of this exercise.

If you scored between 60 and 70, your skills are good, but take time to review anyway. It will pay dividends at exam time.

If you scored below 59, the next section will be especially beneficial to you.

If you have been out of school for a period of time, your study skills are likely to be rusty. Seek help before you run into trouble. Here are some things you can do:

1. Take a class. Most colleges have study skills courses. Taking a class is an efficient way to learn new skills and refine old ones, because you have the benefit of an instructor's knowledge and experience, class time to practice new skills, and the opportunity to ask questions. An added benefit is the presence of other students who can support you as you learn and grow. You probably will find special-topic study skill classes as well. For example, math anxiety is recognized as a problem for many students, and campuses often offer courses to help students deal effectively with it.

2. Look for seminars on your campus. Most colleges offer noncredit lectures on various aspects of study skills. Although these one-time workshops do not provide the depth of a semester-long course, you still can benefit from attending.

3. Read a book. Some excellent study skills books and materials are suggested in the bibliography at the end of this book. Or ask your librarian to help you find one that meets your needs. If you check the catalog listings in your college or public library, you probably will be amazed at the number and variety of books for all aspects of study.

4. Form a study group. Enlist the help of your fellow students as you study together. The experience and information shared can be useful to all as you learn from each other.

5. Talk with your instructor. Most teachers are happy to answer your questions about how you can do better in class.

6. Make sure your reading skills are adequate for college work. If your school offers a reading assessment, take it, whether it's required or not. You can get by with lower reading skills, but the price you pay is reduced efficiency and wasted time. You need good reading skills to succeed in college.

7. Ask for help when you need it. See your academic advisor, counselor, instructor, or tutor. The professionals at your school are anxious to see you succeed. Help is available.

REFLECTIONS

You may wish to refer to the discussions on assertiveness and campus resources to help you determine where and how to ask for the assistance you need. Your success in college is too important to be left to chance. Make sure you know your skill level and how to get assistance if you need it. List one area you have targeted for improvement. _____

Planning Sufficient Study Time

Understanding how much time is *really* required for adequate study of course materials is a critical piece of the school success puzzle. Many new students underestimate the time they need to complete tasks because they don't understand how college works. A credit hour means that for every credit you carry, you will be in the classroom for that amount of time. So, when you register for a three-credit class, you will be in class for a minimum of three hours per week (lab classes may require even more time). In addition to time in class, you need to plan twice that for study time. This is what is known as the 2:1 formula for study success.

Study Time Formula

Here are sample schedules for a part-time and a full-time student:

Norm's schedule (part-time student)

English 101	=	3 credits
Algebra 130	=	3 credits
Total:		6 credits × 2 hours of study per credit
	=	12 hours of study per week
		6 hours in class
	=	18 hours devoted to college per week

Dorothy's schedule (full-time student)

English 101	=	3 credits
Math 070	=	3 credits
Computers 100	=	3 credits
Sociology 100	=	3 credits
Study Skills	=	3 credits
Total	=	15 credits × 2 hours of study per credit
	=	30 hours of study per week
	+	15 hours in class
	=	45 hours devoted to college per week

The study time formula provides an estimate of the time commitment of college. Many classes take more study time if they are difficult subjects for you, and other classes take less time if the subject comes easily. For example, your first algebra class will probably require more hours than the 2:1 formula shows, so adjust your time accordingly.

Awareness of the time commitment needed for college will allow you to budget study time accordingly. Alleviating the demands of an overloaded schedule through awareness of personal roadblocks, along with family help and support, will increase your chances for college success.

EXERCISE

UNDERSTANDING TIME REQUIRED FOR STUDY

PURPOSE

To give a realistic idea of time required for adequate study

INSTRUCTIONS

List your classes and the number of credits per class. Apply the 2:1 formula, adjusting where necessary for time-consuming courses.

Total credits ___ × 2 hours of study per credit = ___ study hours per week. My study need is ___ hours per week.

REFLECTIONS

What have you realized about your time commitment to school? Have you planned enough study time? Are there any adjustments you wish to make? Be aware that this is only an initial estimate of the time you will need. You may find it necessary to revise after you try out this study plan.

DEVELOPING YOUR SUPPORT SYSTEMS

Identifying and developing support systems is another key to your success in college. You will find that you are more likely to stay in school when you have people around you who care about your success and will help you get where you need to be.

Humans are social animals, and we utilize support groups for everything from ending compulsive shopping to giving up drugs and alcohol. Look around for individuals or groups to support you. Connect with a respected teacher or counselor. Form study partnerships or groups. Successful students are those who can take charge of their own education, get their needs met, and are willing to ask for help and support.

EXERCISE **8.5**

ASSESSING SUPPORT SYSTEMS

PURPOSE

To help you identify potential support networks.

INSTRUCTIONS

Identify at least two potential sources of support in the following areas. Omit those that are not relevant and add any that are not listed.

A. Moral Support and Encouragement

Family:

1.

2.

Friends:

1.

2.

Faculty/Staff at school:

1.

2.

B. Academic Assistance

Family:

1.

2.

Friends:

1.

2.

Faculty/Staff at school:

 1.

 2.

C. Child Care
Family:

 1.

 2.

Friends:

 1.

 2.

D. Other Areas Where I Might Need Support

REFLECTIONS

What support systems do you have in place? Where do you need to develop others? Brainstorm ways to develop support with your classmates. List one goal regarding developing support systems: _____

SPECIAL STRATEGIES

In returning to school, many students feel they have been particularly impacted by the teachers, curricula, and educational systems of the third circle in the circle model and by negative messages portrayed in the media of the fourth circle. If this is the case for you, specific strategies will help you begin minimizing or eliminating the messages and behavioral effects that are detrimental to self-esteem in college and in general.

Academic

In Chapter Four, we discussed the lack of strong (or any) female, nontraditional male, and minority role models in textbooks, history classes, literature, and so on. Many readers might conclude that these individuals have not been important or haven't done much and, therefore, what they do accomplish is not very important. The women's and civil rights movements as well as increased awareness of people with disabilities during the 1950s, 1960s, and

1970s had an effect on the educational system. From elementary school through college, many required classes have been infused with content covering the "hidden history" that rarely was taught previously.

An important contribution to self-esteem comes from learning the history of people whose gender, race, or religion rarely or never have been acknowledged in textbooks. Learning this history will help you discover the lessons that may not have been pointed out during formal schooling. It will provide role models of achievement through books, instructors, and guest speakers who visit the classroom. To do that, we recommend that you build the following strategies into your college career.

1. Look in the index of your college catalog. Find classes in women's studies, African-American history, gender psychology, gay and lesbian studies, disability studies, or other areas that interest you. These classes may be listed under "history of . . . ," "sociology of . . . ," "psychology of . . . ," or "literature of"

2. Write down three to five class options you can take to learn about the contributions and issues of minorities and women.

3. Take one of these classes as an elective, even if your program does not require it. Ask the professors for their syllabi to learn what to read on your own.

4. Write research papers and present reports in your classes focusing on the issues and achievements of women, nontraditional men, and minorities, especially those of your own culture.

5. To increase your understanding of other cultural points of view, take classes and write papers about cultures other than your own.

Personal

A mentor is a guide, a coach, or a role model who can show you the ropes. People who haven't been to college or are the first in their families to attend college may feel inadequate regarding the ins and outs of academic and professional success. Professionals such as counselors, advisors, professors, and graduate teaching assistants can give you advice about campus organizations, jobs on campus, and "survival" techniques in different subjects. They can guide you by offering concrete information and the psychological boost and encouragement needed at various junctures. Use assertiveness and risk-taking skills to set up meetings and ask for help.

Another boost to self-esteem and competence as a college student is becoming an observer of professionals you admire. How do they treat people? How do they teach? What do you like about their styles? What aspects of yourself would you like to develop to learn how to do the things you admire in those role models? Hone your analytical skills and your powers of observation to decide what makes a person successful. We call this becoming an "observer mentoree." Don't stop at observing. Talk to the individuals you admire. You'll also want to ask them about their career paths.

Many campuses have formal student organizations that provide for students cultural, political, and sometimes simply social avenues to meet individuals like themselves. Students of color and of minority religions learn to support one another in practical and emotional ways while working on common projects. These groups foster a sense of belonging to a community on college campuses that can seem alienating and impersonal. Connecting with established campus groups can answer questions in your mind such as "Am I the only one who's like this?" Your confidence is boosted when you meet others who hold common cultural beliefs and experiences. Often, joining campus groups is an avenue to meet caring advisors to serve as mentors or role models.

For example, Brian, whom we met in Chapter Five, decided to visit a meeting of his college Hillel chapter (Hillel is a campus-based organization for Jewish students). Through that organization, he was able to attend and celebrate religious observances with other Jewish students. He also participated in workshops to learn more about the philosophy of Judaism. He made friends who supported him and easily accepted his beliefs and identity. He even selected an Old Testament class to meet a college humanities requirement. In that class, he learned to understand and celebrate his rich religious and cultural background.

Brian's process of enhancing his self-esteem by reaching out to the campus Hillel group is paying off. He is finally forming a sense of pride and confidence in his heritage and in himself.

Support groups can be informal. These range from small groups of re-entry students meeting for coffee after class to study groups with the purpose of passing the next management exam. In one study, Astin found that the most important influence on growth, development, and success in college is the opportunity to regularly interact and learn with similar students. Similarities might include major, age, or going though a similar life experience.[1]

Smith's theory of self-esteem and race, described in Chapter Five, also highlighted that the protection, belongingness, and security offered by a group of like individuals can raise one's confidence level and chances for success.[2] If your schedule permits, you may want to consider joining a student group. Regardless of the type of group you join, the aim is to meet other students to create a sense of belonging for yourself.

IDENTIFYING CAMPUS RESOURCES

Most college campuses provide a variety of support services specifically designed to encourage student success and to assist students who attend their institution. These services have various names and titles. The student services offered at most schools are outlined below.

Counseling

If you are undecided about your career or major, need assistance with educational planning, or have personal problems that interfere with your schoolwork,

counseling is usually free and career testing carries little or no charge. On most campuses, college counselors have training in helping students deal with school-related anxiety issues. If you feel that text anxiety blocks you from performing well in school, seek help in your counseling center. Also watch for classes and seminars specifically designed to help you combat text anxiety. The counselors are there to assist you. You may want to talk over some of the self-esteem strategies in this book or may need one-to-one counseling in some area. These professionals can be helpful, especially if education, career, or personal concerns become overwhelming.

Ric, (see Chapter Two), who has little interest in sports and is more interested in photography and other art forms, went to see a counselor at his school because he was unsure what to major in. After taking the *Myers–Briggs Type Indicator* (described in Chapter Two), he learned to accept and celebrate his nontraditional (for males) personality style. He also took career interest tests that confirmed what he knew about himself all along: he enjoyed and wanted to pursue artistically oriented careers.

Ric's counselor referred him to male faculty members in nontraditional fields who could serve as advisors and mentors for him. Through the encouragement of his counselor and other campus faculty, Ric's self-esteem and his belief in his artistic talents have been encouraged and enhanced. He has role models who have broken tradition!

Student Activities

Student activities offices typically sponsor organizations, clubs, cultural events, student government, guest speakers, and concerts. Student organizations may be funded if they have a minimum number of members. Organizations vary from African-American clubs to debate teams to women's organizations. The student activities office will help you find out if a group of students with backgrounds or interests similar to yours exists on the campus.

Financial Aid

Government grants, public and private scholarships, campus-based work study jobs, and loans are administered and coordinated through the financial aid office. It provides applications and assistance in locating sources of financial aid. Part-time students are eligible for much of the available financial aid. Financial aid can ease the monetary (and emotional) burden of returning to school.

Learning Skills Center

Learning styles, study skills, and math anxiety workshops are just some of the topics that a college learning skills center will provide. These offices might help you to learn to get the most out of your textbook or how to take notes from your professors' lectures. A few practical tips offered by the staff of these centers could smooth the way for your college success.

Academic Advising

Academic advisors are specialists in course and program planning. They can answer questions regarding graduation requirements, transferable classes, major requirements, and how to balance a class schedule. You should see an academic advisor at least once a semester. Finding an advisor you feel comfortable with and seeing that person regularly can be a great help to you.

Tutoring

Tutoring is provided in various forms: through tutoring centers, associated academic departments (such as math tutoring through the math department), or special programs for minority or re-entry students. Your instructor or academic advisor should know the best way to get extra help. Pride or lack of assertiveness should not be a roadblock to seeking help in overcoming academic barriers. Tutors are there to help you through these barriers.

Admissions and Records

When you applied and registered for college, you probably received mail from this office. The admissions staff sends transcripts to other colleges or to employers for a small charge, validates the number of credit hours you are enrolled in for insurance and other purposes, and checks your adherence to graduation requirements. This office will also tell you if past credits you have accumulated can apply to your current program of study.

College Level Examination Program (CLEP) Testing and Other Assessments

The CLEP is a series of exams designed to demonstrate knowledge in a variety of subject areas. Through CLEP, students may bypass introductory coursework after testing and at the same time earn college credit. Many campuses also provide placement and language proficiency exams through the testing center. As a student with a busy schedule, any alternative ways to earn college credit are worth seeking out.

Career and Job Placement

Career and job placement centers are resources for printed and computer-based information about job outlooks, college majors, job descriptions, professional career paths, resume writing, and interview skills. Employment openings in the local job market are included. Guest speakers and workshops may be scheduled for certain careers and the local job market. Many students' motivation to attend college is to improve their employment opportunities. This office is the place to go to research your prospects in your chosen career field.

Resources for Students with Disabilities

Students with physical, learning, or emotional disabilities often are eligible for assistance designed to provide support in completing their education. Note-takers and tutors are two examples of services this department may offer.

EXERCISE **8.6**

CONNECTING WITH SERVICES

PURPOSE

To learn to find specific campus offices and services.

INSTRUCTIONS

Individually or in teams, do the following:

1. Utilizing local college directories, student handbooks, computer databases, and print materials your college provides, locate the following resources:

 Student Activities

 Financial Aid

 Counseling

 Academic Advising

 Tutoring

 Admissions and Records

 CLEP and Assessments

 Career and Job Placement

 Services for Students with Disabilities

 Some of the titles at your school may differ from those listed (for example, Financial Aid may be listed under Scholarships and Financial Aid).

2. Call each resource and make an appointment with the director of the program or another knowledgeable staff person to obtain information regarding their services. For each, write down the following information:

 Contact person(s):

 Location:

 Phone number:

 Hours of operation:

 Services available:

 Other comments:

3. Report to the class, individually or as a team, about the information you gathered.

4. (Optional) Arrange with your instructor to invite guest speakers from one or two key campus resources to talk to the entire class.

REFLECTIONS

Contemplate how you can empower yourself and, therefore, enhance your self-esteem by making connections with campus resources and utilizing the full array of available services. You need not feel lost once you have identified student-oriented people and services. You need only call upon your assertiveness and ask.

SUMMARY

The strategies presented in this chapter are geared specifically for the college setting. Based on concepts developed earlier in this book, personality type from the core circle is linked to management of time, and risk-taking and assertiveness are advocated for connecting with campus resources.

The importance of becoming involved and making connections cannot be overemphasized. Students who feel they belong to the college environment are more likely to reach their educational goals. Competency and self-esteem rise as isolation decreases. Support groups, or even one instructor and one study partner, may make the difference in your success at school.

NOTES

1. Alexander Astin, *What Matters in College?* (San Francisco: Jossey-Bass, 1993), pp. 398–404.

2. Elsie Smith, "Ethnic Identity Development: Toward the Development of a Theory Within the Context of Majority/Minority Status," *Journal of Counseling and Development* 70 (Sept./Oct. 1991): 184.

Success at Hand

- What discoveries have you made about yourself?
- How can you maintain the changes?
- How can you identify additional goals for your growth?
- How can you plan for the next steps in the re-entry process?

In this book we have looked at the many facets of self-esteem. We have seen that self-esteem is a unique internal self-rating that determines what we believe we can accomplish. Self-esteem begins to develop from the messages we receive in our formative years. How others treat us and our perceptions of that treatment also contribute to our self-rating and the value we place on their treatment and opinions. Our accomplishments and successes also play a part in our self-definition. Strategies and factors such as assertiveness, comfort with cultural differences, and the presence of role models help to maintain or enhance self-esteem. We have looked at the symptoms of low self-esteem, the potential these symptoms have for sabotaging your success, and how we can raise self-esteem. Now we can summarize what we have learned about ourselves and decide how we will use this information.

EXERCISE

IDENTIFYING SOURCES, SYMPTOMS, STRATEGIES, AND GOALS

PURPOSE

To help you sum up what you have learned about the sources of your self-esteem, symptoms of self-esteem, and strategies to raise your self-esteem, including goal-setting.

INSTRUCTIONS

Answer the following (you may wish to review Chapters One to Six first):

I. Sources:

 A. Inner circle: Inborn preferences

 1. My four-letter personality type is:

 2. The implications of this type for my self-esteem are:

 B. Second circle: Family messages

 1. Important messages learned from my lifescript are:

 2. In regard to family messages, I now know that:

 3. In regard to family values, I now know that:

 4. Birth order affects me by:

 5. The implications of this information for my school performance are:

 C. Third circle: Messages from the immediate environment

 1. Messages I received from the school environment were:

 2. Messages I received about myself as a learner were:

 3. Conclusions I made regarding these messages were:

 D. Fourth circle: Impact of the outer world

 1. Messages I received from the outer world regarding myself were:

 2. The media can impact my self-esteem by:

 3. These messages affected me by:

E. Self-esteem and higher education

 1. Regarding my self-esteem and higher education, I now know that:

 2. I can use this information to my advantage by:

II. Symptoms

 A. In regard to myself and symptoms of low self-esteem, I now know that:

 B. I have identified these four symptoms of low self-esteem to target for improvement:

 1.

 2.

 3.

 4.

 C. These symptoms impact my behavior by:

 D. To help myself succeed in school, I need to alter the following beliefs:

 E. To ensure my success in school, the most important thing I still need to remind myself of is:

III. Strategies (you may wish to review Chapters Seven and Eight):

 A. Two strategies I will use immediately to raise my self-esteem are:

 1.

 2.

 B. Two more strategies I will add after I am comfortable with 1 and 2 above are:

 1.

 2.

IV. Setting goals

 A. A goal regarding my education that I will accomplish in the next week is:

 B. A goal regarding my education that I will accomplish in the next month is:

 C. A goal regarding my education that I will accomplish in the next six months is:

REFLECTIONS

From this exercise you should have a clearer picture of your own self-esteem: where it came from, how it developed, what values it incorporates, and what conclusions you reached regarding yourself and your capabilities. You also can see how self-esteem affects your school performance and potential. Best of all, you now have an individual prescription and plan of action for raising your self-esteem.

Variation: If you are using this exercise in a class or workshop, exchange your responses in small groups or with the class as a whole.

EXERCISE **9.2**

REASSESSING LIFE AREAS

PURPOSE

To review your self-esteem ratings based on what you have learned so far.

INSTRUCTIONS

After thinking about what you have learned concerning yourself and your self-esteem, rate yourself on the dimensions listed below. When you have finished, turn back to the self-esteem assessment you completed in Chapter One, Exercise 1.1. Compare your ratings then and now. What changes have you made? What goals do you still wish to set for yourself?

THE DIMENSIONS OF SELF-ESTEEM

Academic Performance

1_____2_____3_____4_____5_____6_____7_____8_____9_____10
low medium high

Work Performance

1_____2_____3_____4_____5_____6_____7_____8_____9_____10
low medium high

Intelligence

1_____2_____3_____4_____5_____6_____7_____8_____9_____10
low medium high

Sociability

1_____2_____3_____4_____5_____6_____7_____8_____9_____10
low medium high

Family Relationships

1_____2_____3_____4_____5_____6_____7_____8_____9_____10
low medium high

Love Relationships

1_____2_____3_____4_____5_____6_____7_____8_____9_____10
low medium high

Physical Self

1_____2_____3_____4_____5_____6_____7_____8_____9_____10
low medium high

Emotional Self

1_____2_____3_____4_____5_____6_____7_____8_____9_____10
low medium high

Other Dimensions (specify)

1_____2_____3_____4_____5_____6_____7_____8_____9_____10
low medium high

REFLECTIONS

What changes do you see as a result of your efforts so far? What goals do you wish to set next? Complete this sentence: I feel good about my progress in the following area(s): _____

— · — — · — — · — — · — — · — — · — — · — — · — — · —

THE NATURE OF CHANGE

As we pointed out in Chapter One, your self-esteem may fluctuate depending on external life changes and internal emotional upheaval. It can fluctuate from week to week and even day to day at times. Even though you have taken great strides in feeling better about yourself, you still may feel shaky and need a refresher course from time to time. You probably will want to read certain chapters of this book again to bolster your self-esteem. Some discussions in this book will be more useful than others at certain times in your life. Your needs will change. As you gain strength in some areas, you will be ready to work on areas that were a lower priority when you began this book.

Even after you have gained some understanding about yourself and made some positive strides, your task is not over. Looking at the nature of change will be helpful. Humans tend to resist change, even when the new behavior is beneficial in the long run. The familiar seems safe, so we cling to it. Change is a slow process for most of us, and self-understanding is only a beginning. You need to know that the old fears and behaviors that got in your way in the past developed slowly, so you should not expect them to disappear overnight. At times the old messages about yourself seem strong, reactivating your self-doubt. You may even observe yourself backsliding. Here are some things you can do to strengthen your new behaviors and attitudes:

1. Seek support. Appeal to your family, friends, fellow students, counselors, teachers, and advisors. The stronger your support system is, the more likely you will be able to maintain changes you have made.
2. Surround yourself with positive people who believe in your success. One of the best ways to have a positive attitude is to hang out with like-minded people. Optimism is contagious.
3. Review the personal strategies (Chapter Seven) and the school success strategies (Chapter Eight) in this book. Use the information to make the most of your educational experience.
4. Keep a journal. Write about your successes, hopes, fears, and dreams. This can be a personal support system as well as a place to record your growth.
5. Make connections at school. Find a counselor or advisor with whom you feel comfortable. Make this person your guide, mentor, and sounding board. Having a consistent source of advice and information gives you a strong base of support.

6. Find a role model. Look for someone who embodies the qualities you are striving for, and hold that person up as a model. Keep in mind your own special qualities as well as those of your role model.

7. Take care of yourself. To help you maintain your new behaviors and attitudes, you need to be at your physical and spiritual best. Develop your spiritual self, however you define it. Take a fitness class; learn about nutrition; do something to keep your body healthy along with your mind.

8. Celebrate your progress. Every small step is important and worthy of acknowledgment.

EXTRA SUPPORT IN DEVELOPING SELF-ESTEEM

As you read this book and completed the exercises, certain issues may have surfaced that surprised you, either by the intensity they generated or by the discomfort you felt. Most of us have past or present experiences that are painful and troubling. Perhaps you are questioning whether to seek more help in dealing with these issues. You may wish to talk to a professional counselor or therapist if:

- You find yourself depressed, obsessing about the past, constantly angry, or blaming others for your difficulties.
- You find that some sections of this book stirred up old memories that caused you extreme emotional pain and you now have difficulty moving on.
- You could use additional help and encouragement in putting the strategies presented in this book into actual practice.
- You get feedback from others that tells you to work on some aspect of your personal life. Maybe you are having trouble getting along with your fellow students, teachers, or co-workers, or are exhibiting behaviors (such as perfectionism, procrastination, eating disorders, self-doubt) that get in the way of your success.
- You simply want to live your life in the most productive way possible and want some assistance in doing so.

If you have any of the above needs, you may wish to find professional help. The help you seek and choose will vary with your belief system and personal needs. Some people look to a religious or spiritual leader for help and guidance. Others seek out a professional counselor or therapist. If you are having difficulty deciding where to start your search, speak with a counselor at your school to discuss the various options open to you. You are important. You have made a conscious decision to better your life. Seek out the help you need.

CONGRATULATIONS

Attending school is a major life event. You deserve a round of applause for taking this positive step. You can and will succeed. Those of you returning to

school after an absence will soon learn that your life experience can give you an edge over first-time students. You bring with you the wisdom accumulated in the years you were out of school, a clear sense of priorities because you are a bit older, and the determination to succeed. You, too, will succeed!

Bibliography

Acquavita, Ronald, ed. "Tight Job Market Continues." *NRA Newsletter* 48:4. Reston, VA: National Rehabilitation Association, 1992.

Alberti, R. E., and M. L. Emmons. *Your Perfect Right*. San Luis Obispo, CA: Impact Publishers, 1974.

Allen, Caffilene. "First They Changed My Name . . ." *MS.* January/February, 1994.

Associated Press Service. "Hispanics Rarely on Prime Time, Study Finds." Reported in the *Arizona Daily Star,* Sept. 7, 1994.

Astin, Alexander. *Preventing Students from Dropping Out*. San Francisco: Jossey-Bass, 1975.

——— . *What Matters in College?* San Francisco: Jossey-Bass, 1993.

Barbe, Walter. *Growing Up Learning: The Key to Your Child's Potential*. Washington, DC: Acropolis Books, 1985.

Barcus, Earle. *Images of Life in Children's Television*. New York: Praeger Scientific, 1983.

Baumeister, Roy. "Understanding the Nature of Low Self-Esteem." In *Self-Esteem: The Puzzle of Low Self-Regard*, edited by Roy Baumeister. New York: Plenum Press, 1993.

Behan, Maria. "Atlanta Brave-Computerphobe Contest Winners." *HomePC*, Nov. 1995, No. 211.

Belenky, Mary F., et al. *Women's Ways of Knowing*. New York: Basic Books, 1986.

Bendat, William, ed. *The Career Fitness Newsletter* 2:1. Scottsdale, AZ: Gorsuch Scarisbrick, 1994, p. 1.

Bouchard, Thomas J., et al. "Sources of Human Psychological Differences: The Minnesota Study of Twins Reared Apart." *Science* 250 (1990): 223–228.

Butler, Pamela. *Self-Assertion for Women*. San Francisco: Harper and Row, 1976.

Caplan, N., M. Choy, and J. Whitmore. "Indochinese Refugee Families and Academic Achievement." *Scientific American*, Feb. 1992.

Carrillo, Ann Cupolo, Katherine Corbett, and Victoria Lewis. *No More Stares*. Berkeley, CA: Disability Rights Education and Defense Fund, 1982.

Coman, M., and K. Heavers. *How to Improve Your Study Skills*. Chicago: VGM Career Horizons, 1990.

Cooper, D. "The Best Gift Ever: The Love of Reading." *Arizona Daily Star,* Dec. 16, 1991.

Coopersmith, Stanley. *The Antecedents of Self-Esteem*. Palo Alto, CA: Consulting Psychologists Press, Inc., Reprint Edition, 1981.

Courtois, Christine. *Healing the Incest Wound: Adult Survivors in Therapy*. New York: W. W. Norton, 1988.

Cross, William E. "A Two-Factor Theory of Black Identity: Implications for the Study of Identity Development in Minority Children." In *Children's Ethnic Specialization*, edited by Jean S. Phinney and Mary Jane Rotheram. Newbury Park, CA: Sage, 1987.

Davenport, Donna, and John M. Yurich. "Multicultural Gender Issues." *Journal of Counseling and Development* 70 (1991): 64–71.

DiTiberio, John K., and Allen L. Hammer. *Introduction to Type in College*. Palo Alto, CA: Consulting Psychologists Press, Inc., 1993.

Dryden, W., and R. Diguiseppe. *A Primer on RET.* Champaign, IL: Research Press, 1990.

Eckstein, D., L. Baruth, and D. Mahrer. *Lifestyle: What It Is and How to Do It.* Henderson-ville, NC: Mother Earth News, 1975.

Ellis, Albert. Address on RET. National Convention of American Personnel and Guidance Association, St. Louis, MO, March 21, 1983.

Ellis, A., and R. Harper. *A New Guide to Rational Living.* North Hollywood, CA: Wilshire Books, 1975.

Ellis, David. *Becoming a Master Student.* Rapid City, SD: College Survival, 1994.

Eurich, N. *The Learning Industry.* Lawrenceville, NJ: Princeton University Press, Carnegie Foundation for Advancement of Teaching, 1990.

Evans, Ellis, et al. "Content Analysis of Contemporary Teen Magazines for Adolescent Females." *Youth and Society* 23 (1991): 99–120.

Field, Anne. "Women and Work." *Self*, Jan. 1992.

Fisher, Alan. "Take Charge of Your Career or Await Downsizing." *Arizona Daily Star*, March 24, 1996.

Forer, Lucille. *The Birth Order Factor: How Your Personality Is Influenced by Your Place in the Family.* New York: David McKay, 1976.

Gawain, Shakti. *Creative Visualization.* New York: Bantam Books, 1985.

Golden, Bonnie. *Self-Esteem and Psychological Type: Definitions, Interactions, and Expressions.* Gainesville, FL: Center for Applications of Psychological Type, 1996.

Grenier, Guillermo. "Who Are We? Hispanotrends Profiles: Hispanics' Lives and Aspirations." *Vista*, Jan. 4, 1992.

Guttentag, M., and H. Bray. "Teachers as Mediators of Sex-Role Standards." In *Beyond Sex Roles.* New York: West Publishing Company, 1977.

Hall, Roberta, and Bernie Sandler. *The Classroom Climate: A Chilly One for Women?* Washington, DC: Association of American Colleges, Project on the Status and Education of Women, 1982.

Harter, Susan. "Causes, Correlates, and the Functional Role of Global Self-Worth: A Life Span Perspective." In *Competence Considered,* edited by J. Kolligan and R. Sternberg. New Haven: Yale University Press, 1989.

Helfgot, Steven R. "Counseling at the Center: High Tech, High Touch." *New Directions for Student Services,* Spring 1995, No. 69.

Hirsh, Sandra, and Jean Kummerow. *Lifetypes.* New York: Warner Books, 1989.

Jakubowski, P., and A. L. Lange. *The Assertive Option.* Champaign, IL: Research Press, 1978.

Jensen, George. "Learning Styles." In *Applications of the Myers–Briggs Type Indicator in Higher Education,* edited by Judith Provost. Palo Alto, CA: Consulting Psychologists Press, Inc., 1988.

Jones, Dionne J., and Betty Collier Watson. *High Risk Students in Higher Education.* Washington, DC: George Washington University, School of Education and Human Development, 1990.

Jung, Carl. *Man and His Symbols.* New York: Doubleday, 1964.

———. *Psychological Types.* Princeton, NJ: Princeton University Press, 1971.

Kagan, Jerome. *The Growth of the Child.* New York: W. W. Norton, 1978.

———. *The Power and Limitations of Parents.* Austin, TX: Hogg Foundation for Mental Health, 1986.

_____ . *Unstable Ideas: Temperament, Cognition, and Self*. Cambridge, MA: Harvard University Press, 1989.

Katz, Judy H. *White Awareness*. Norman: University of Oklahoma Press, 1978.

Kilmarten, Christopher T. *The Masculine Self*. Macmillan, 1994.

Kogelman, S., and Joseph Warren. *Mind Over Math*. New York: Dial Press, 1978.

Kopecky, Gina. "The Age of Self-Doubt." *Working Mother*, July 1992, pp. 46–49.

Lakein, A. *How to Get Control of Your Time and Your Life*. New York: Signet, 1973.

Lawrence, Gordon. *People Types and Tiger Stripes: A Practical Guide to Learning Styles*, 3d ed. Gainesville, FL: Center for Applications of Psychological Type, 1993.

Leman, Kevin. *The Birth Order Book: Why You Are the Way You Are*. Old Tappan, NJ: Fleming Revell, 1984.

Lopez, Maria Elena. "Learning Enabled." *Tucson Daily Citizen*, Dec. 26, 1992.

Losoncy, Lewis. *You Can Do It*. Englewood Cliffs, NJ: Prentice-Hall, 1980.

Luce, Gay. *Your Second Life*. New York: Delacorte Press, 1979.

Mace, Don, ed. "Defense Expects Loss of 120,000 More Jobs." *Federal Employees News Digest*. Falls Church, VA: Federal Employees News Digest, 1992.

Maeroff, Gene. *The School-Smart Parent*. New York: Times Books, 1989.

Majors, Randall. *Is This Going to Be on the Test? and Nine Other Questions That Can Save Your College Career*. Scottsdale, AZ: Gorsuch Scarisbrick, 1992.

Maslow, Abraham. *Motivation and Personality*. New York: Harper and Row, 1970.

Maultsby, Maxie. *Help Yourself to Happiness*. New York: Institute for Rational Living, 1975.

Maurer, Lydia. *Opening Doors: Educating the Disabled*. Phoenix: Arizona Department of Education, 1985.

McKay, Matthew, and Patrick Fanning. *Self-Esteem*. Oakland, CA: New Harbinger Publications, 1987.

Miller, Krystal. "Attention Deficit Disorder Affects Adults but Some Doctors Question How Widely." *Wall Street Journal*, Jan. 11, 1993.

Mruk, Chris. *Self-Esteem: Research, Theory, and Practice*. New York: Springer, 1995.

Myers, Isabel Briggs, with Peter B. Myers. *Gifts Differing*. Palo Alto, CA: Consulting Psychologists Press, Inc., 1980.

Myers, Isabel Briggs, and Mary H. McCaulley. *Manual: A Guide to the Development and Use of the Myers–Briggs Type Indicator*. Palo Alto, CA: Consulting Psychologists Press, Inc., 1985.

Nolting, P. *Winning at Math*. Pompano Beach, FL: Academic Success Press, 1991.

Nuerenberger, Phil. *Freedom from Stress: A Holistic Approach*. Honesdale, PA: Himalayan Institute, 1985.

Pauk, Walter. *How to Study in College*. Boston: Houghton Mifflin, 1984.

Ray, Keith. "So Long to School." *Arizona Daily Star*, Dec. 16, 1991.

Rosenberg, Morris. *Conceiving the Self*. New York: Basic Books, 1979.

Rosenthal, Doreen. "Ethnic Identity Development in Adolescents." In *Children's Ethnic Socialization*, edited by Jean S. Phinney and Mary Jane Rotheram. Newbury Park, CA: Sage, 1987.

Rubenstein, Carin. "*New Woman*'s Report on Self-Esteem." *New Woman*, Oct. 1992, pp. 58–66.

Rule, Warren. *Lifestyle Counseling for Adjustment to Disability*. Rockville, MD: Aspen Systems, 1984.

Sadker, Myra, and David Sadker. *Failing at Fairness: How America's Schools Cheat Girls*. Macmillan, 1994.

Sanford, L., and M. E. Donovan. *Women and Self-Esteem*. New York: Penguin, 1984.

Schurr, K. Terry, and Virgil E. Ruble. "The Myers–Briggs Type Indicator and First Year College Achievement: A Look Beyond Aptitude Test Results." *Journal of Psychological Type* 12 (1986): 25–37.

Signorielli, Nancy. *A Sourcebook on Children and Television*. New York: Greenwood Press, 1991.

Smith, Elsie. "Ethnic Identity Development: Toward the Development of a Theory Within the Context of Majority/Minority Status." *Journal of Counseling and Development* 70 (1991): 181–188.

Steiner, Claude. *Scripts People Live*. New York: Bantam Books, 1975.

Thaler-Carter, Ruth E. "The Making of Strong African-American Families." *Guidepost* 34 (1992).

Thompson, Sarah. Educational Department Announcements. Office of Graduate Studies, Central Michigan University. http://pip.ehhs.cmich.edu/chart/grants1/grantss.txt

Tobias, S. *Succeed with Math: Every Student's Guide to Conquering Math Anxiety*. New York: College Board, 1987.

Trelease, Jim. *The Read-Aloud Handbook*. New York: Penguin Books, 1985.

Wabnik, Alisa. "Typical University Student Becoming Not-so-Traditional." *Arizona Daily Star*, August 24, 1995.

Walz, Garry R. *Enhancing Self-Esteem*. Alexandria, VA: American Association for Counseling and Development, Individual Study Program, 1992.

Wilcox, Melynda Dovel. "Starting out in America Today," *Kiplinger's*, April 1994.

Wilson, B., and G. Edington. *First Child, Second Child . . . Your Birth Order Profile*. New York: McGraw-Hill, 1981.

Wilson, M., Marlin Languis, and James Newman. "Did You Know?" In *Typeworks, USA, 4*, edited and published by Kay Abella and Sue Dutton. Washington Depot, CT, 1994.

Woititz, Janet. *The Struggle for Intimacy*. Deerfield Beach, FL: Health Communications, 1983.

Index

Journal